THE INSPIRED
RETAIL SPACE

ROCKPORT

First published in the United States of America by
Rockport Publishers, Inc.
33 Commercial Street
Gloucester, Massachusetts 01930-5089
Telephone: (978) 282-9590
Fax: (978) 283-2742
www.rockpub.com

Library of Congress Cataloging-in-Publication Data
Dean, Corinna.
 The inspired retail space : attract customers, build
branding, increase volume / Corinna Dean.
 p. cm.
 ISBN 1-56496-982-7 (hardcover)
 1. Stores decoration—History—20th century. 2.
Display of merchandise. I. Title.
NK2195.S89D43 2003
747'.8521—dc21 2003009078

Design: deep.co.uk
Cover Image: © J. D. Peterson / Kanner Architects
Text on pages 126-131 and 152-159 by Cheryl Dangel Cullen

Printed in China
Printed in Hong Kong
Printed in Singapore

THE INSPIRED
RETAIL SPACE
ATTRACT CUSTOMERS, BUILD BRANDING, INCREASE VOLUME

GLOUCESTER MASSACHUSETTS

ROCKPORT PUBLISHERS

CORINNA DEAN

CONTENTS

INTRODUCTION
THE CHANGING FACE OF RETAIL

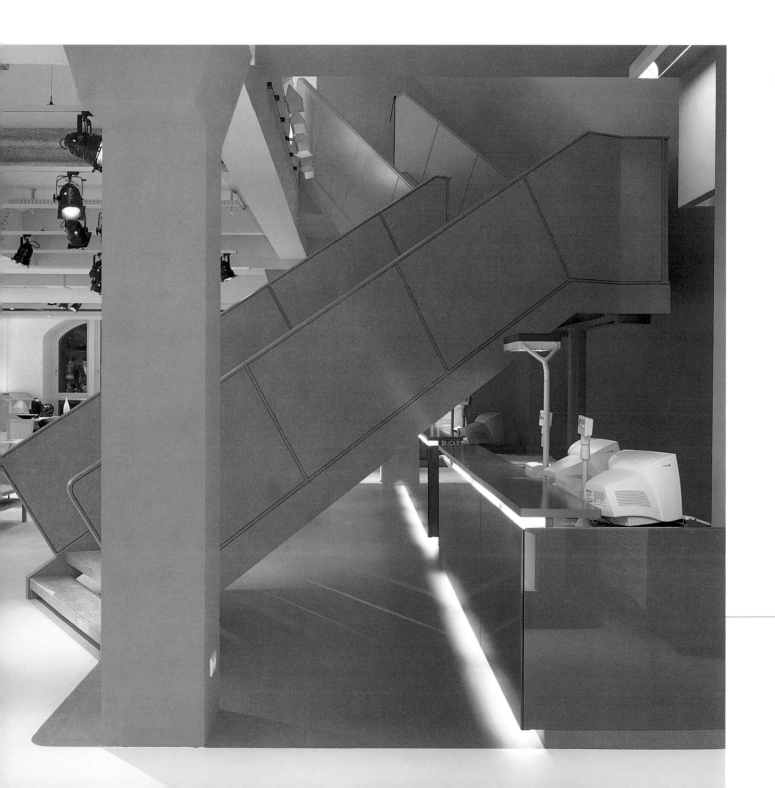

A quantum leap has occurred in retail-space design. As shopping becomes one of the most popular leisure pursuits of contemporary society, consumers become more discerning and sophisticated. Retail stores, aware of the increasingly visually astute customer, are up against a sea of competitors to gain brand loyalty. What was once the domain of select retail designers is now open to the less specialized architectural professional. Take, for example, Future System's succession of fashion boutiques for Marni, the Milan-based company, and the New York boutique for Comme des Garcons, under the directorship of Rei Kawakubo, the much revered Japanese fashion designer who has headed Comme since 1971. The practice, whose conceptual backbone is exploration of the relationship between futuristic technology and architecture, is in hot demand by a long list of retail clients. Herzog and de Meuron, the Swiss architectural practice, was commissioned to design the Prada headquarters in Italy; and Rem Koolhaas, the cultural living icon of architecture, was called on to design Prada's main showroom in New York.

Cutting-edge design once seen only in bars and hotels is spilling into the retail sector; new expressions of retail design are becoming a testing ground for design and architecture. The spartan minimalism of the Calvin Klein store by John Pawson became integral to the identity to the fashion house. On a wider scale, the minimal style was adopted almost universally for shop interiors. However, the supremacy of the minimalist style is now being challenged by a pluralist approach to design.

Mid-market retail stores, such as Jigsaw, the British fashion retailer, or the German-based company Reiss, are introducing elements borrowed from the highly designed, distinctive styles executed in the up-market retail boutiques. But despite the power of introducing strong design statements into these environments, attracting customers into the store and building brand awareness are still the principal concerns of the design process. These goals are often achieved by reinforcing the logo throughout the store or creating an environment synonymous with the brand.

The rule for retail space is that the design should reflect the product. This book examines a broad representation of retail projects, from the high-end boutique to the mid-market store. Each project is assessed in terms of the relationships among client, product, and design, and each design is reviewed with respect to how it reflects the product. In high-end markets, projects include the exclusive Alexander McQueen boutiques, launching the British designer's collection on a global scale due to the courting of McQueen by one of fashion's major powerhouses, Gucci, who has financed a chain of international boutiques. The design challenge in creating the architecture for McQueen, renowned for his originality in creating a look, came when he and architect William Russell set out to represent the brand three-dimensionally. In the mid-market arena, the Keds design brief called for a design that would broaden the appeal of the product and a concept that could be applied to retail outlets across a chain of shopping malls. Gerard Taylor Design Consultancy, commissioned to design the Habitat home furnishings store in Hamburg, successfully introduced a dynamic architectural solution that responded to the specific site and the varied array of products on sale.

As new designs for retail space flourish, the old formulas of display and movement through space are still at play, first to entice the consumer onto the shop floor, and second to gain their brand loyalty. How these aims are achieved is illustrated through the design strategy of each project.

This book also examines how design concepts are formulated with close consultancy with the client, as well as commenting on design details, surface finishes, lighting, and the relationship between product and space.

The theatrics of the circulation and transaction zone are heightened by dramatic lighting, achieved with input from a lighting consultant specialist. Parallel aluminum box beams run the width of the Habitat store, supplying ambient light with the display lighting that works off aluminum tracks running at right angles above.

THE RISE OF THE BRAND

Fashion houses are moving beyond selling luxury brands to performing a new role in contemporary culture. An exhibition celebrating the work of Giorgio Armani opened at New York's Guggenheim Museum, in exchange for an undisclosed donation rumored to be in the region of $15 million. London's Victoria and Albert Museum played host to a celebration of the designs of Gianni Versace in an exhibition that celebrated the haute couture label favored amongst celebrities. Fashion, branding, and culture are becoming inextricably linked. These associations are good for fashion houses, as the luxury goods market is saturated with must-have accessories from competing companies; those who can't afford the whole outfit can always buy the Gucci handbag.

The design of stores reflects the increasing influence of retail on culture. In a stiff contest to attract consumers, the association with culture affords companies the status associated with the so-called high arts, and with these newly acquired associations, the fashion houses are having an impact on the contemporary architectural scene. Leading architects are contributing to this burgeoning arena of culturally and aesthetically significant design. Prada recently commissioned architects actively engaged in architectural debate: Rem Koolhaas, founder of the Office for Metropolitan Architecture (OMA) and architect of the Rotterdam Modern Art Gallery; and Jacques Herzog and Pierre de Meuron, who designed Britain's most significant contribution to modern art, the Tate Modern Gallery. Both teams of architects were commissioned to design major buildings for the fashion house. Koolhaas was approached to redefine the Prada shop experience just as he was completing

The Harvard GSD Guide to Shopping I, "a two year student-based research project on the current state and future implications of shopping in the world." The research fed into the design of the showroom that opened in New York in 2001 to great acclaim.

It is interesting to glance back to the 1980s, when the fashion empires were vying for domination of the shopping strips. Richard Gluckman, the New York architect, worked within the minimalism mold until the style reached almost hegemonic levels. He designed such New York landmarks as the DIA Foundation, formerly a 40,000-square-foot (3,716-square-meter) warehouse; the exhibition space opened in 1987. Together with the minimalist artists Donald Judd and Dan Flavin, Gluckman went on to design the Yves Saint-Laurent Soho store and stores for Helmut Lang on Greene Street, New York, Gianni Versace in Miami Beach, and YSL Homme in New York and Paris. Other architects created their own versions of the minimalist style. The minimalist interior became the predominant retail style, and its position was reinforced when Calvin Klein hired the British architect John Pawson, renowned for propagating the minimalist style, to design their flagship store on Madison Avenue in New York City. Other retail outlets seemed to dramatically fall from favor because of their out-of-date style; the 29,000-square-foot (2,694-square-meter) French Renaissance Revival townhouse that Ralph Lauren turned into a $14 million palazzo started to look fussy. The pattern was similar in London.

Aware of the blandness of modernism and the artistic poverty of the style's imitations, brand retailers today recognize the public's need to distinguish one store from

another. The new McQueen stores take a significant step in the creation of a new retail aesthetic with the landscape of hanging display units that create stalactite forms.

Perhaps it is fair to say that the Guggenheim treatment that worked so well in Bilbao, with American architect Frank Gehry's design for the city's art gallery, grew to an overexpectation in architecture's abilities. The attempt to put a city on the tourist trail by providing a landmark tourist attraction was emulated by many other regional cities.

A more candid approach to architecture's role in retail, also due to the retail outlets' expected time scale, has to consider a balanced approach to design, accessibility, function, and identity. McQueen, previously head of design at the Parisian fashion house Givenchy, joined forces with architect William Russell to interpret his personal style and introduce it into the environment of the McQueen store to express the inception of the McQueen brand supported by Gucci.

Two brands that have demonstrated longevity in the market are Chanel and Bally. Bally, the 150-year-old Swiss shoe manufacturer, was keen to modernize its image and attract a younger clientele. The company appointed American architect Craig Bassam to reinterpret the craft-based skills that the company prides itself on and expressed this via its flagship store on Berlin's main shopping street, the Kurfsturmdam. The new Chanel store in Osaka, designed by Peter Marino and Associates, promotes the use of high-tech materials through the execution of the much-imitated Chanel logo.

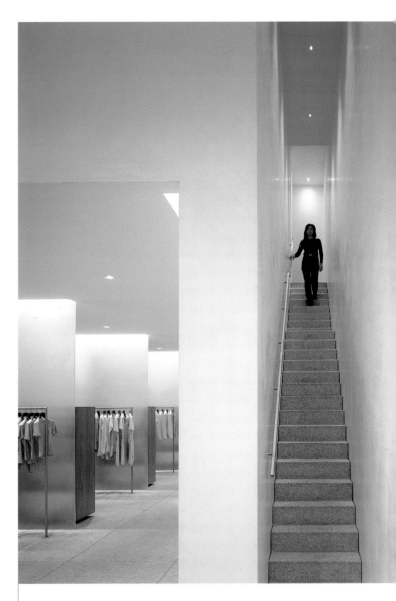

The DKNY flagship store, which opened on London's Bond Street in 2002, introduced a gold-leaf wall to accentuate the luxurious nature of the store. Gone are the cool, buffed metallic finishes of previous decades, influenced by the high modernist architectural style, or the predominance of shadow gaps and glass favored by the minimalists.

CHANEL, OSAKA, JAPAN
PETER MARINO + ASSOCIATES, NEW YORK, NY

The prominent corner location of the Chanel store on 1-10-11, Shinsaibashi Suji Chuo-ku, has become a visual beacon through the introduction of a new glazed façade that incorporates the latest LED lighting technology. By day, the building is a pure white cube of glass; by night, the glass curtain wall transforms into a dynamic installation with programmable backlighting. This reinterpretation of the Chanel logo as a dynamic object is a strong contemporary feature that competes with the plethora of signage that adorns Osaka's streetscapes. The double-C logo, which first appeared on the package of the world-famous Chanel No. 5 perfume in 1921, is still exclusive to the house and defines its classic and minimal style.

The store is defined by a perimeter of patterned and textured panels of carbon fiber and gold leaf, poured resin, and glass fiber. The panels are dynamically composed to accentuate the scale and detail of the environment. In addition, they form support systems for the glass and silk-fiber shelving. Behind the panels are slim sections of woven aviation fiberglass that adds to the enriched atmosphere, providing a silver light that reflects off the walls. The decision to use such unconventional and high-tech fabrics, some borrowed from the aeronautical industry, paralleled the continuous search at the house of Chanel, under the direction of Karl Lagerfeld, to find the latest fabrics. Two results are in the 2005 bag and the J1 for men and women—part of the accessories collection—that incorporate materials such as high-tech ceramic and rubber.

The focal point of the interior scheme is a feature wall of moving scrims that punctuates the black, gold, and white combination of interior colors. The kinetic structure adds vibrancy and energy to the architecture.

The interplay of minimal planes, the elegant proportions, and the sophisticated deployment of technological materials yield an enriched and contemporary environment reflecting the chic elegance of the Chanel fashion house. The introduction of the classic Chanel logo as a major design feature in the dynamic façade of the store reinforces the importance of the brand as a major signifier of all things associated with Chanel.

The architecture solution employs a series of panels that relates the exterior and the interior of the building. By introducing design consistency between the exterior and interior, the store becomes an object clearly related to the Chanel brand and not to the surrounding urban environment.

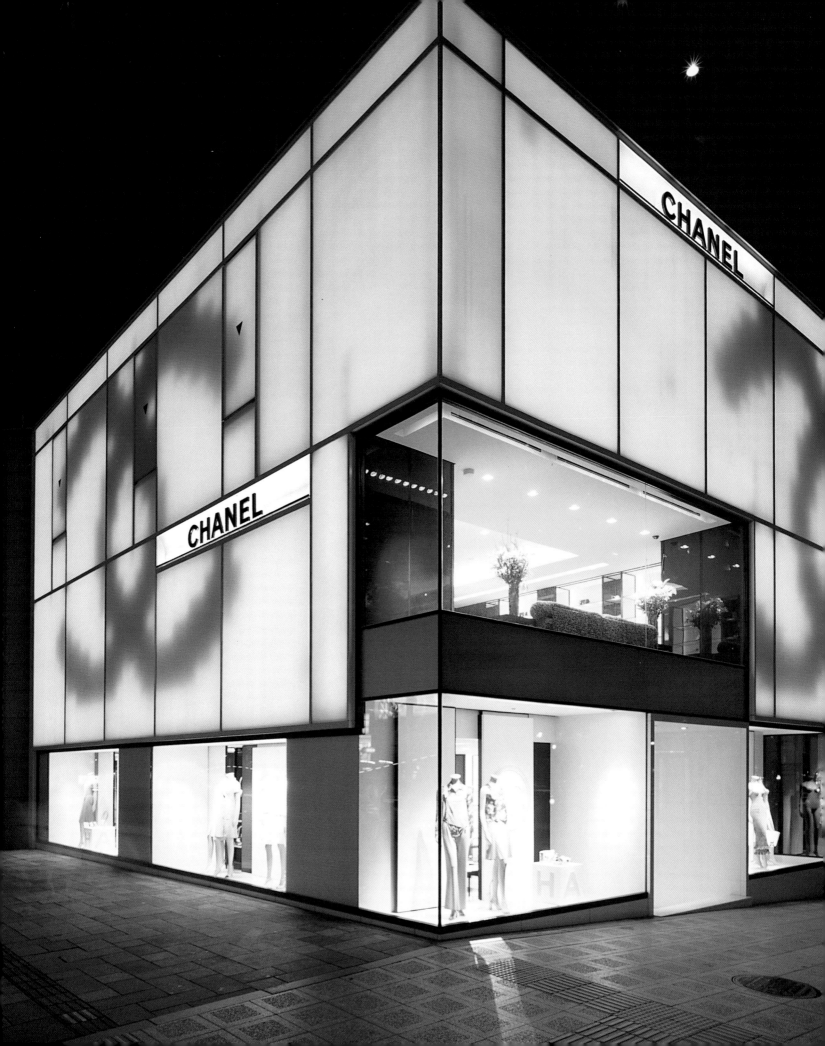

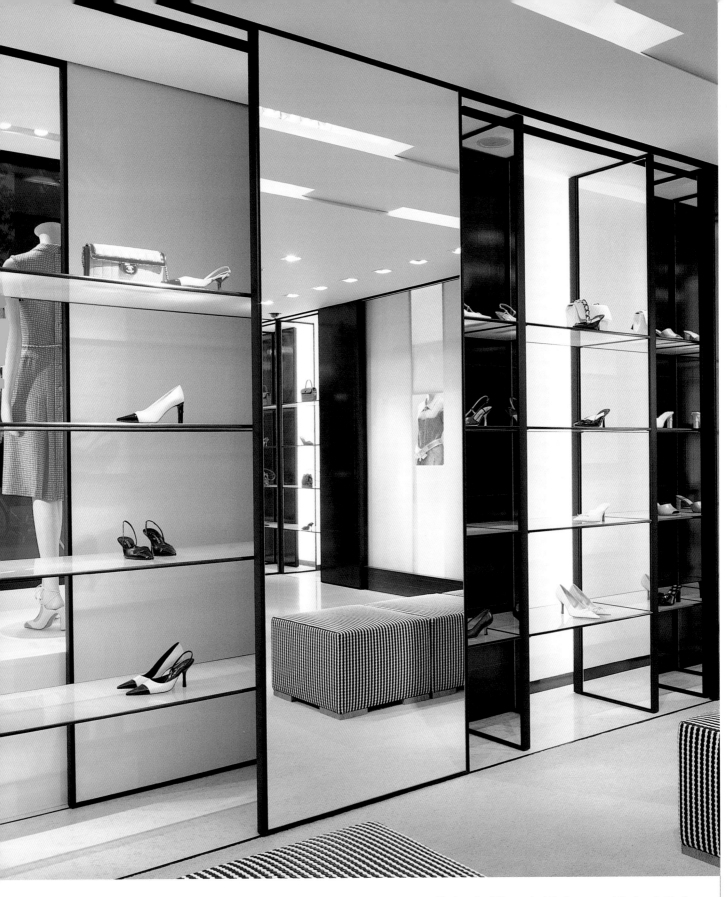

The interior fittings adopt the language of the logo in black and white. In addition, they introduce sophisticated materials borrowed from aviation techniques, such as the woven aviation fiberglass backlit panels, which emit a gentle, colored light. The allure of the environment acts as a seductive tool to attract customers.

Moving LED lights create a kinetic effect that uses the Chanel store's façade as a technological screen announcing the brand.

"The interplay of minimal planes, the elegant proportions, and the sophisticated deployment of technological materials yield an enriched and contemporary environment reflecting the chic elegance of the Chanel fashion house."

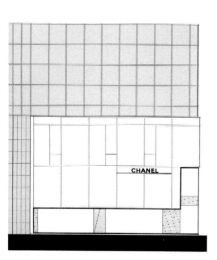

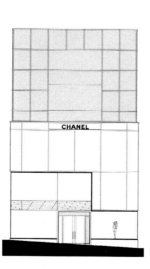

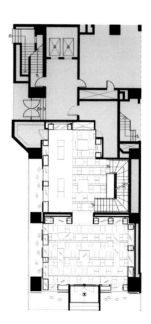

Plan of Chanel store.

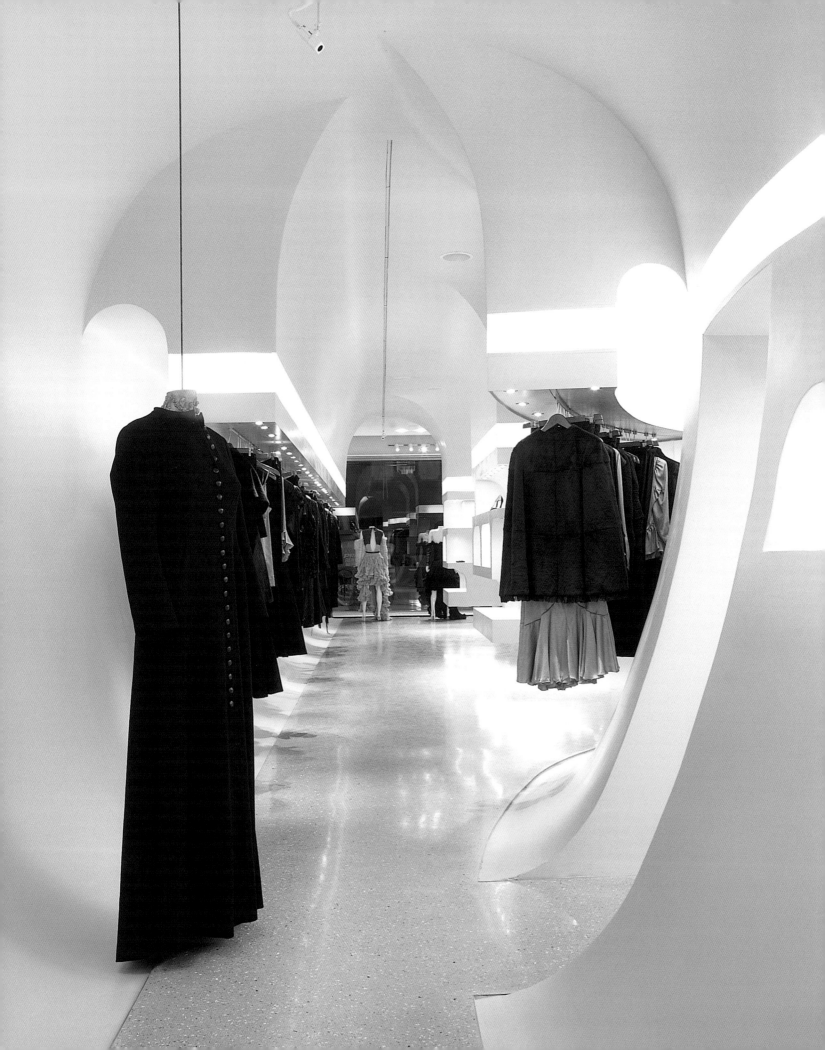

McQUEEN, NEW YORK, NY
WILLIAM RUSSELL ARCHITECTURE, LONDON, UK

The sticking power of McQueen, an icon of British fashion, has probably just as much to do with his business savvy and talent as has the big fashion houses' desire to capture and promote a brand. For the few designers who are staked out on the big stage, McQueen, along with Stella McCartney, Bella Freud for Jaeger, and John Galliano, the symbiotic relationship is in full flow, but McQueen has the rare opportunity of a large degree of creative control over the string of eponymous shops that have opened around the globe.

McQueen got his first taste of fashion as an apprentice as a Saville Row tailor. He then went on to St. Martins and completed a postgraduate degree in fashion at the Royal College of Art. He moved to Paris to head Givenchy's couture house but left in 2001 to launch, with Gucci's backing, his own label.

Gucci's investment in McQueen suggests that his position in fashion is solid. In fact, the firm bought a stake in the McQueen label in December 2000. Asked if McQueen has longevity, Gucci Group CEO Domenico de Sole dismissed any uncertainty. "The question that I had to ask myself—because it is my job—is does he really have the power and the talent to turn McQueen into a global brand? I think he does; otherwise I couldn't have done the deal." And so the McQueen label was launched. With shops opening in London, Tokyo, Milan, Los Angeles, and New York, the brand is going global. "I see Alexander McQueen as a luxury goods label, very modern, very twenty-first century," says McQueen, "but it doesn't have to be a global brand to the point of Calvin Klein underwear splashed across billboards." In the long run, McQueen envisions fifteen stores worldwide, but not before carefully analyzing how the principal stores function.

The seamless interior is created by hanging the structures from the ceiling. The lighting datum level remains constant throughout the store.

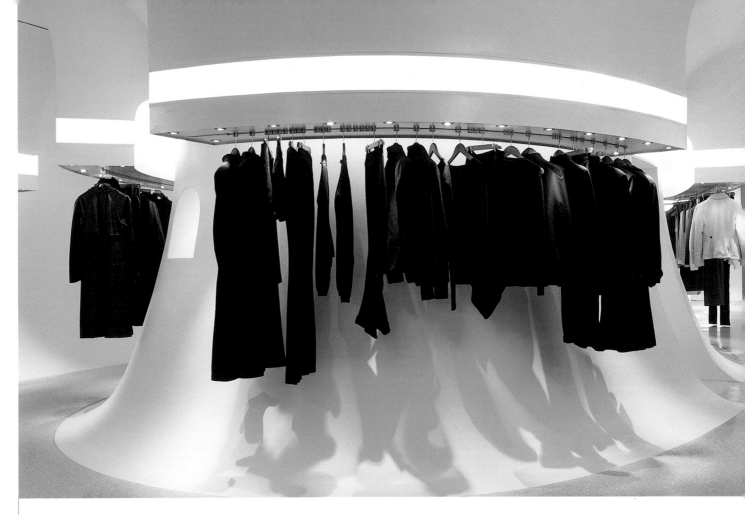

The hub, called the mother ship, encloses the changing rooms.

The design brief was a challenging exercise "to create an environment as a brand." William Russel, Architect

To design these stores, McQueen approached the architect William Russell, who had designed exquisite private homes for Ewan MacGregor, Chris Offili, and others, as well as innovative bars, while practicing with David Adjaye. Russell is in demand from the retail sector and works for such retailers as Margaret Howell and Reiss.

The design brief was to develop a distinctive design concept that could be reproduced worldwide to suit each location, from flagship stores such as New York and London to small concessions within department stores or even airport duty-free retail outlets. For Russell, it was a challenging exercise "to create an environment as a brand."

Russell worked closely with McQueen, discussing how the recurring themes in his designs and their apparent contradictions—such as traditional versus modern, sharp versus soft, and craft versus mass production— could be expressed in the design of the shops yet subordinate to the clothes themselves. The resultant design has its own aesthetic vocabulary, with hints of the ecclesiastical as well as the ultramodern.

McQueen New York is located on West 14th Street in a former meatpacking warehouse. Russell describes the creative process: "McQueen practically spews out creativity. It's learning how to harness and translate these ideas into three dimensions that has been part of the challenge."

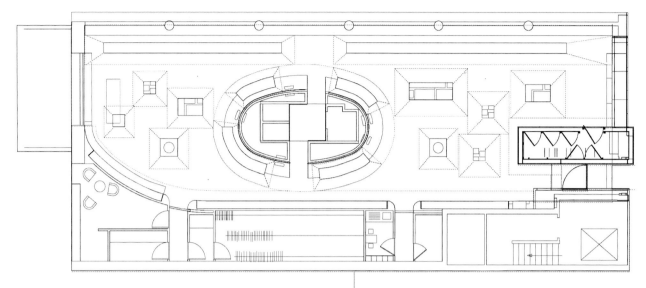

The plan of the space illustrates the main features of the hanging structure, which hovers from the ceiling to form display points

The cash wrap desk rises from the floor level.

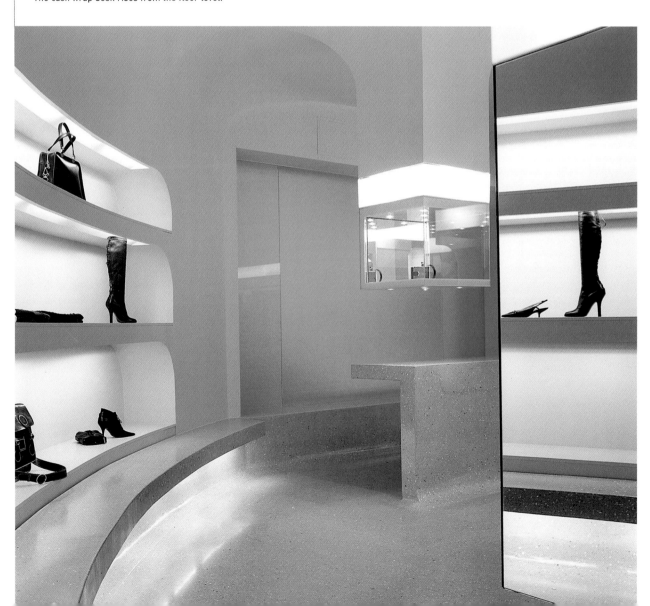

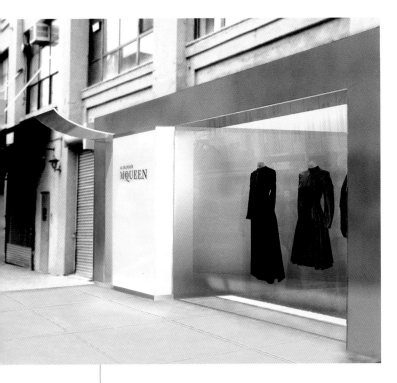

The New York McQueen store is located on West 14th Street in a former meatpacking warehouse.

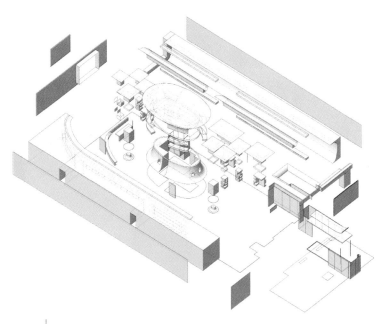

The cash wrap desk rises from the floor level.

The executed design features an extraordinary vaulted space with curvilinear dove gray walls and chambers. The display elements are suspended from a steel frame bolted to the floor slab above. This frame extends to the lighting datum level and the cabinets bolted to it. The whole construction is flush and painted in the same color so it appears as a single monumental form. The hanging display cabinets are modular and repeatable while the sculpted ceiling/wall surface are more freeform so as to allow flexibility for adaptation to each site. The expressive and aesthetically challenging design reflects the dynamism and originality of McQueen's collection.

Russell also worked closely with the Gucci store planning department, which has extensive knowledge of retail design for the whole of the Gucci group.

The department advised on many areas, including the obvious correlation between the amount of merchandising space and sales achieved.

"The clothes will seem to hang in midair, as there are no rails or shelving." Russell refers to the mother ship, a central pillar that plunges below ground level and that houses the changing rooms. "Technically, that part has been the most challenging."

The store combines a sophisticated execution of design with a creative language that mirrors the originality and rich diversity of McQueen's collections that always stand out from the design trends. McQueen has created a highly individual and, at times, theatrical creativity that continues to shock and delight the fashion world.

An initial concept drawing demonstrates the sculptural
structure and its cathedral-like elements.

CAMPER, NEW YORK, NY
ESTUDIO 22, BARCELONA, SPAIN

Camper shoes are fun, quirky, strong, and, above all, robust—and the manufacturer, based on the island of Majorca, works hard to promote environment-minded lifestyle principles. Ole Armengol, director of Estudio 22, designed one of the first Camper shoe stores and comments on his experience: "To work with a company that is so individual and that has created such a clear path that remains apart from high street trends but keeps pushing its own aesthetic based on quality has been a rewarding challenge."

The somewhat oblique marketing campaigns, which mainly omit the product, focus on the simple rural Spanish lifestyle. The advertising campaigns promote the Camper customer as supporting individuality and environmental and local issues without ignoring the global picture-issues that are reflected in the shops as well. Camper's "magolog" covers topics such as the Forestry Stewardship Campaign (FSC) and the anticar campaign; their motto is "Walk, don't run!" Respect for individuality is expressed in the unique design of each store; no layout is ever repeated.

Respect for individuality is expressed in the unique design of each store; no layout is ever repeated.

The Barcelona-based design practice Estudio 22 was established in the 1960s by Armengol, an early multi-disciplinarian who works in photography, graphic design, and interior design. His firm has designed a range of international and national projects. In 1981, Estudio 22 was asked to design the point-of-sale area for Camper within a department store. Since that first commission, a string of corporate designs for Camper has included the design of its main office in Inca, Majorca, in 1984. In fact, Estudio 22 has completed over ninety Camper stores from Tel Aviv to Hong Kong, plus six Camper factories. The practice has collaborated with all company departments, including marketing, publicity, and graphics, and has teamed up with external designers such as the British graphic designer Neville Brody and the Spanish product designer Xavier Mariscal.

The large steel dome lights, a central feature of the New York store, were designed by the German lighting designer Ingo Maurer.

CAMPER MEANS PEASANT
in Catalan, a language spoken by six
million people in Europe. Camper was born
recreating a rustic old peasant's shoe using
the insides and outsides of pneumatic tires.
This word (camper) defines our way to walk.
Our dream is to walk very close to Earth.

CAMPER IS PEOPLE:
Camper is an open house to people from
many different countries and cultures that
share values and a different way of walking
through life. People who walk, who smile,
who imagine. Walk more. Imagine more.

CAMP

CAMPER IS
NOT ALWAYS
NECESSARY

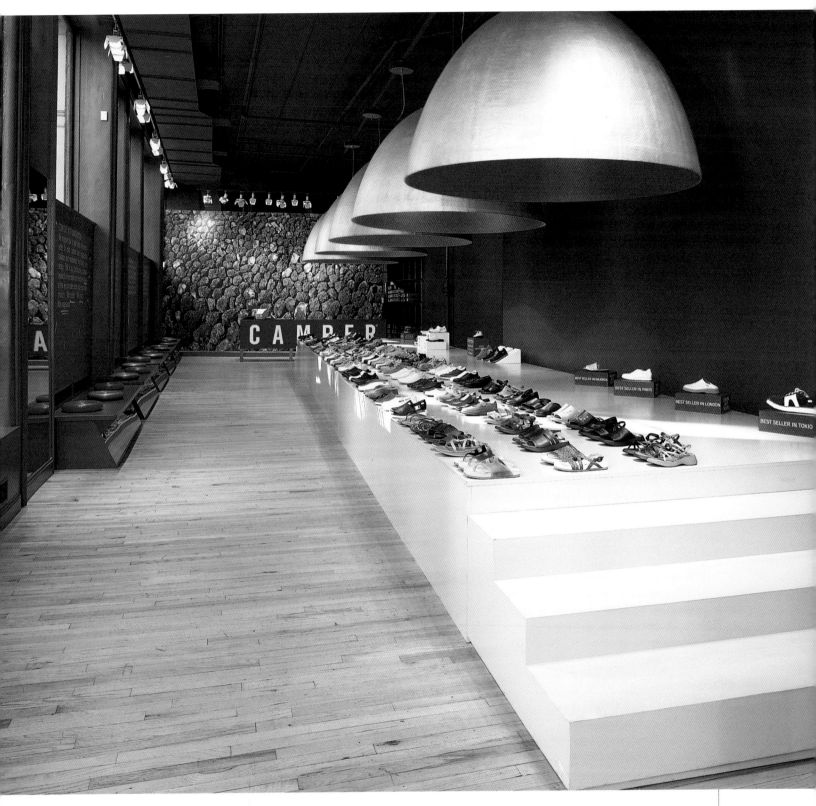

The trademark features of the Camper store are strong graphics and novel ways of displaying the product. Here, shoes are attached to the walls with Velcro and displayed on a central, large-scale podium.

The store designs are based on a recurring set of principles. Natural woods and untreated building materials were used for the principal architectural elements. The antitheses of conventional shop lighting and basic display methods were introduced in the New York store, manifested in a centrally placed table in the shop or rows of robust shelving. The interior design is supplemented with bold graphics and advertising posters. The color red predominates each store's graphics and interior scheme. In the New York store, Ingo Maurer's large conical spun-steel dome lights are painted red and dominate the simple space. The exaggerated use of scale, as executed in Maurer's oversized lights, dominates the simple linear space typical of many of the converted warehouses in New York.

Although Camper now has over one hundred stores worldwide, it has been careful to respond to the subtle cultural preferences of each country, be it a more reserved collection, as in Paris, and an interior to match or the reverse in London, where shoes are attached to strips of velcro running horizontally across the walls. This sensitive approach reinforces the highly individual nature of the product, still manufactured at the family-run factory on Majorca. It is clear that Camper's unswerving style premise is to produce shoes that appeal to the customer who enjoys wearing shoes that are not part of the seasonal look of the moment but about wearability, durability, and the great outdoors. Camper shoes are designed to last, which has strong appeal to the customer who puts quality alongside fashion.

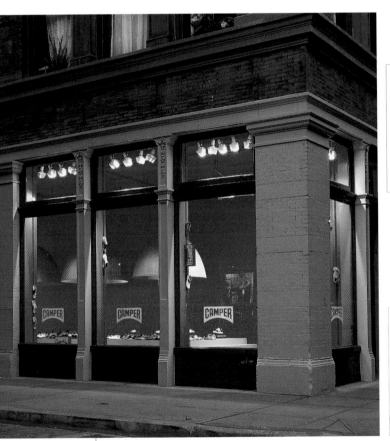

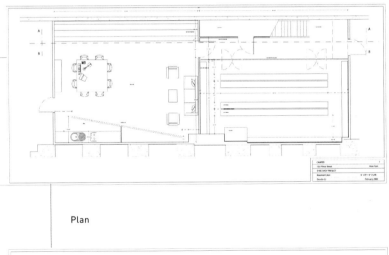

Plan

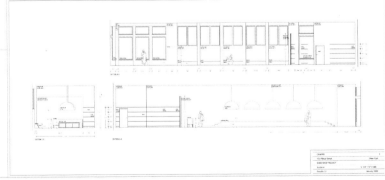

Estudio 22 embraced Camper's philosophy of individuality when designing its stores. In fact, every design is unique and never repeated—as seen here with Ingo Maurer's dome lights and shoes velcroed to the wall.

BALLY STORE, BERLIN, GERMANY
CRAIG BASSAM ARCHITECTS, NEW YORK, NY

The 150-year-old Swiss shoe manufacturer, Bally, known more for quality than style, has taken a dramatic turn in the rebranding of its product under the direction of Bally's new creative director, Scott Fellows. Fellows cites such influences as Collette, the Paris boutique that houses a water bar and art gallery amid its fashionable lifestyle products and fashion apparel. Fellows wanted to push the function of retail space not only aesthetically but functionally: "With nothing nailed down, the store can be whatever you want it to be, whenever you want it to be." Plans are in the making to use the stores as temporary art spaces and venues for literary readings and other public gatherings. To help create this new branding strategy, Fellows hired architect Craig Bassam.

Bassam, who splits his time between the United States and Switzerland, was asked to tackle the redesign by Abel Halpern, partner and managing director of Texas Pacific Group, the American investment fund that acquired Bally in 1999. Halpern had previously appointed Bassam to design his London apartment and offices.

Bally's new flagship store is situated on Berlin's main shopping street, the Kurfurstendamm. Bassam had not worked in retail design before and was slightly ill at ease with the genre but, assured that he would have free rein, rose to the challenge of designing in the dynamic German capital. "It's a new city, a modern city, a great place to do a first concept," comments Bassam. "My attitude was that the whole project would be a complete experiment."

The theme of handcrafting is expressed in every detail, from the pull-out cabinets set flush in the wall to the stools.

Mirrored panels conceal storage drawers finished in lacquered red paint.

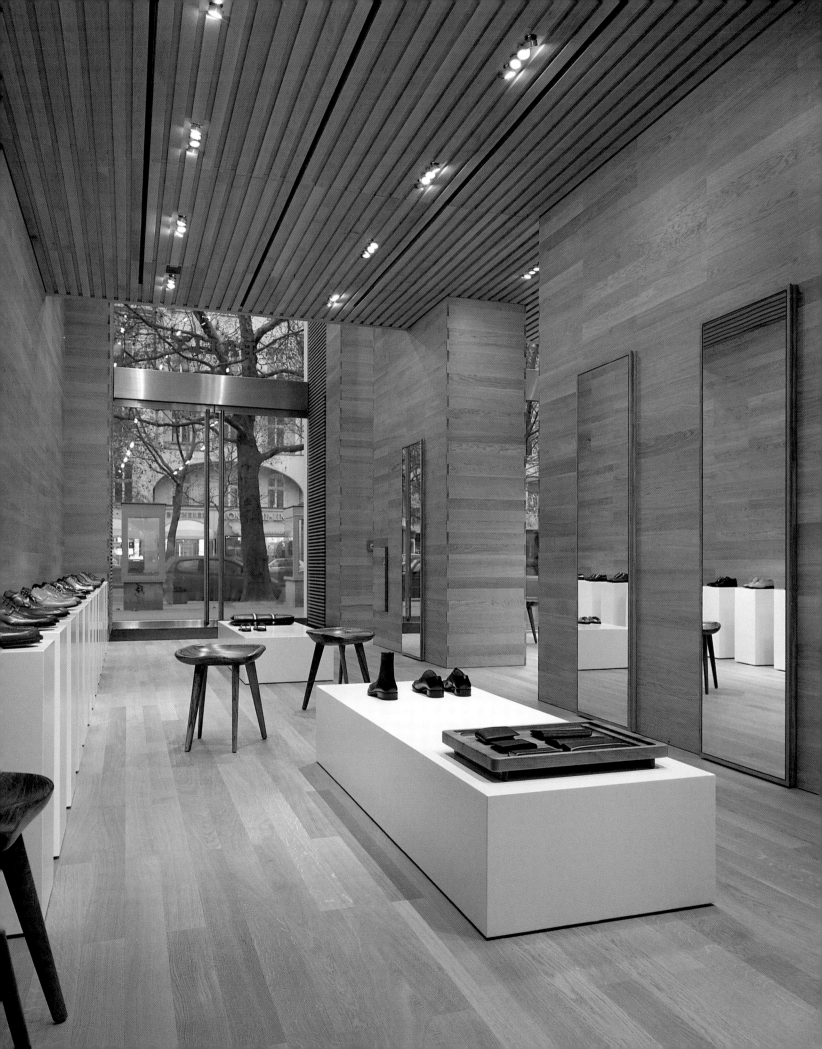

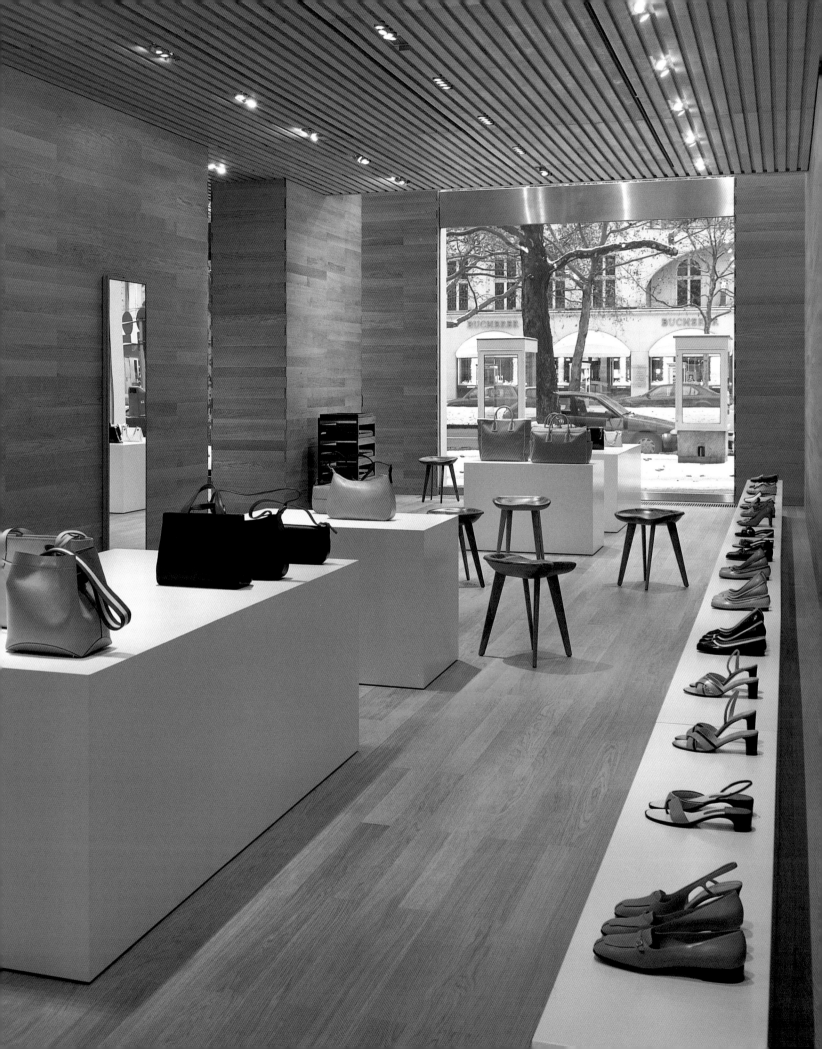

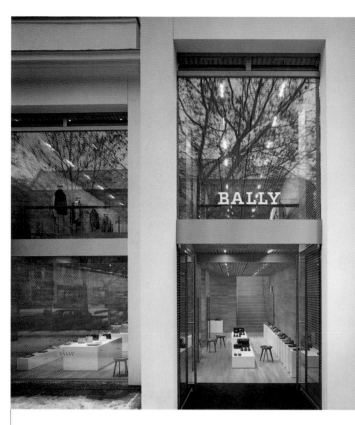

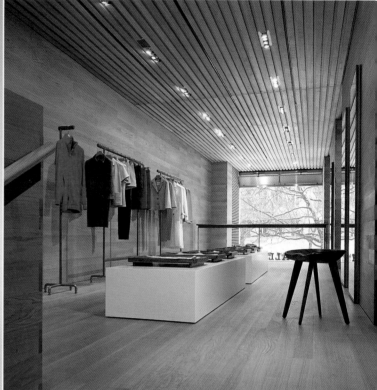

The mezzanine floor has open balustrading lined with toughened glass. This approach maintains visibility between the two floors.

A simple wooden handrail on steel bars guides one up the wood-clad stair. Stair risers are slightly canted, with rubber insets on the wooden treads.

Bassam sought to translate the quality of craftsmanship at the heart of the Bally shoe into the store design. Dissatisfied with the concept of a white box lined with rows of products, Bassam created a strong piece of architecture that pared down the elements. The store is executed entirely in oiled European oak; the secondary elements, the display units, never touch the interior structure; and the furniture is simply crafted. The result is a spacious solid oak box with modular white blocks complemented with custom solid wood stools. All the joinery work was carefully crafted by a team of Swiss cabinetmakers, Blurner Schfeinerei of Waldstatt, who were brought in to the Berlin site. Their work was carried out to exacting standards. Bassam notes, "The oak boards on the floors and walls follow a grid pattern. This affords a sense of rationality and rhythm and creates a sense of order." He cites the work of the cabinetmakers as crucial to the successful execution of the concept.

The display furnishings depart from the norm with modular cabinets, finished in white lacquer, that show off the shoes. The movable display cabinets are set on rubber bases that allow the store to be reconfigured without major disruption. The theme of handcrafting is expressed in every detail, from the pull-out cabinets set flush in the wall to the stools, which were actually carved on shoe lasts in the Bally factory in Switzerland. Even the hangers are custom made from solid walnut.

Bally's signature store is certainly making waves. A leap ahead from its traditional image, the new store design is contemporary yet has a timeless aesthetic that is discreet but at the same time monumental. The flagship store may be reproduced across the globe in locations such as New York, Tokyo, and Beverly Hills. In the meantime, all eyes will be on how the Berliners react to this multifaceted, handcrafted gem of a store.

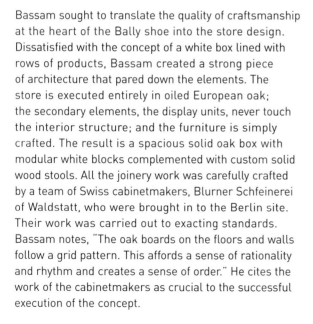

The display plinths are completely mobile, allowing the space to be cleared. The space itself is executed entirely in oiled European oak, which reflects the quality of the brand.

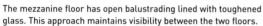

PAUL SMITH SHOPS, WEST LONDON, UK, AND MILAN, ITALY

SOPHIE HICKS LTD. ARCHITECTS, LONDON, UK

Paul Smith, the British fashion designer and retailer, humbly started in business as a small shopkeeper in Nottingham, England, in the early 1970s. Thirty years on, he is just as connected with day-to-day events in his international company, from goings-on on the shop floor to the length of a skirt hem. "It has always been of prime importance to me to retain a personal touch with every level of the business, which is often lost in companies of a similar size."

Smith began designing his own menswear collection while taking evening classes at the local technical school. In 1976, while acting as a consultant to an Italian shirt manufacturer and to the International Wool Secretariat, Smith decided he was ready to go it alone and showed his first collection in Paris under the Paul Smith label. He now has a worldwide network of stores, with a concentration in the Far East, where he has over two hundred shops. Today, he acts both as chairman of the business and as designer of the seasonal collections. In February 2001, Smith's long career in British fashion was recognized by Queen Elizabeth II, who awarded him a knighthood in the Birthday Honours List.

Paul Smith's clothes have been described as the epitome of Englishness-fine tailoring in colorful woolen knits daubed with a hint of English eccentricity—and it is easy to see how these qualities extend into his stores. Smith decided to commission Sophie Hicks Architects because of Hicks' background in fashion. Hicks' first project for Smith was the Westborne House in West London. The concept was to emulate the English Georgian Townhouse, resplendent with the elegant trappings of the urban fashionista. The existing building, which lay within the historic preservation area, was so dilapidated that the practical move was to demolish it

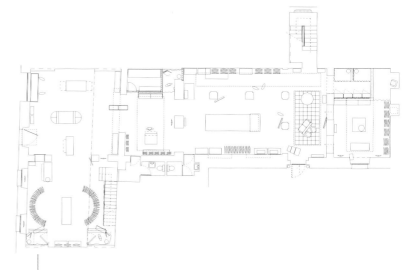

Plan of the Milan store illustrating how its interior fits into the framework of the original palazzo.

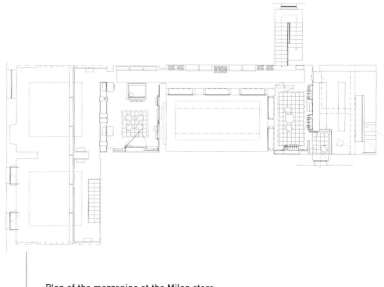

Plan of the mezzanine at the Milan store.

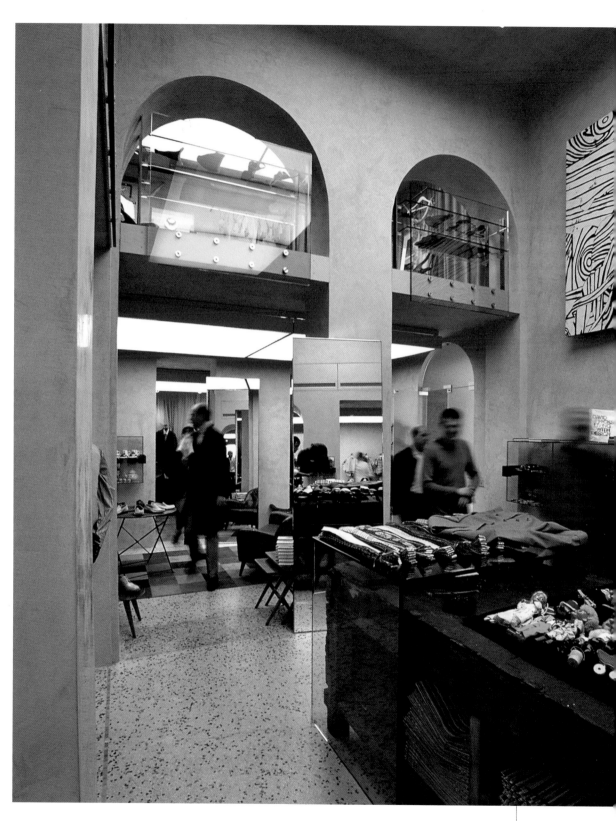

The Milan store interior is a collection of eclectic furnishings, some of which are hybrids made from old tables crossed with a contemporary furniture design.

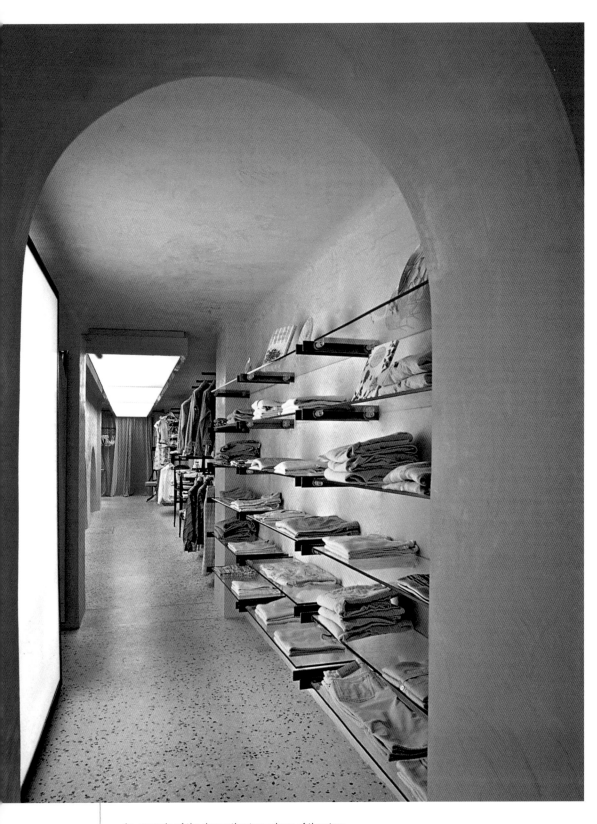

An example of the domestic atmosphere of the store.
The women's clothes are displayed in a relaxed
manner reminiscent of a ladies' dressing room.

The store's eclectic mixture of antique and modern objects set within the environment of the English town house encourages customers to act as if they were invited guests.

The Georgian town house was completely rebuilt. The building, with lavish pediments and stucco work, has an imposing air of grandeur.

and build a replica from scratch. However, moldings and plaster details, rather than slavish replications, were playfully selected to adorn the copings and external fenestration. Internally, each room emulates the setting of the traditional townhouse; the ladies' dressing room is fitted out with ladies' clothing, the living room with accessories. A custom tailoring service is housed in the cutting room. It offers made-to-measure suits to meet the individual's choice; exclusive fabrics and an imaginative approach to lining and detailing are encouraged to subvert the traditional Englishman's suit. The store's eclectic mixture of antique and modern objects set within the environment of the English town house encourages customers to act as if they were invited guests into a domestic setting where they can lounge and browse at their leisure, slowly absorbing the collections on show.

Sophie Hicks then designed the flagship store in Milan. Smith insisted that the design of each new store reflect characteristics of its location and not slavishly reproduce the signature elements associated with the Paul Smith name. Smith's sensitive approach to drawing on the contextual setting of each location combined with acknowledging the cultural differences of each country means that the brand is less aggressively represented and globally reproduced; each location retains an element of surprise. The Milan store was originally a palazzo, complete with original frescoes and a cloistered courtyard. Hicks reinterpreted the fresco approach, increasing the amount of red pigment for a stronger hue. The original terrazzo floor was kept, and where new areas had to be poured, a thin line of mosaic tiles separated them from the original. Smith's love of scouring London's West End antique markets influenced the store's fittings, where an eclectic mix of furniture displays the latest Paul Smith accessories.

PAUL SMITH HORN STORE, TOKYO, JAPAN

SOPHIE HICKS LTD. ARCHITECTS, LONDON, UK

Paul Smith has made an extraordinary impact on the Far East retail market—especially in Japan, where he has two hundred shops, including licensees. Sophie Hicks was asked to design the Horn store in Tokyo, a licensee that stocks the hard-wearing denim Red Ear Jeans. With the independence of style typical of Paul Smith stores, this time the approach was to reproduce the raw, robust character of the jeans with rough-sawn timber. Hicks admired the work of the artist Richard Woods, whose cartoon-influenced wooden floorboards she had seen at his solo show at Modern Art, Inc., in London. Hicks commissioned Woods to design a series of screen-printed floorboards for the Tokyo store. These floorboards line the space, creating a hunting lodge atmosphere complete with trophy heads and horns on the walls. Hicks dislikes jeans hanging from hooks, so piles of the merchandise on tables completed the robust nature of the design.

Paul Smith and Sophie Hicks jointly demonstrate their understanding of design and its gentle intervention in the relationship of site and product. At times, the intervention is subtle, allowing the site itself to create the ambience; at others, it is more obviously themed, as in the case of Horn, which caters to Japanese consumers who are aficionados of British culture.

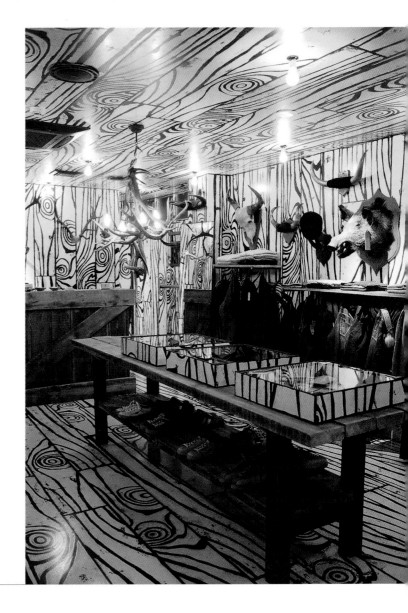

The warmth of the space and its style, which is resonant with history, creates a sense of magic and expresses a touch of humor.

Screen-printed floorboards create a hunting lodge atmosphere complete with trophy heads and horns on the walls.

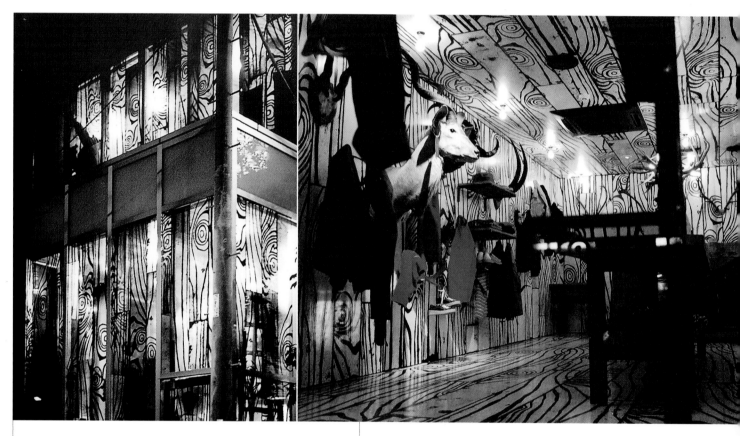

Horn was conceived as a contemporary take on a hunting lodge. The theme was carried through the façade, where the wood grain was printed on a film and attached to the windows.

The jeans are displayed on tables as they would have been when sold at the local hardware store as workers' clothes.

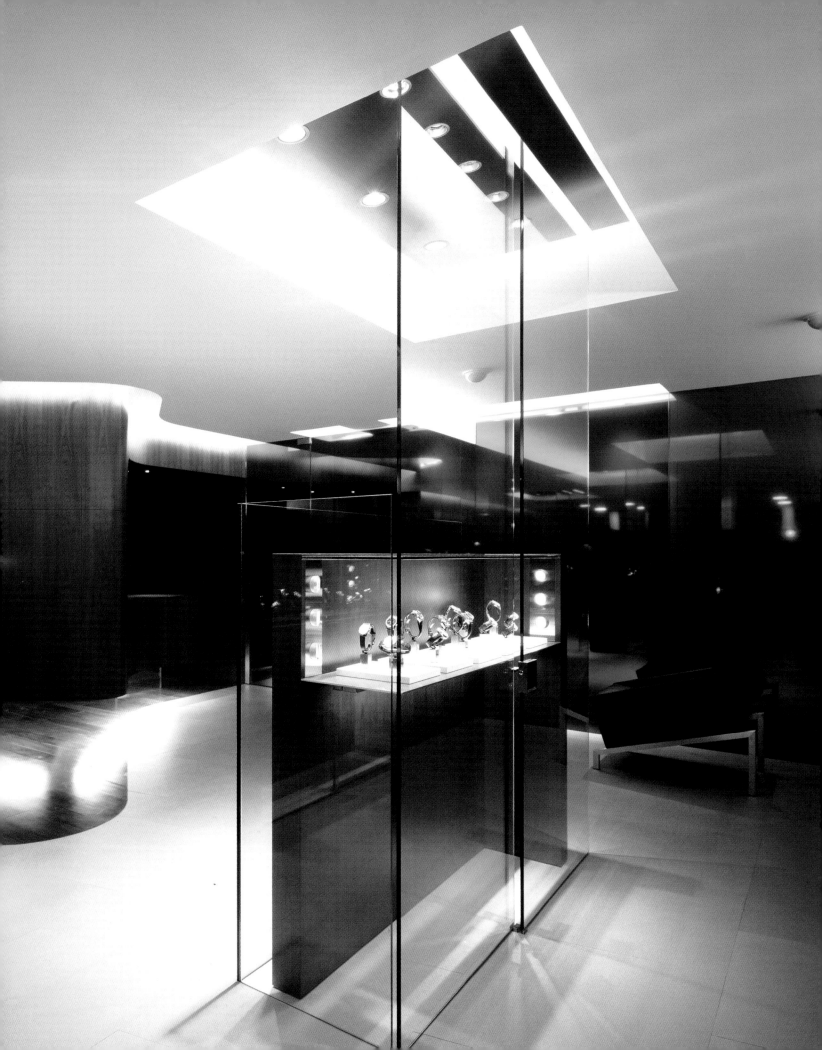

TAG HEUER, TOKYO, JAPAN
CURIOSITY, INC., TOKYO, JAPAN

Curiosity, the design, graphics, and branding company, whose impressive list of brand-savvy clients includes Armani, Issey Miyake, and Yves Saint-Laurent, has designed perfume and cosmetic bottles, furniture, interiors, and even a Nintendo Advanced Gameboy handset. The practice's inventive skill in detailing is seamlessly transposed to the larger scale, as demonstrated in their recently completed shop for Tag Heuer, the Swiss watch manufacturer.

The Tag Heuer boutique sits on Tokyo's prestigious Omotesando Street. The client wanted the shop to reflect the product, which is modern but classic, with a sophisticated sports image. The 1,765-square-foot (164-square-meter) store has an impressive glass façade measuring 13 by 20 feet (4 by 6 meters). Attached to the façade are layers of transparent blue and mirror reflection; at night, different hues of blue are dramatically reflected on the brushed-stainless steel frame façade, creating a wash of color. The processional staircase set within the façade places the customer in public view and provides a clear overview of the store's layout. The display cabinets, set in glass floor-to-ceiling cases, are treated as architectural elements. Three display units and a curved seating bench are placed within the main floor area, allowing a generous amount of circulation space more reminiscent of a museum layout than a retail store. Recessed directional lights are set above each showcase; a VIP lounge is discreetly placed behind an undulating, curved paneled wall. The store reflects an element of exclusivity with the execution of state-of-the-art display cases and the generous sweep of space reached by an elegant staircase, which contributes to the seductive appeal of the store and, in turn, reflects the appeal of the brand.

Running along the walnut-paneled wall is a series of nonscratch acrylic display boxes. Each box can be pivoted, allowing different permutations of display. Because of a clever locking system, the locks are visible only when the boxes are open.

Curiosity designed all of the internal furnishings, such as the spider chair and the curved bench set, in a brushed stainless steel frame. The shop's floor surface partners two distinct materials—walnut and glass, the latter backed with black film. In 2002, the design was recognized by the Japanese Society of Commercial Space for its excellence and for its imaginative interpretation of the Tag Heuer brand.

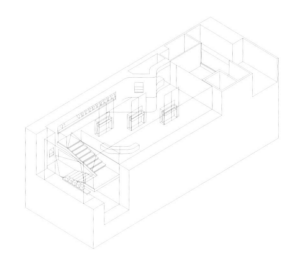

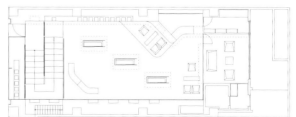

The axonometric floor plan shows the prominence of the stairwell in relation to the display area and more private areas, such as the meeting room and VIP room.

Curiosity's design emphasizes the don't-touch nature of the locked display cabinets and incorporates it into the architecture of the interior with a floor-to-ceiling glass encasement. Encasing the watches with such high security adds to the unique quality of the brand.

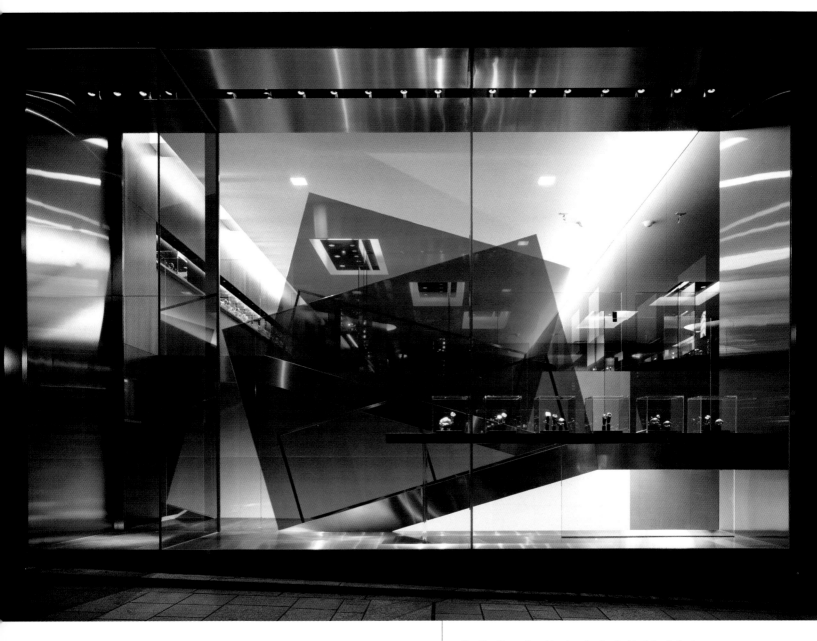

The Tag Heuer flagship store is situated in Tokyo's Aoyama district. The façade makes a dramatic impact on the street with its layered double film applied to the boutique's 13-foot (4-meter) -high front. The transparent façade framing the activities on the first floor and the jewellike display cases contribute to the exclusivity and quality of the brand of watches.

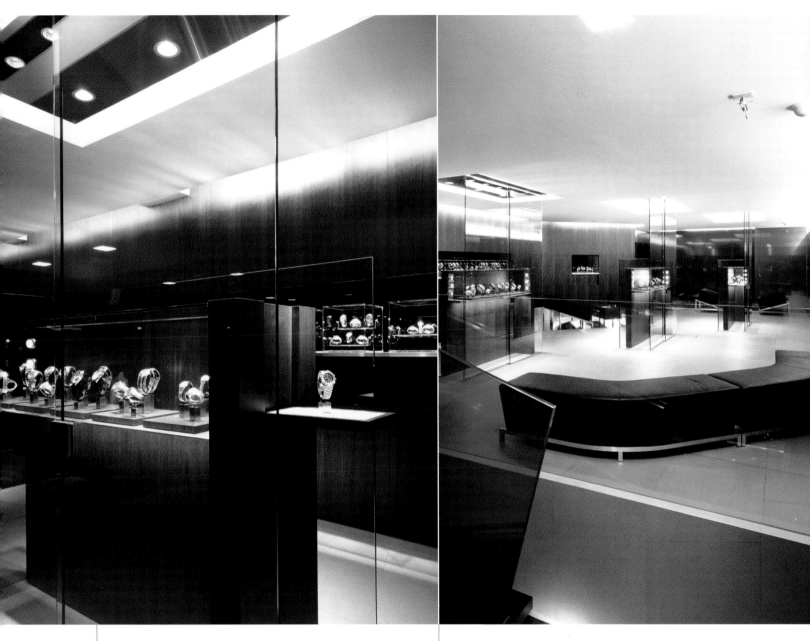

The lowered false ceiling that hides the recessed lighting above plays dramatically with the double-height stairwell.

The boutique's uncluttered style and seating opportunities give the space a contemporary gallery atmosphere that encourages customers to contemplate the product and browse leisurely.

> "The look of the Puma environment was developed to enhance the brand—to act as a built representation of the Puma image." Steve Kanner, Kanner Architects

PUMA, SAN FRANCISCO, CA
KANNER ARCHITECTS, LOS ANGELES, CA

Puma approached Kanner Architects with the directive to create a retail environment that was both hip and cutting-edge but that would not date easily—seemingly a design paradox. Kanner Architects has been designing buildings, mostly in California, for almost six decades with a portfolio ranging from retail design to the construction of industrial and residential buildings. Steve Kanner applied his personal language of modernism to create a space that communicates the energy and quality of the sports brand but, at the same time, expresses permanence and restraint. He describes his architectural language as providing "an environment that is a marriage between aesthetics and function. The look of the Puma environment was developed to enhance the brand—to act as a built representation of the Puma image. Additionally, the store must function as a backdrop for the product, allowing for it to be viewed and experienced in the most appropriate way."

The chosen site, a building from the late nineteenth century, had housed many previous retail tenants. The building was in need of complete refurbishment, including the replacement of major structural elements, in order to retain the shell. The ground floor was replaced with a new concrete slab while the upper levels were reinforced with steel frames. The building's façade was rebuilt with steel I-beams, board-formed concrete, and punctured openings that allow glimpses of the interior. The bare-concrete façade establishes a clear architectural link between the interior and exterior, enticing customers into the shop.

The style of the Puma store was developed to complement the brand and to embody the essence of Puma. The brand was stripped down to its semantic properties: movement as communicated by the leaping puma, vibrancy, and athleticism. The space

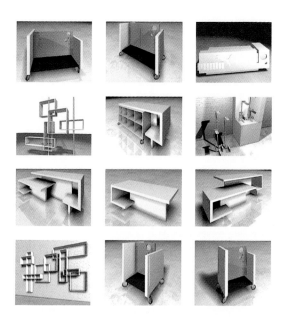

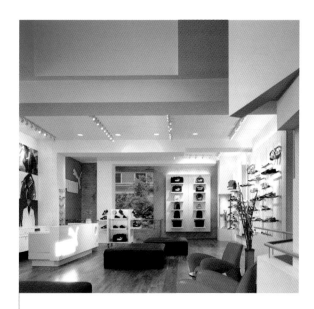

Above: All the interior furniture and fittings were designed to complement the architecture.
Below: The store interior combines bare, untreated materials, such as the exposed concrete wall, with the warmth of wood. The overall effect of quality and relaxation encourages the customer to linger.

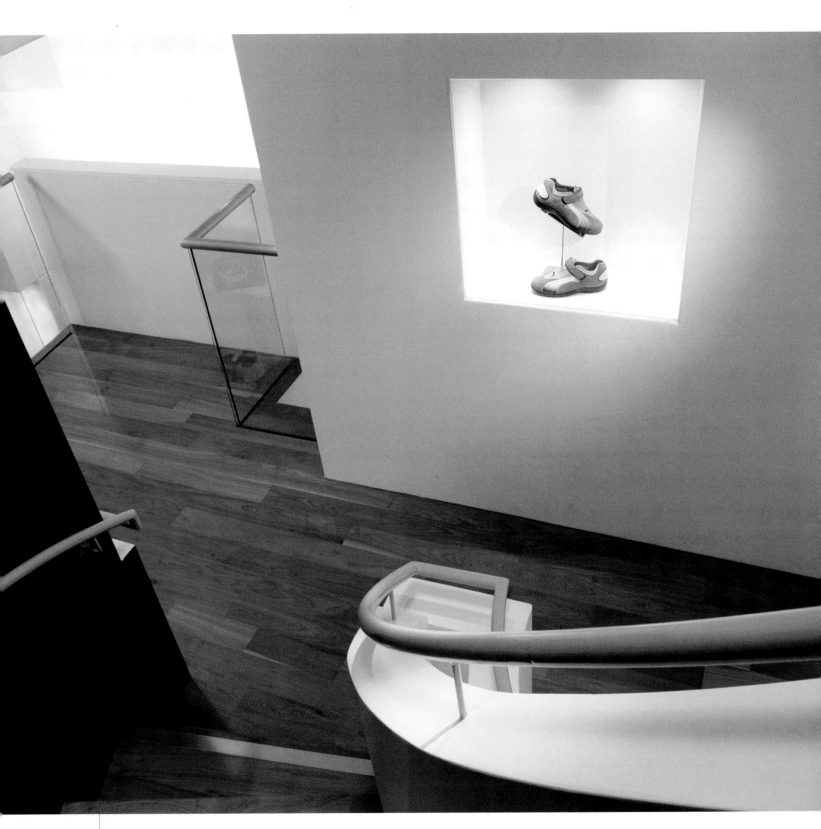

The elegant staircase introduces a strong, curvilinear feature
among the angular spaces.

echoes this dynamism with offset angles that break up the planes and dissect the 90-degree angles of the building. A staircase handrail continues its line into a wall recess, which then becomes a sculptural element. The principal staircase is taken beyond its elementary function and becomes a viewing platform by means of balconies extending from its landings.

Red is the store's predominant color, symbolizing power and energy with its associations with heart and fire. The vivid shade is punctuated by natural materials, white ash fixtures, poured concrete, walnut flooring, and white walls. All of the store fixtures, display units, and merchandising elements were designed for the complete Puma line of apparel, accessories, and footwear. The fixtures and fittings mirror the surrounding architecture in that they resemble scaled-down versions of the architectural elements at play in the building. The lighting concept mixes recessed and concealed lights with the use of track and industrial loft lighting, depending on the functional and aesthetic requirements. These elements, together with the Puma logo, establish a strong and recognizable Puma store identity.

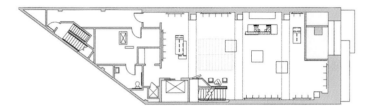

Above: The plan demonstrates the sheer angle to the rear of the site and how the circulation space and stair is separated from the merchandise areas.
Below: The section shows the generous floor-to-ceiling height on the top floor. The interior design is about portraying Puma as a high-quality product.

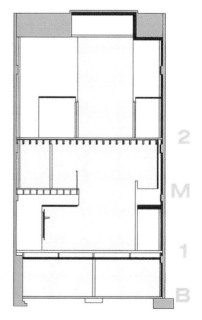

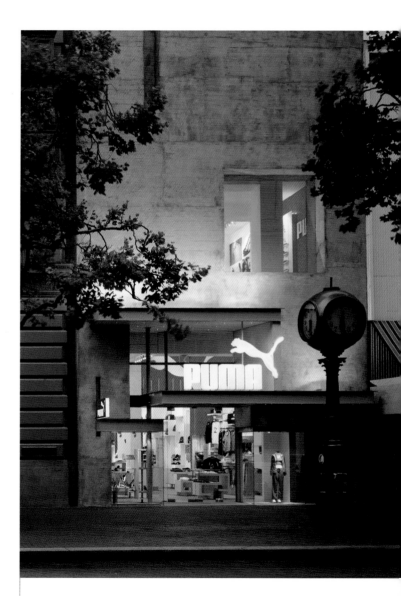

To entice the customer into the store, the façade is articulated with asymmetrical openings that frame the interior. The main façade of the nineteenth-century building was completely rebuilt of concrete cast in situ.

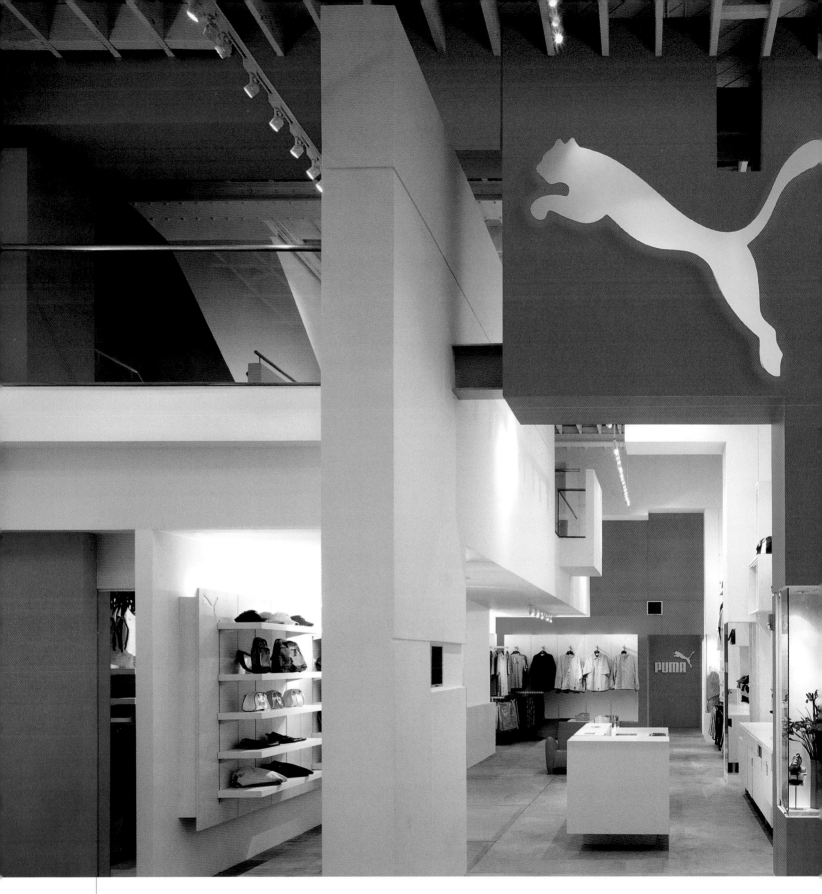

The dissection of the interior elements creates a dynamic
architecture that reflects the vibrancy of the brand.

> "It became crucial for me to create a space that would allow many design languages to cohabit without suffocation." Shideh Shaygan, Shaygan Interiors

ALESSI, STOCKHOLM, SWEDEN
SHAYGAN INTERIORS, LONDON, UK AND STOCKHOLM, SWEDEN

Stockholm has a long tradition of promoting functional, modern design. Olle Anderson, the president of the International Federation of Interior Architects/ Designers (IFI), summed up the underlying idiom of Scandinavian design as "a strong consciousness concerning the usefulness and purpose of our creations combined with an inherent feeling for how we use our resources. Our awareness is based on history." He added, "There is a pronounced function in Nordic design, sometimes in an almost pedantic manner. Foreigners usually call our products light, elegant, and discriminating."

Shaygan Interiors, of London and Stockholm, was commissioned by the exclusive distributor of Alessi products to design the Stockholm showroom. The client's brief specified the need for three distinct areas within the concept of the showroom: a retail display area with a generous area for storage, a sales office with stockroom, and a private staff area. The display area was required to showcase both the classic Alessi line and new products from Alessi.

Alessi has been manufacturing kitchen and domestic products in Italy since the sixties, and its signature style is one of humor and design. Many of its products are the results of commissions carried out by established names in architecture and design such as Phillippe Starck, Ettore Sotsass, and Michael Graves. Shideh Shaygan described the challenge of designing for such a range of products: "It became crucial for me to create a space that would allow many design languages to cohabit without suffocation."

The cool green mosaic tiles and green limestone reflect the characteristics of Italian design rather than the often pale Swedish color palette. The showroom acts as a theatrical stage for the performance of the products. Carefully placed lighting, mobile display units, and a predominance of the Alessi brand color green are the principal design elements.

Flexibility is crucial to the design of the showroom. The seven island units are on casters to permit different groupings, which enable the showroom to accommodate design forums and temporary exhibitions. Electricity is supplied to the display units from floor sockets underneath each unit; alternatively, if grouped together, the units can be connected serially. The perimeter units house both storage and display elements, with a discreetly built-in reflective glass panel that visually connects the office to the showroom.

The lighting plan played an important role in the exhibition-style display of the objects. Two principal types of lighting were used. Antiglare downlights from the Italian lighting specialist Erco spotlight specific zones, and recessed fluorescent tubes give soft and indirect light. The lighting can be adjusted in response to changes in ambient light. In addition, nighttime settings allow passing pedestrians to view the showroom after hours. The glowing island units illuminated the objects from below to create an impression of great value. The clear layout and freshness of the space attract customers to view the products on display.

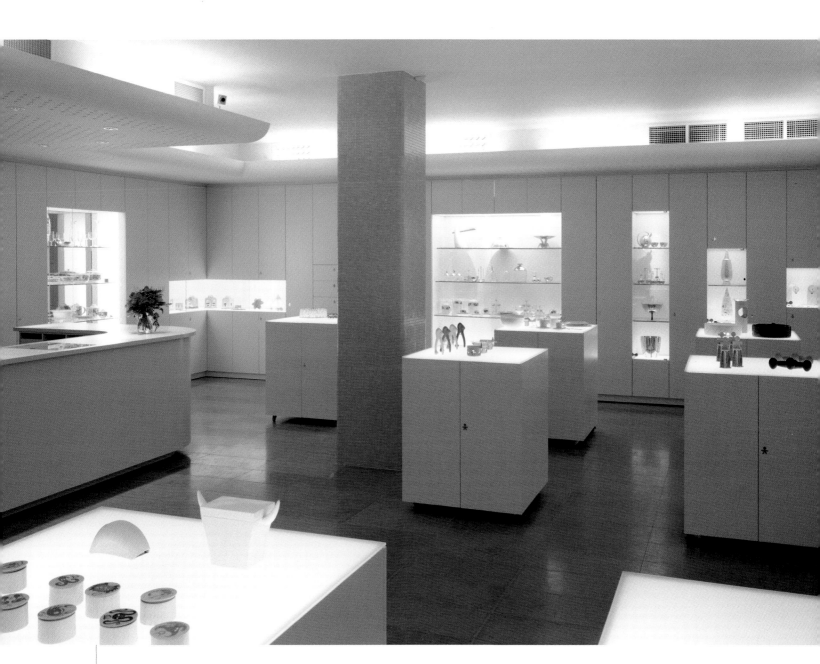

All structural elements are finished with Italian glass mosaic
tiles. The lacquer-painted MDF display units can be easily
reconfigured to accommodate a variety of functions.

The shop lighting blends spotlights and indirect ambient light
for a dramatic effect in varying hues of green.

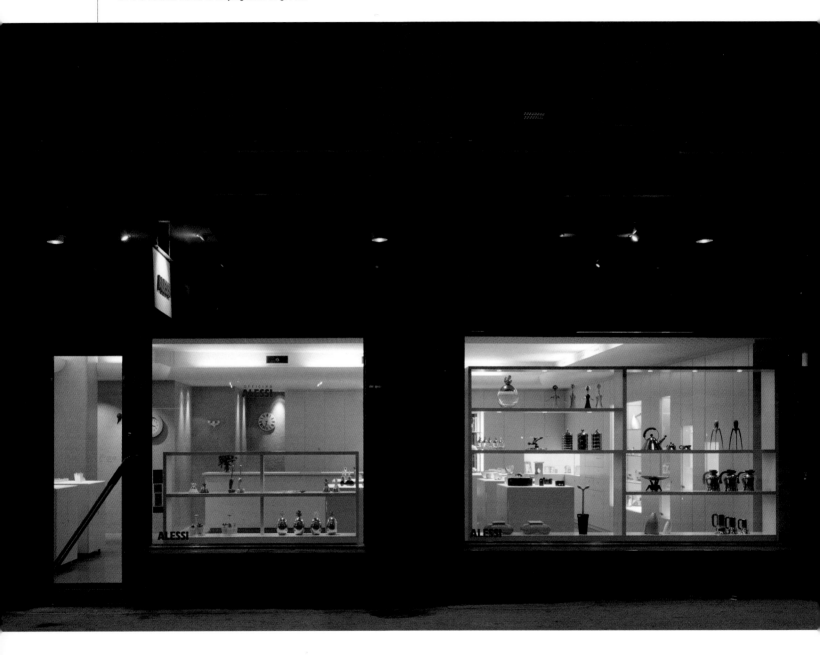

Shaygan subtly introduced the Alessi logo by incorporating it into the plasterboard ceiling. A Norwegian company that specializes in customizing plasterboard was able to stamp the logo through the material. The customized plaster board ceiling also improves acoustic performance.

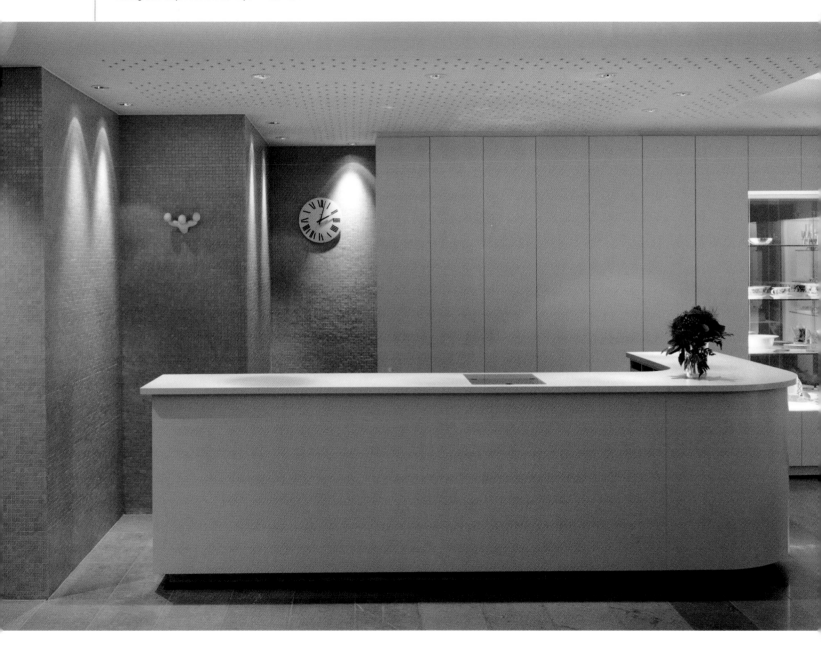

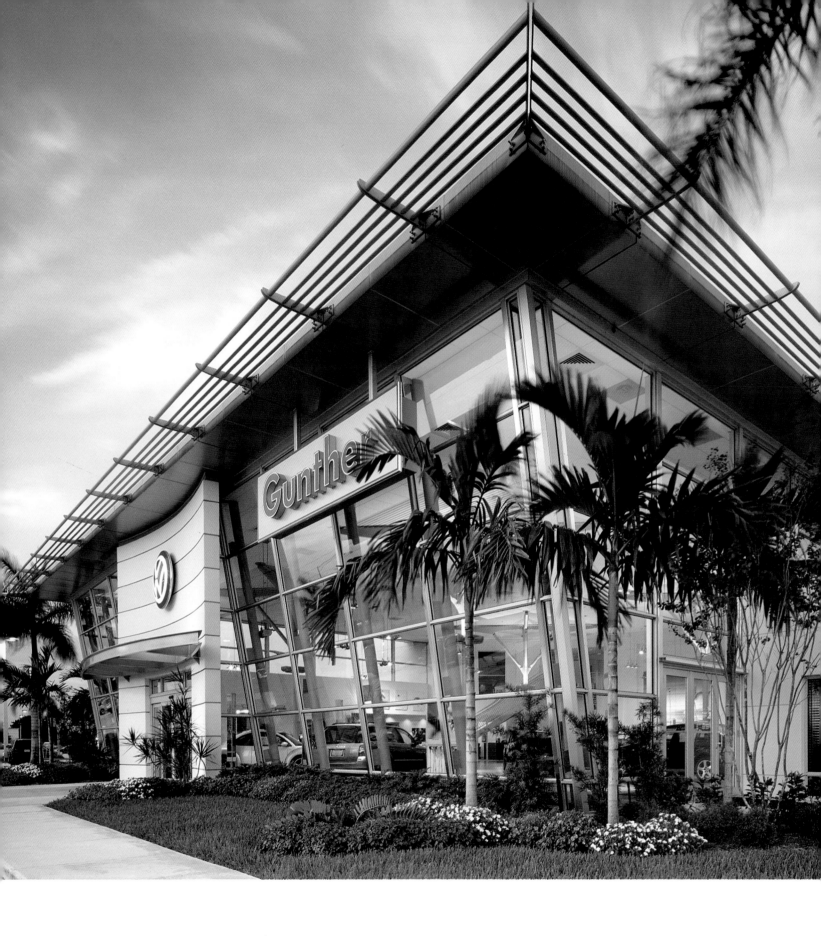

VOLKSWAGEN MARKETPLACES, U.S.
GENSLER ARCHITECTS, DETROIT, MI

The vigorous new North American campaign of Volkswagen, the German automaker, was initiated in Germany in the 1990s to enhance the Volkswagen brand and to improve customer relations. Ralph Mocerino, the appointed architect from Gensler Architects who was responsible for rolling out the marketplace concept in America, highlights the role played by architecture in communicating the brand experience on the retail floor: "Architecture is a supporting element. Through design, we take a retail environment and we support the message and support the emotion that is being transcribed to the customer." The principal marketplace concept is to make the showrooms like traditional European markets, where informal shopping and general perusing are part of the greater social activity.

Gensler, a Detroit-based architecture firm, was chosen based on its extensive experience in global auto retailing in urban retail centers, malls, and town center developments, including mall repositioning.

The aim of the marketplace campaign is to make 50 percent of the 608 U.S. Volkswagen dealers marketplace dealerships. The strategy of introducing the marketplace dealerships is part of Volkswagen's drive to become more customer-friendly, to build consumer trust, and to overcome consumer skepticism, as statistics show that the average U.S. consumer is wary of the car sales process.

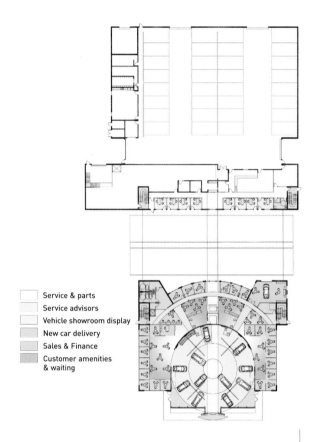

- Service & parts
- Service advisors
- Vehicle showroom display
- New car delivery
- Sales & Finance
- Customer amenities & waiting

The radial floor plan allows for the intimate meeting and point-of-sale rooms to fan out from the center. The interior product pylons communicate information on the history of and technical information about the cars.

The architecture consists of a steel frame with a glass façade to provide as much transparency as possible at this Coconut Creek, Florida, Marketplace.

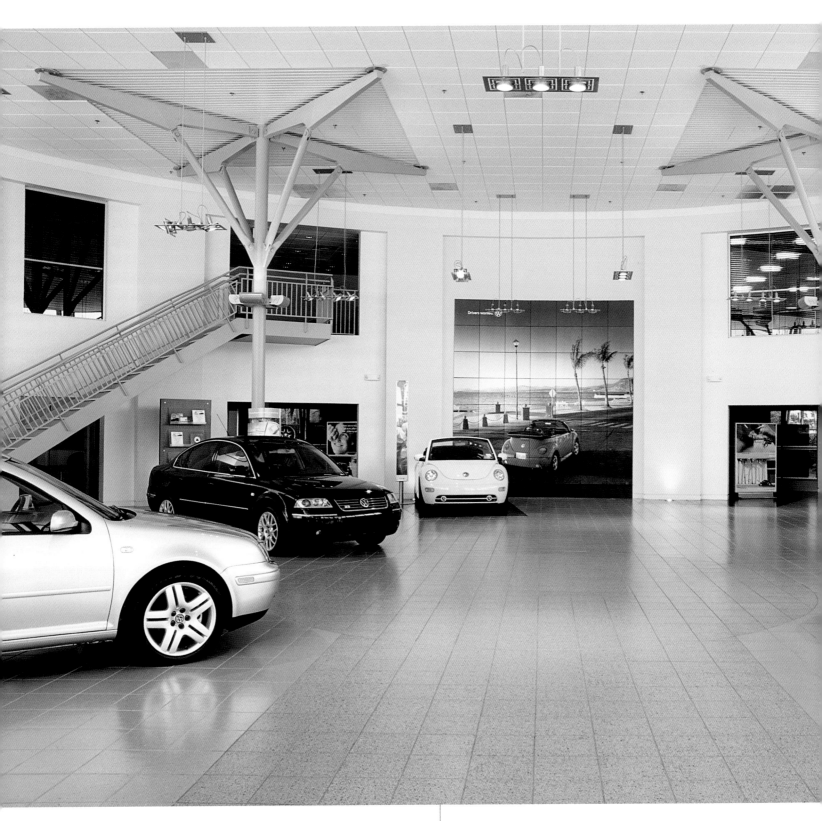

The Volkswagen Marketplace is part of a bold campaign to return the Volkswagen to the top of the American market, where it was once America's best-known foreign car. The marketplace concept is fully adaptable to showrooms for four to twenty-five cars.

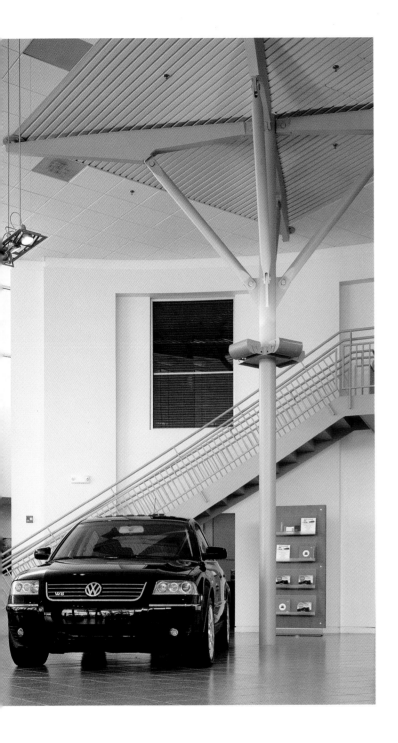

Before embarking on the design, Gensler took an informed look at the cultural differences between American and German Volkswagen advertising campaigns. In Germany, the ads were about control, accuracy, and decision making; they were mainly targeted at single users and associated the product with the future. In the United States, the ads promoted experience, risk, and spontaneity; they targeted the multiuser and placed the product in the present.

Another difference between the U.S. and German markets is the amount spent on fitting out showrooms. On average, American dealers spent $60 per square foot; in contrast, German showrooms cost $150 per square foot—almost three times as much. The challenge was to maintain a high standard of design while keeping costs within budget.

John Hill, Volkswagen's network development manager for North America, describes the brand strategy of the Marketplace concept as "our worldwide commitment to enhancing our customers' brand experience at the showroom level. It recognizes that the dealerships here must focus on the individual, which is exactly the feeling that the Volkswagen Marketplace is meant to convey." In constructing the brand experience for the consumer, managers felt that a consistent brand image was lacking. The benefits of the design enable complete flexibility of execution; in the case of a renovation or a multidealer, the design can be modified to a large standalone exclusive. It can also be installed within existing dealership facilities. Because of the demand from individual dealerships, Gensler has had to think strategically about the rollout of the design—in Mocerino's words, "how you reproduce it dozens of times under real-life conditions." Gensler designed five showroom models of either one or two stories that address new construction and renovation. Renovation designs can accommodate Volkswagen sales only, dual Volkswagen-Audi sales, and multiline dealerships that sell Volkswagen in addition to other brands.

"The dealerships [in the U.S.] must focus on the individual, which is exactly the feeling that the Volkswagen Marketplace is meant to convey."
John Hill, Volkswagen network development manager for North America

The design firm's interpretation of the brand is carefully considered in a sea of branding identities. "When people hear the word brand, they often think of the logo or the packaging or the product itself. All these things are the brand but the idea can be taken further—or diluted. The confused signage that announces many dealerships is an example of brand dilution," says Hill. Gensler is aware that the Volkswagen brand often must perform among competition in the showroom. To address this, the designers introduced twenty branding elements, including the overall look of a distinctive building in an often crowded streetscape. Children's play areas underscore the family orientation of the product; the reception desk in the main space reflects the sales process, which eliminates the hard sell. A radial floor plan facilitates the layout of the cars with hub areas around the central space, and the focal wall is covered with bright lifestyle graphics.

Volkswagen U.S. wanted to reintroduce to the showroom the famous original Beetle ads by Doyle Dane Bernbach, which were designed by Helmut Krone and written by Julian Koenig. This reflected the promotion of the Beetle as building on its legacy. The ads were reintroduced as a poster campaign and displayed in the central showroom space.

The showroom offers retail products and services conveniently located in a friendly market square atmosphere. The style of architecture can be read as inviting, fun, and functional—all qualities found in Volkswagen products—while the consistency in architecture and product contribute to brand recognition.

Gensler knew that the average U.S. consumer is wary of the car sales process, so they created a design for the dealerships that conveys trust and a customer-friendly atmosphere.

CONCEPT STORES

This is retail with a difference. What was once called *niche marketing*, where products are targeted at small buying groups, is now being revamped to meet the demands of exclusivity by customers who want to purchase limited, production-run garments that stand out from the crowd. The concept store, the antithesis to the megastore or mall, is a growing sector of the retail market, where customers prefer to shop in intimate and challenging environments.

Within the concept store, the retailer is prepared to stretch the conventional boundaries of retail space. The flower store Bloom creates a spectacle in flower presentations where customers can view the flower sculptures being created on a specially designed bar whose style is more akin to a cocktail bar than flower arranging bench. The environment is one of tranquility and theater, where customers can escape the urban commotion at the store's doorstep.

What drives the concept store is often the highly individual nature of the merchandise. The design of the Gibo store in London can be read as a series of sculptural interventions reflecting the influences on Gibo's fashion designer Julie Verhoeven's apparel. Verhoeven worked as an artist and illustrator as well as a fashion designer before launching her own fashion label with the major Italian manufacturer Gibo.

Kerquelen, conceived as an international shoe project, brings together carefully selected designs from around the world. To reflect the exclusive selection of merchandise, the architects Stürm and Wolf designed two very different stores, each responding to the individual site conditions. Consumers step off the street to a magical environment with sculpted furniture, wall paintings, and customized graffiti.

It has been said that retail spaces are becoming indistinguishable from art galleries, the implication being that consumerism and culture are merging. One has only to look at the retail adjuncts to any museum or public gallery to witness the interdependence of the two.

As retail spaces begin to adopt a design language that borrows from many styles and genres—art gallery, art installation, bar, club—it is clear that customers are becoming more sophisticated and that retailers are responding to this shift. In addition, customers are invited to linger in the new environment and to feel relaxed as at home. Especially with the concept store, the experience comes first, and the purchases, preferably, follow.

Passersby and New York policeman stop to take a closer look at the Kerquelen store in Manhattan. Kerquelen's highly individual interior reflects the selection of exclusive shoes on sale.

Gordon Kipping Architects brought in Frank Gehry to collaborate on the Issey Miyake store, New York. Frank Gehry's expressive form, expressed in the use of minimum-gauge sheets of undulating stainless steel that sweep through the store, provides an original and unique identity for Miyake. Friezes of large-scale cityscapes adorn the walls.

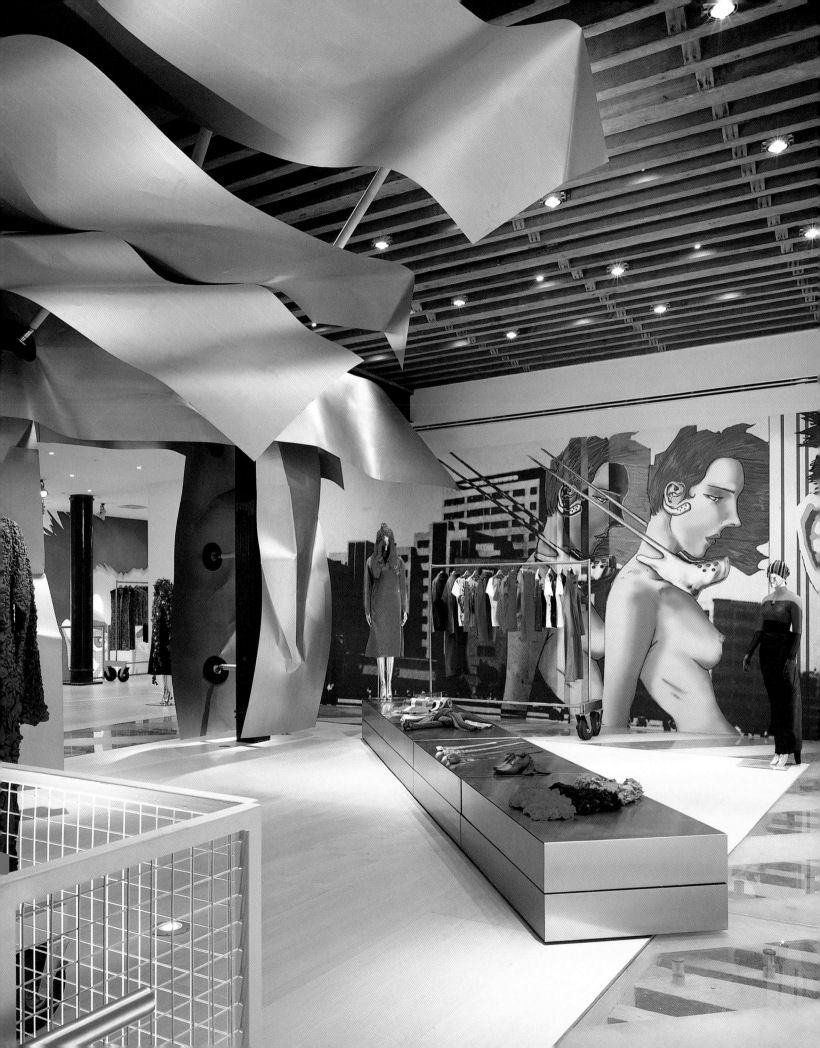

> **"The store was conceived in the spirit of the W Hotel as a place where you not only watch flower arrangements being created at the Flower Bar but where you may choose to spend some time."**
> Hal Goldstein, Janson Goldstein Architects

BLOOM, W HOTEL, NEW YORK, NY
JANSON GOLDSTEIN ARCHITECTS, NEW YORK, NY

The flower store Bloom has created a new way to sell flowers. Two years ago, Lesly Zamor opened the first Bloom store in the Chelsea district of Manhattan. The decision to open a second store in the sleek, modern W Hotel meant that a more contemporary look was needed than that expressed in the rustic Chelsea interior. The architectural firm Janson Goldstein was called on to rise to the challenge. Hal Goldstein sums up the mood conveyed in the ultraseductive and modern setting of Bloom: "The store was conceived in the spirit of the W Hotel as a place where you not only watch flower arrangements being created at the Flower Bar but where you may choose to spend some time."

The architectural practice Janson Goldstein has built a reputation for creating modern settings that are innovative and comfortable as well as conveying a sense of luxury and refinement. The firm has attracted a premier list of clients from the fashion industry, including Giorgio Armani, Salvatore Ferragamo, Michael Kors, and Calvin Klein. By calling on a firm with this background in high-end retail, the client clearly was looking to create a space influenced by the sumptuous and design-conscious environments of the fashion genre. The partners aimed to make a serene oasis in the middle of a busy street in midtown Manhattan, a place where customers feel invited to linger in the lush and richly decorated space. Located on the corner of Lexington Avenue and 50th Street, Bloom turns around the conventional features of flower shops.

A glass façade 13 feet (4 meters) high invites passersby to look directly into the store. Two 10-foot (3 meter) parallel brushed–stainless steel bars form the orchestra, so to speak, from which the creation of each bouquet can be watched as if it were a stage performance. To add to the sense of theater, a pool set flush with the floor displays arrangements of water plants.

SECTION A-A

SECTION C-C

Floor plans.

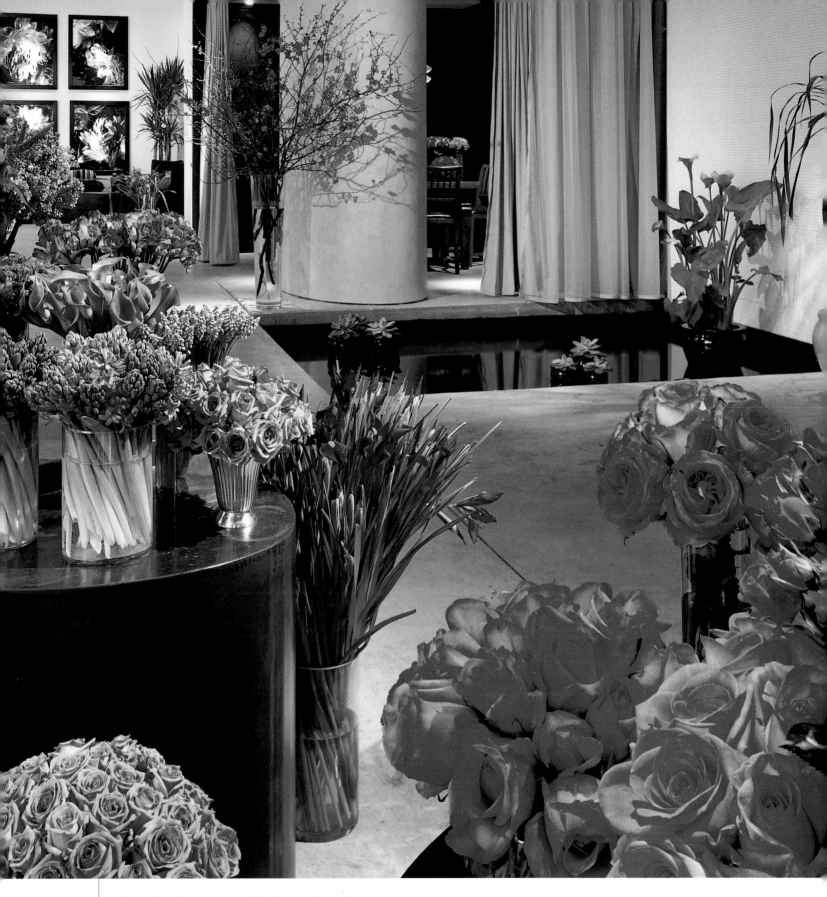

The semiprivate meeting room is for the benefit of customers
who want to discuss their requirements quietly.

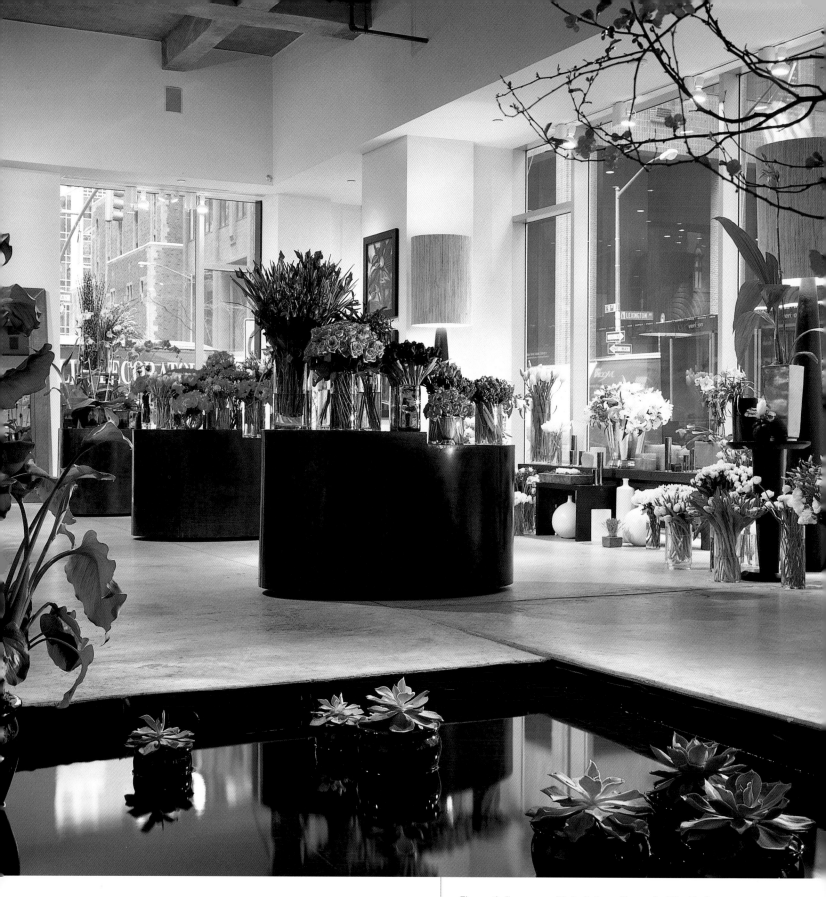

The exotic flowers provide lush decoration against the black-painted podiums and polished concrete screed. The contrast of the profusion of flowers against the hard surfaces creates a dramatic atmosphere.

Not every activity is public. To address the highly personal demands of the flower-buying customer, which can range from the conciliatory to the celebratory, a semiprivate meeting area lined with retractable drapes was introduced. The walnut interior walls pivot to reveal concealed storage. Bloom also offers a full party- and event-planning service that emphasizes the professional display of exotic flower sculptures.

To complement the lavish display of flowers, Venetian plaster with a red hue was applied to the walls. Plinthlike flower troughs made from tarnished stainless steel are used as display containers.

The neutral poured-concrete floor unites the space, artfully displaying products ranging from fresh flowers to antique furniture, and frames the reflecting pool. The combination of Janson Goldstein's design and Bloom's products creates a luxurious respite from the bustle of its Manhattan location.

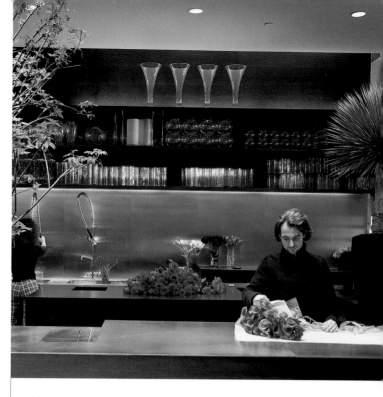

All the flower arrangements are prepared on the brushed–stainless steel counters, which take central stage within the store.

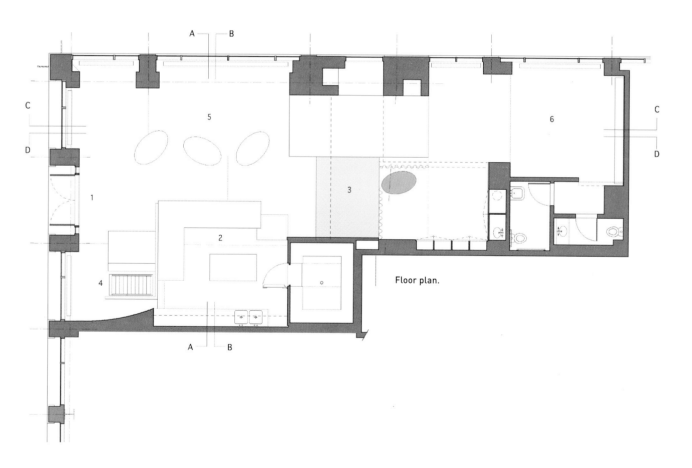

Floor plan.

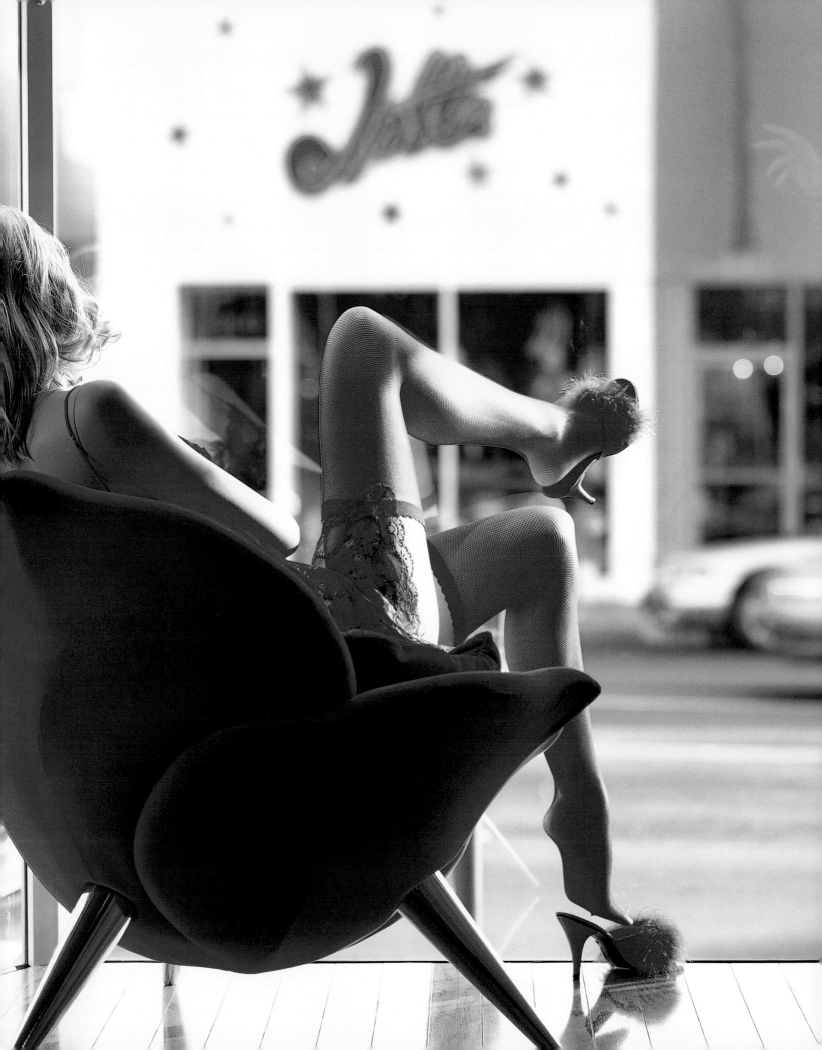

AGENT PROVOCATEUR, LOS ANGELES, CA

JENNY ARMIT DESIGN, LOS ANGELES, CA

Agent Provocateur's codirectors, Joseph Corre and Serena Rees, have carved an exclusive niche in the lingerie market. The husband-and-wife team has bridged the gap between raunchy and seductive, titillating but tasteful.

In December 1994, they opened their first Agent Provocateur shop in Soho, London, with the goal of selling high-quality lingerie with creative flair that would stimulate, enchant, and arouse both wearers and their partners. The rise of Agent Provocateur has been a phenomenal success, with further store openings and a thriving mail order catalog.

At the heart of Agent Provocateur is a profound belief in the intimacy of the experience on offer. Corre describes it as "the difference between a mass experience, dictated by market forces and meaningless advertising, and an intensely private and personal experience." This personal experience involves the relationship of each individual woman with the garment she selects and is realized by the company through quality, service, and a refusal to adhere to fluctuating trends.

One of the company's U.S. ventures is a new store on Melrose Avenue in Los Angeles. Jenny Armit Design was called in to design the store. Jenny Armit moved to Los Angeles in 1998 after working in London for fifteen years in collaboration with architects such as the minimalist John Pawson. In California, her eclectic mix of the traditional and the contemporary was in demand, and commissions started rolling in.

At the heart of Agent Provocateur is a profound belief in the intimacy of the experience on offer.

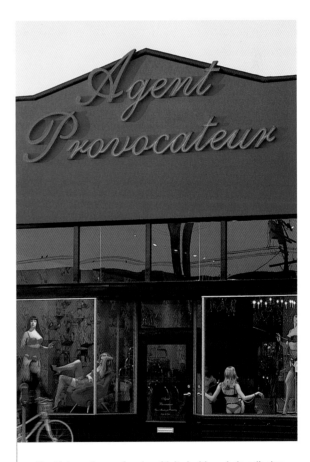

The Melrose Avenue façade, with its inviting window display, does not shy away from the essence of the product on sale.

Agent Provocateur's goal of selling high-quality lingerie with a creative flair that stimulates, enchants, and arouses both its wearer and her partner is illustrated in the sexy window displays.

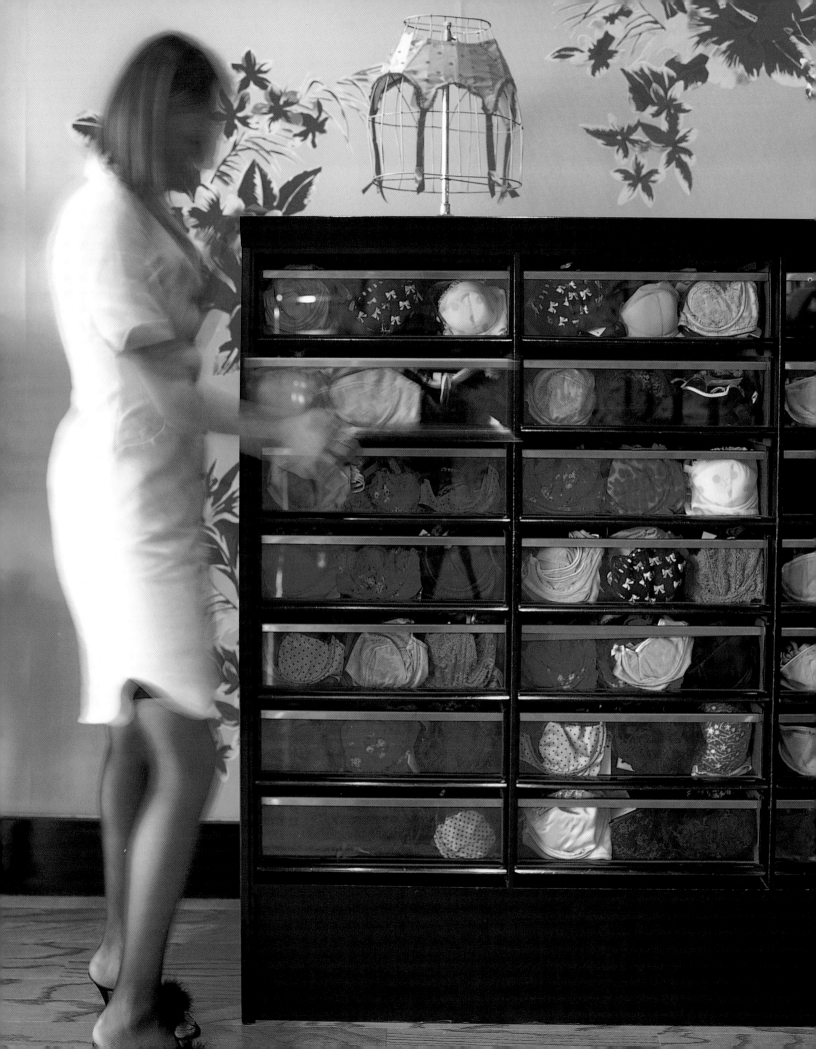

Armit's job for Agent Provocateur was to introduce in the American store the distinctive look that had been executed in the two London stores. The underlying objective was that the design should exude sexiness; hence, the first reference is on display in the window design, where playfully positioned showroom dummies are dressed in provocative lingerie. The lingerie is targeted at women who want to have fun; this is reflected in the design philosophy of the store—upbeat, daring, and sexy.

Armit describes the design as the result of a strong collaborative process. "Joe and Serena are brimming with creative ideas, and it was inspiring to work with clients who were so directional with their ideas," she states.

The Melrose Avenue building was previously a vegetable shop, which was gutted to clear the site. The relatively small area had to incorporate changing rooms, offices, storage, and a bathroom on the upper level. The overall look is that of an intimate boudoir fitted out with pop-art furnishings from the Italian manufacture Edra. Tropical motifs on the boudoir curtains are repeated and offset by specially commissioned futuristic silver wallpaper. The curtains separate the showroom from the changing area—a discreet space for the select clientele, which includes celebrities and, often, accompanying boyfriends.

The hand-screened wallpaper, designed by Alan Jones, features tiger lilies and is hung to cornice height—a reference to the Victorian interior. Details such as 1950s porcelain table lights were carefully handpicked for a personal touch, as if in a scene from Luis Buñuel's *Belle de Jour*. All details were carefully planned to combine the seductive appeal of the lingerie itself and the attraction of its exclusiveness as a high-end product. All merchandise is packaged in traditional pink boxes wrapped with a black ribbon— a final touch to complete the treasure-trove boutique.

Luxurious seating against a backdrop of Hollywood-style wallpaper sets the scene for intimacy and indulgence.

The storage cabinets are reminiscent of haberdashery units from the 1940s, which add a sense of eclecticism to the lingerie.

GIBO STORE, LONDON, UK
CHERIE YEO ARCHITECTS & DESIGN, LONDON, UK

The words *English* and *eccentric* are too readily thrown together but, when applied to Julie Verhoeven, the fashion designer fronting Gibo, they seem apt. Her talents and creative output spread from one medium to the next. The designer, artist, and illustrator, renowned for her feminine fashion fairy tales that include mythical creatures and fashion heavens, has just launched her own label with the backing of Gibo, the Italian clothes manufacturer. Verhoeven—who works from her base in South London, accompanied at times by her husband, painter Fabio Almeida—developed her firm grounding in fashion working in the studio of John Galliano in the 1980s.

Verhoeven's feet are firmly on the ground. "The whole process seems to be going well. It's weird. I thought I'd be more nervous, but I'm not, I'm just enjoying it. I don't want it to be a life-and-death thing with the fashion game," says Verhoeven. She's far too busy looking after the design of the showroom and collection in one of London's prestigious shopping streets to get too carried away with the excitement. Her collections for Gibo are extremely idiosyncratic, and the store, with its highly unconventional design language, complements the collection perfectly without detracting from the work.

To design the shop, Verhoeven selected Cheri Yeo Architecture + Design. Her brief to Yeo was to create a space that would be "playful, individual, and inviting." Verhoeven was drawn to Yeo for her sensitivity in conveying space through the drawn line. Neither client nor architect had previous retail experience, and both found this liberating. In fact, Verhoeven insisted that the store break from the conventional codes of the designer store, with all its über-cool associations.

The perspective illustrates the shelf-corset wall, so called because of the elasticized leather strips stretched over pegs; these allowing flexibility in the display of the season's accessories.

On entering the store, customers pass through the narrow peg wall to the rear of the store, where the clothes are on display.

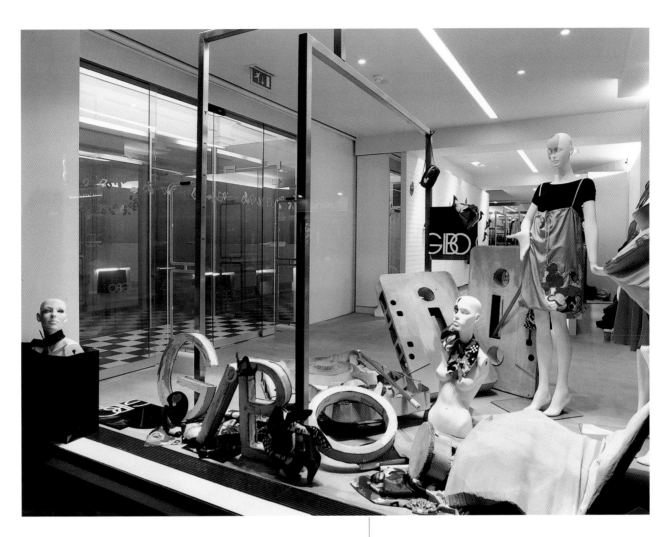

The Gibo store front introduces the hinged frames that provide ultimate flexibility within the store. The front window is deliberately kept free of screens or backdrops to allow views through to the rear of the narrow store.

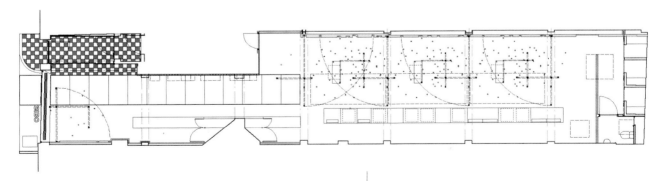

The plan illustrates the three groupings of the hanging mobilelike structure on which the clothes are hung.

The counter desk continues into the rear of the space to form the peg wall constructed out of Corian. An array of accessories can be pegged into the wall on transparent Perspex hooks.

The site posed a challenge in that it was a thin sliver with natural rooflights. It had changed hands many times, leaving layers of fittings that were peeled away to reveal the remaining decoration of the conservation-listed interior, complete with historic cornices. The excavation became a central feature of the store's design, a canvas to which Verhoeven added her personal style of drawing. Each season, an artist will be invited to enhance the wall, resulting in layers of drawing. This mixture of wall painting is a refreshing antidote to the gloss and glitter of high-end boutiques.

Verhoeven's work thrives on clashing contradictory movements; she cites both Arte Povera and Pop Art as major influences. The poetic elegance of taking an everyday object out of context creates a playful spark that is extended to the design of the store, such as the giant peg wall, where pegs are used to position the season's accessories.

Client and architect have worked closely to design a space that will react to each season's collection. The key elements of the design perform equal roles as sculptural and functional objects. The peg wall, suggestively titled the *shelf-corset*, is a 21-foot (6.5-meter) shoe wall with elasticized leather stretched over pegs, allows for complete flexibility of display in accordance with the season's accessories.

Verhoeran's brief to Yeo was to create a space that would be "playful, individual, and inviting."

The unusual approach to hanging the clothes creates a series of sculptural frames that can be folded into cast recesses in the lightweight concrete cladding walls, thus allowing the area to function as a space for exhibitions or catwalk shows.

The second architectural element is the hanging structures for the clothes. A series of hanging frames inspired by Alexander Calder mobiles fold out into the space in a variety of configurations. The scaled-up mobile structure creates a secondary structure within the space and can be folded away into the concrete relief wall to leave the linear space free for catwalk shows or exhibitions. The 56-foot (17 meter) wall is constructed of lightweight, thin, glass fiber–reinforced concrete that measures just over 2 inches (5 centimeters) at its thinnest dimensions. The lighting plan subtly tracks the positioning of the locating feet of the steel frame.

The design of the store is a unique blend of fashion and architecture. Yeo is excited by how the space allows for many interpretations by its user. The highly idiosyncratic space is as much about the relationship between client and architect as it is the freedom handed over by Franco Pene, the CEO of Gibo, who realizes that to suppress a creative spirit would be to naturally suppress her creativity.

The Gibo store is under construction at the time of writing. It is illustrated here with three-dimensional visualizations.

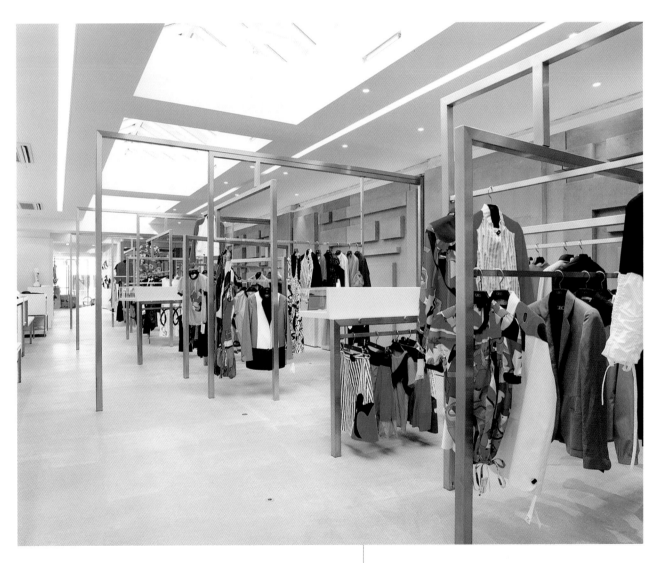

The hinged clothes hanging frames can be fixed back in to the relief walls. The 56-foot (17 meter) long walls have been cast out of lightweight fiber-reinforced concrete.

L'HUILLIER BRIDAL STORE, BEVERLY HILLS, CA
STUDIO ETHOS INC., SANTA MONICA, CA

Monique L'Huillier and her husband, Tom Bugbee, established her Los Angeles bridal salon in 1996. Before long, it was hailed as the leading bridal showroom in the region. Hot on the heels of the bridal success came the launch of a couture eveningwear collection, which was snapped up by prestigious American-based retailers such as Neiman Marcus, Nordstrom, and Saks Jandel.

Studio Ethos was approached to design their first retail store, L'Huillier. The brief was to create the perfect backdrop for the exquisite dress silhouettes in a modern environment that would attract a young, dynamic clientele. To achieve this, the studio decided to borrow the language of the contemporary art gallery. A clean space with clear architectural planes and uncluttered surfaces became the principal elements of the scheme. Against this calming background, the sumptuous wedding dresses take center stage. The stark simplicity of the interior, with its exposed concrete floor screed, dramatically contrasts with the rich silks of the gowns.

In the tradition of minimalism, great attention was paid to the detailing of the store. Walls float 1/2 inch (1.25 centimeters) above the concrete screed. To fully exploit the restricted space, the ceiling height was dropped as little as possible to 14 feet (4.3 meters) while still concealing the ducting and lighting. Luminescent milk glass wraps around the store's façade, enveloping the front window display. Glass transoms concealed in the ceiling add to monumental impression conveyed by the showroom. The grandeur is echoed in the execution of the store's entrance, whose 12-foot (3.65 meter) door has a 7-foot (2.13 meter) handle in brushed stainless steel.

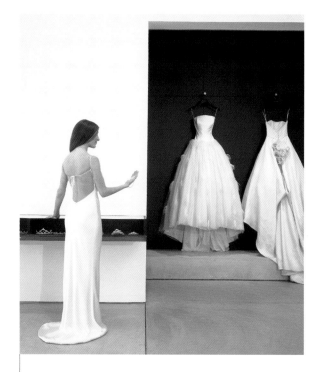

The podium recess, finished in chocolate brown, provides a starkly dramatic setting for the detailed gowns.

The more private aisle section is laid out between dressing rooms, thus providing a balance of the private and public within the space.

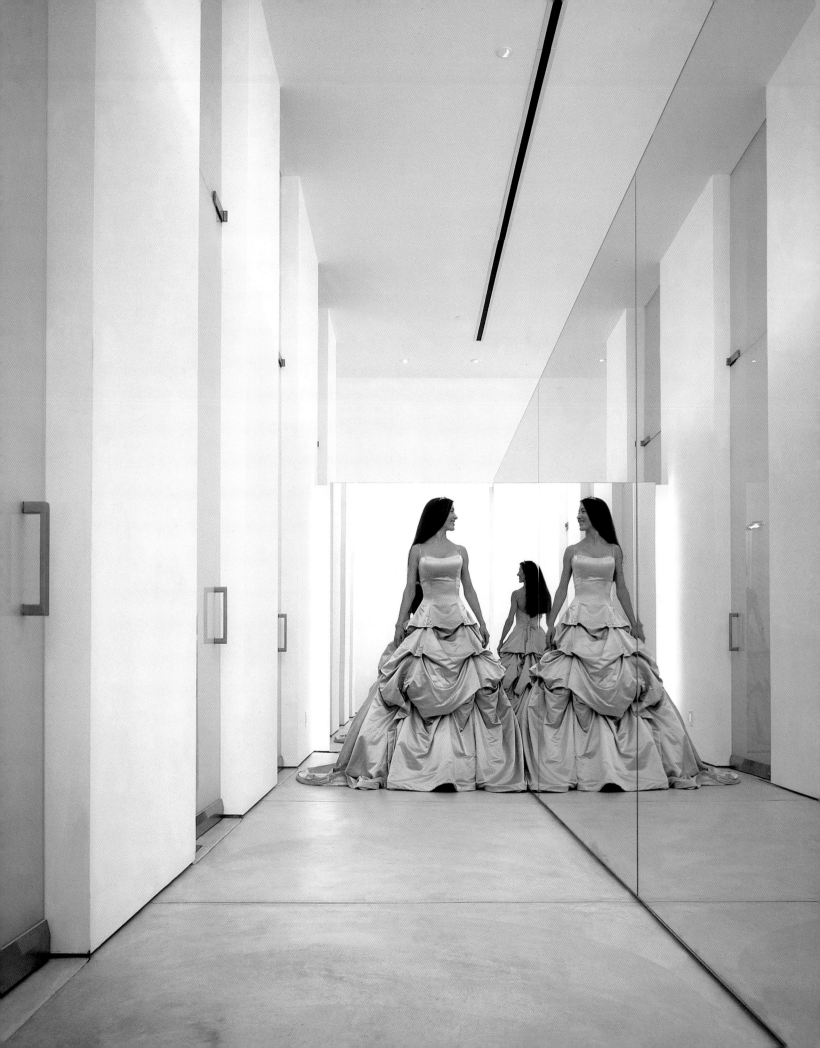

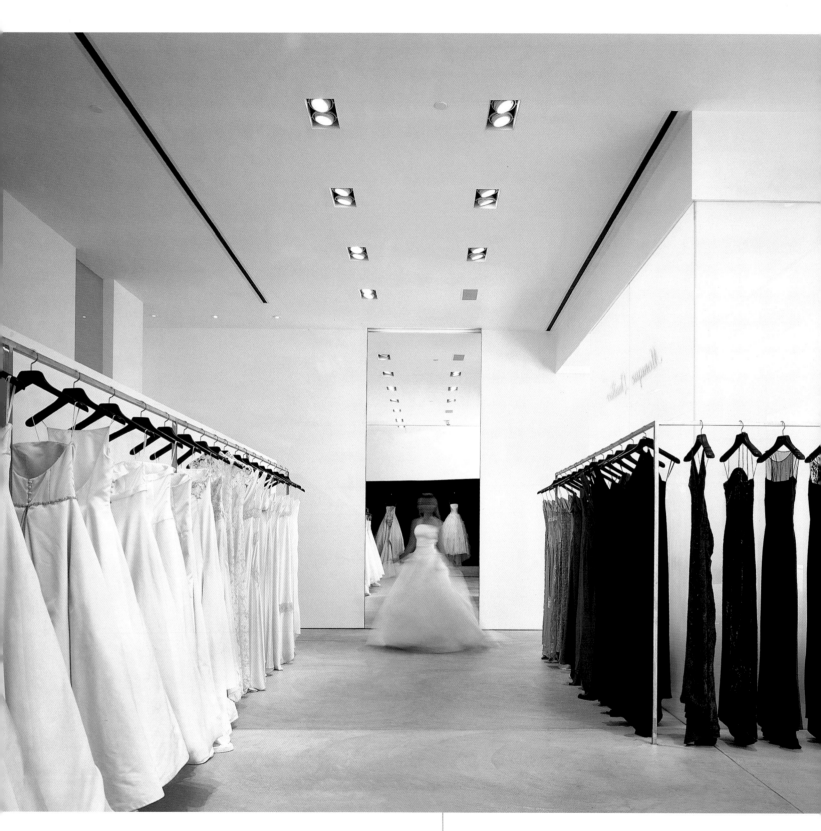

The natural layout of the store creates a catwalk area
behind the dwarf wall.

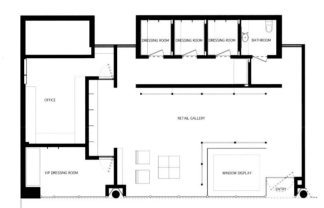

The simplicity of the plan belies the carefully considered balance between the public and the private areas of the store.

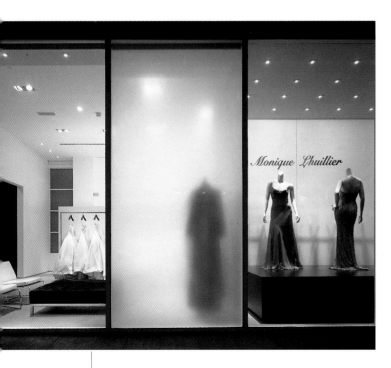

The façade is a careful composition of three elements—transparency, solid, and semitransparency—that showcase the couture gowns and allow a clear view into the interior.

One of the main design requirements was a hall of mirrors wherein clients could see themselves from every angle. To enhance clear vision, a combination of recessed and trough lighting was used in the ceiling as well as behind mirrors to create a sense of mystery. The total floor area is 1,600 square feet (149 square meters), and within this space the clients wanted an area where clients could walk the aisle and model dresses. In addition, a more discreet catwalk area was introduced to the scheme. To create the former requirement, a dwarf wall runs the length of the store, directing light toward the ceiling from a row of concealed lights at its crown. The wall creates a natural catwalk terminating in a floating 14-foot (4.25 meter) mirror. The more intimate area is the hidden space created by the dwarf wall on the opposite side to the main catwalk; there, customers can emerge from the dressing rooms but still have some privacy.

Four dressing rooms were required, one large enough to hold a VIP client and her entourage. These are situated at the rear of the store and lined with a soft floor covering.

Central to the design of the showroom was the creation of an alluring space that shows off the exclusive couture wear and draws clients in from outside. Floor-to-ceiling panels of darkly stained oak create a niche where three dresses seem to float on square pegs of brushed stainless steel. Below the dresses, a concrete base rises from the floor to display the delicate shoes and bags designs to complement the gowns.

Each season's collection of bridal gowns is displayed against the dwarf wall on a square brushed–stainless steel fixture 30 feet (9 meters) long. The evening gowns are hung on a similar fixture that folds around the front window display. Two white mannequins clothed in L'Huillier's exquisite gowns adorn the podium and beckon passersby into the store. The overall effect is one of drama with a contemporary edge. This is expressed in the combination of features that range from the raw, bare polished concrete screed to the showcase podiums in rich chocolate brown.

> **"I wanted to capture the resort ambience of Palm Springs."**
> Trina Turk, designer

TRINA TURK RETAIL BOUTIQUE, PALM SPRINGS, CA
KWID, LOS ANGELES, CA

Trina Turk designs exquisite women's fashions that combine exuberant, bold prints with fine tailoring—fashion must-haves among trendsetters such as Drew Barrrymore and Kate Moss. When searching for a new retail outlet in Palm Springs, Turk jumped at the chance to lease a former classic modern furniture store, housed in a building designed by Albert Frey, which she had long admired for its elegant architecture.

As does Turk, the interior design firm Kelly Weastler Interior Design (KWID) skillfully combines vintage and modern elements in its work. Having visited the KWID-designed hotel Maison 140 in Beverly Hills and admired its sense of elegance and restraint, she commissioned the firm to design her first retail premise. "I wanted to capture the resort ambience of Palm Springs and provide a showcase for my contemporary sportswear line that is created using

graphic prints and strong-colored fabrics," says Turk when summarizing her brief to KWID. The design has resulted in a stream of clients who are "genuinely surprised and delighted by the store's atmosphere," in Turk's words, as they discover the store among a line of antique and contemporary furniture shops. "Clients want to explore the space and the merchandise and often seem to just want to hang out for a while."

KWID's style displays a quiet exuberance, with a portfolio of discerning residential and commercial properties, including the refurbishment of the legendary Avalon Hotel in Beverly Hills, where Marilyn Monroe once lived. Its designers pride themselves on offering their clients a comprehensive service including architecture, interior, graphic, lighting, landscaping, textile, tile, furniture, and fixture design.

Polished-acrylic door handles add a sculptural angle to the doors. Antique chinoiserie-style wallpaper complements the strong graphic prints that feature in the boutique's fashion apparel. The exotic references continue in the choice of furnishing—for example, the colonial-style china elephant and cane-and-wicker seating with bold upholstery to match.

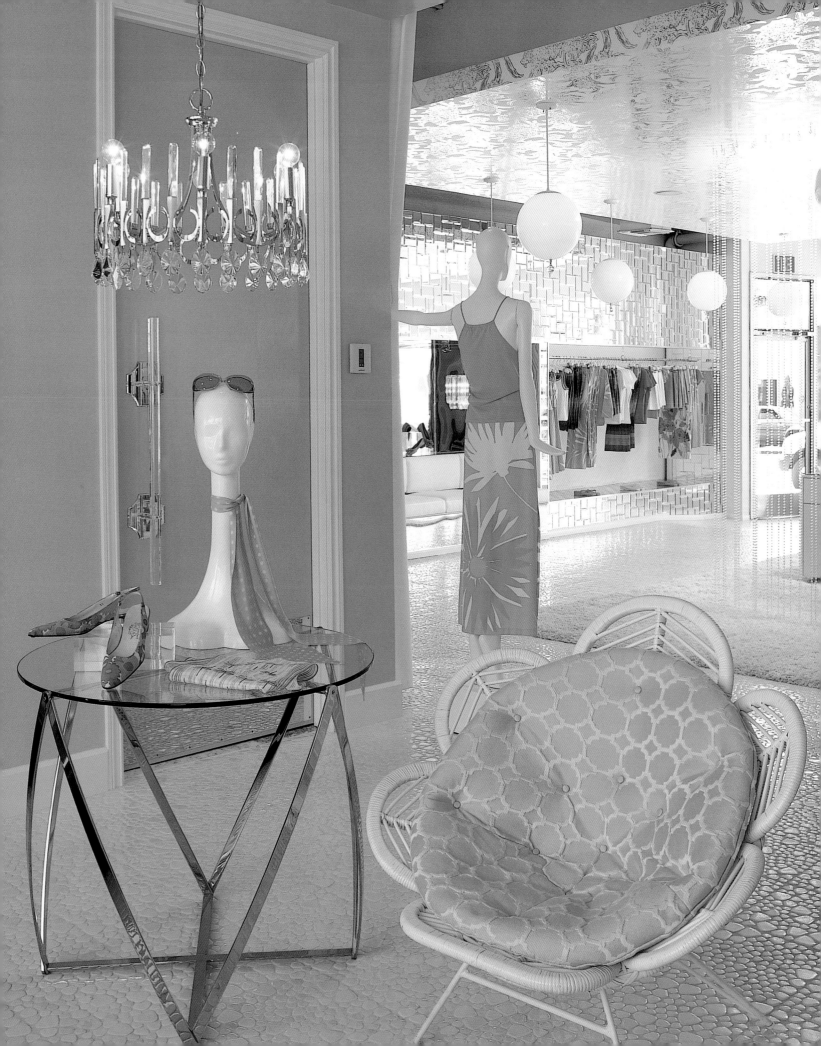

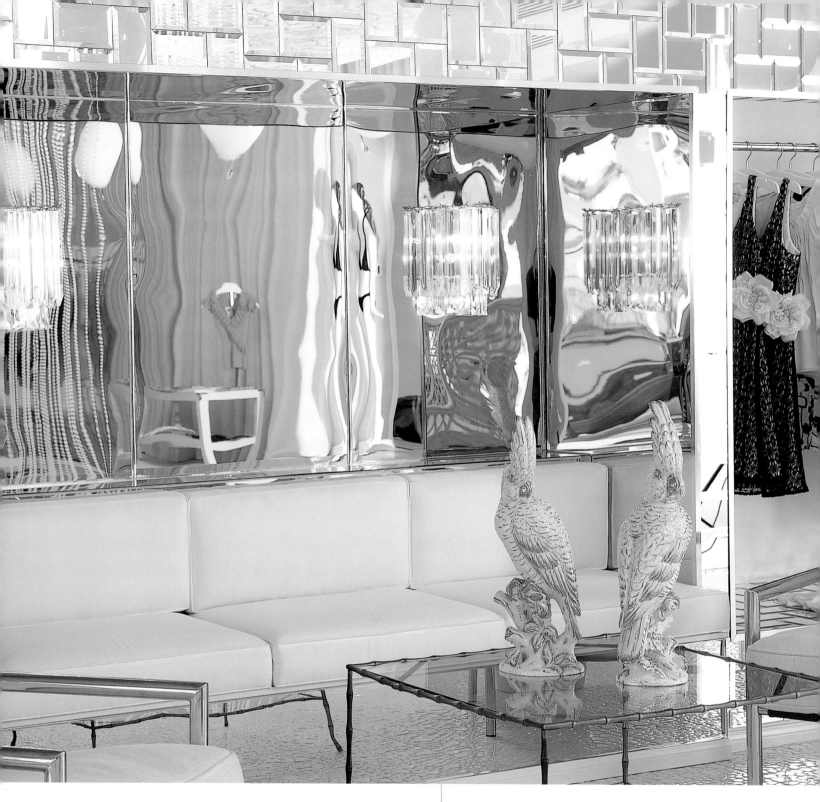

White leather-upholstered seating alcoves are intimate spaces. The attention to surface detail is demonstrated in the reflective surfaces such as cut-crystal tiles, mirror-lined walls, and white globe light fixtures customized with gold finials and crystal balls—the same attention to detail reflected in Trina Turk's collection and accessories.

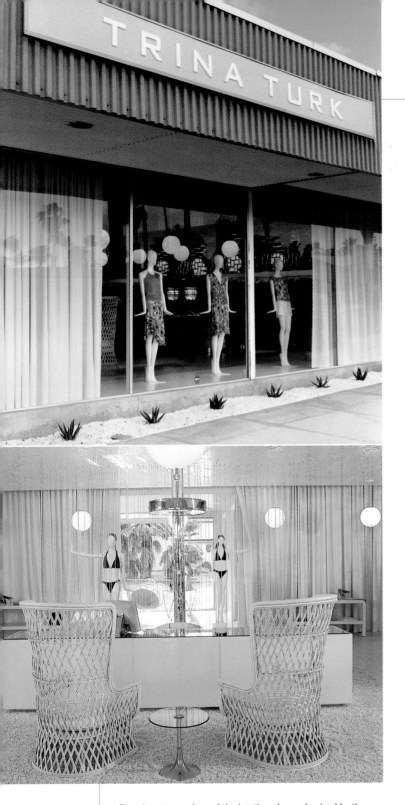

The emphasis within the store is on creating a sensual environment that is bright, welcoming, and shows off the specialized ranges of lingerie. Crimson pink complements the warm tones of the wood floor and fixtures. The sensual but welcoming environment provides a relaxed space where customers feel at ease to browse and purchase.

The personalization of the store—filled with a careful selection of contemporary furniture, refurbished original Pucci mannequins, and luxuriant surfaces—adds to the glamour of the space, creating a unique atmosphere in contrast to the department store. The boutique, unusually, has entrances at both front and rear, where there are parking bays for clients. The principal retail area has a square floor plan with changing rooms and storage space along the perimeter. Clients are taken through a series of loosely defined spaces veiled by discreet beaded curtains; the sense of privacy increases in the transition from the exterior to the more intimate interior. Resin-coated white pebble tiles cover the main areas, and a luxuriant shag-pile carpet softens the more personal spaces, such as the changing rooms. The palette of crisp fresh interior colors complements the collection.

Reflective surfaces used throughout play with the mirroring of the viewer's image and give it more than a hint of Hollywood glamour. Cut crystal and Mylar complement the 1930s-style light fixtures. Polished-acrylic tubular door handles provide an inventive twist.

To encourage a leisurely atmosphere, there are seating alcoves with white leather and chrome sofas surrounded by mirrors along the walls. These lounge areas, similar to those in couture houses, are comfortable spaces in which to pause.

The elegant grandeur of the boutique is emphasized by the symmetry of the interior. The showroom mannequins are refurbished vintage Pucci mannequins. The cash desk is at sitting height rather than the usual leaning height; this adds to the exclusive feel of the boutique, where the atmosphere is like that of a nineteenth-century salon. The brass-coated, low, circular table mirrors the chrome plate hung above from the 1930s-style globe light fixtures.

The owners conceived of the space more as a cultural laboratory where experimental art and fashion could be displayed rather than a traditional retail environment.

ZAO STORE, GALLERY, AND GARDEN, NEW YORK, NY
CALVERT WRIGHT ARCHITECTURE, NEW YORK, NY

The compact block of Orchard Street in Manhattan's Lower East Side has become a small, multicultural oasis brimming with select curated boutiques, French bistros, and velvet-roped nightspots. Compared to Soho and Chelsea, but with greater rawness, it has yet to be overdeveloped. Nevertheless, the graffiti-heavy sidewalks are threatened with gentrification as the area's Business Improvement District introduces visitor-friendly ploys such as walking tours, wrought iron benches, and new street lamps. Zao Store, Gallery, and Garden is nestled on Orchard Street, its façade a seductive layer of translucence. The store has been described by the New York City Guide as "an off-beat assortment of fabric and frippery that decorates the walls in gallery-ready display selling wares by cutting-edge designers like Jeremy Scott and Punk Empire to cater for urban bohemians in search of the Next New Thing."

The commission for Zao did not fall within the usual parameters of a retail space. The owners conceived of the space more as a cultural laboratory where experimental art and fashion could be displayed rather than a traditional retail environment. Calvert Wright, working in collaboration with Maria Gray, approached the scheme with a holistic concept for bringing together all the diverse requirements of the space. Gray has since founded the design firm Gray Area. Wright worked for such challenging architectural practices as Diller + Scofidio, 1100 Architects, and Rafael Vinoly Architects before setting up his own architectural design studio, Calvert Wright Architecture PC/Spatial Discipline, in New York City in 1998.

Zao showcases a carefully curated, rotating, progressive collection of art, fashion, design, furniture, and housewares. By establishing a venue where customers are also viewer/spectators, there is an element of surprise and anticipation as to what will be on offer in the venue, thus promoting a constantly rotating program of events and contemporary products. The architectural design directive from the owners demanded enormous flexibility. The aesthetic requirement was that the architecture of the store be as progressive as the items on sale but not upstage them.

The store had formerly been divided into two narrow, separate shops, each with a mezzanine. While the construction budget and the need for maximum floor area mandated that the mezzanines remain, the two spaces were joined to make the primary retail space as open and flexible as possible. The material and color palette of the fixtures and insertions is deliberately muted to whites, off-whites, transparencies, and translucencies so as not to overwhelm the merchandise.

The rear yard and gallery space provide an ideal area for exhibitions and events and a retail outlet where cutting-edge products, magazines, and journals are sold. The design of Zao, with its cleaned, stripped-down, almost clinical look, reflects the "laboratory" concept of the store.

The unifying element of the scheme is the strip of fluorescent lighting that runs around the perimeter of the floors.

To create the flexibility demanded by Zao's rotating and varied display of products, the interior walls of the store are sheathed in a modular display system of back-painted acrylic panels held in place by milled aluminium plugs. These plugs can be replaced with posts that support shelves for folded clothes, design objects, or housewares. Alternatively, the plugs can be replaced with posts that support rods for hanging clothes, face out or shoulder out.

The store fixtures were also designed for maximum flexibility. Fabricated from clear acrylic and sitting on concealed casters, the fixtures allow maximum visibility of the objects on display while also allowing for ease of mobility. The fixtures are lit from below and appear to float above the seamless poured–epoxy resin flooring. The lighting is a combination of halogen track fixtures for direct lighting and larger custom-blown acrylic hung fixtures for ambient lighting.

The store's façade is fabricated from frameless tempered glass and sheathed in a translucent film. A 14-foot (4.3 meter) circle was cut out of the film, revealing a clear circle or O, which is the store's logo.

The gallery and garden space for Zao were designed in conjunction with, and are immediately adjacent to, the retail space. These areas are meant for art exhibits, performances, and events that enhance the owners' vision of Zao as a creative laboratory.

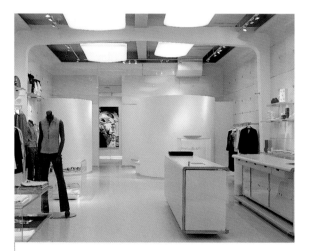

The interior walls of the store are sheathed in a modular display system of acrylic panels held in place by milled aluminum plugs.

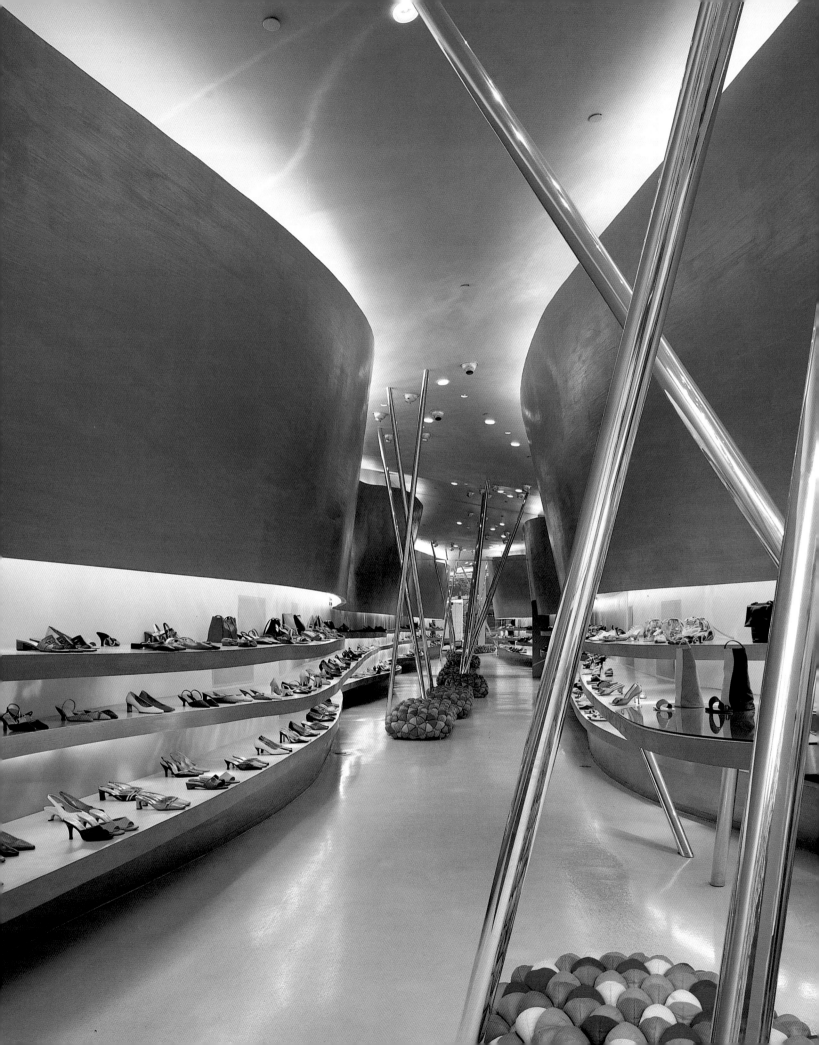

KERQUELEN, WEST BROADWAY AND SOHO, NEW YORK, NY
STÜRM AND WOLF, ZÜRICH, SWITZERLAND

The Swiss shoe company Kerquelen was destined to create a stir when its products hit the American market. Kerquelen is conceived as an international shoe project bringing together carefully selected designs from around the world, from sultry stiletto boots to funky fur sneakers. "We exemplify the electrical joie de vivre of the stores' downtown locations, and the shoes reflect the cosmopolitan brilliance of the city. Kerquelen features the most enviable, thrilling, and daring shoes from the world's finest designers," states the director of Kerquelen, Anders Perbo.

To complement the company's design ethos, the Swiss architects Stürm and Wolf were invited to design the two New York City stores, one on West Broadway and the other in Soho. The firm is noted for its work in high-end fashion retail spaces, having completed designs for Issey Miyake and Yohji Yamamoto as well as Kerquelen.

The goal was to create an environment that responded to the site conditions and the immediate neighborhood. The client left the brief open, stating only that the shopping experience was to be enticing and exciting experience. The Kerquelen store at 430 West Broadway is located in a contemporary commercial building from the 1990s and the second store takes a linear slice through its Soho block, occupying the full depth of the ground floor.

The various sections, taken at different depths within the West Broadway site, demonstrate how the walls create varying forms within the interior, adding to the drama of the space.

Undulating curves and angled metallic columns flow through the West Broadway space.

The architects wanted to create an artificial skyscape that would provide a cool and airy refuge from the noise and activity of West Broadway. To do so, they introduced undulating walls painted in muted tones of iridescent blue; these lead the customer to a full-length mirror at the rear of the store that captures the activities of both the street and the customers. The interior conveys the illusion of a delicately surreal passageway. A forest of angled metallic columns that appear to prop up the ceiling creates a dynamic entrance and continues through the slice of space, while the anthropomorphic leather-clad stools appear to march across the floor.

A staggered arrangement of wall units with built-in display shelves makes for an almost infinite variety of presentation possibilities. The star-speckled ceiling, its brightness echoing the shiny white floor, appears to have pulled loose from the walls. Kerquelen's dramatic stage set is achieved through skillfully composed elements that work as a sculptural whole without overshadowing the merchandise. The highly individualized merchandise is reflected in the imaginative visual language created by the architects to add an element of drama and surprise to the stores' environments.

The graphic horizon is constructed of acrylic sheeting to which digital print is applied.

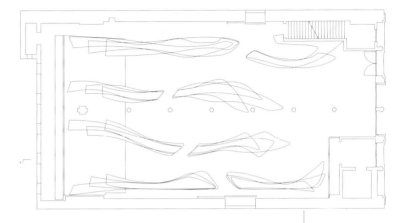

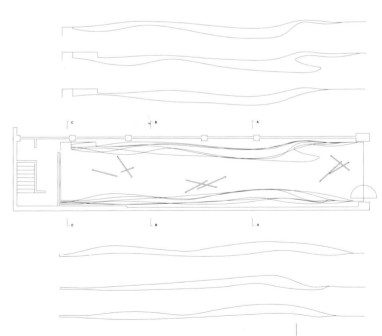

The principal interventions in the Soho space are free-flowing forms constructed of polished sheets of stainless steel and Alucore panels.

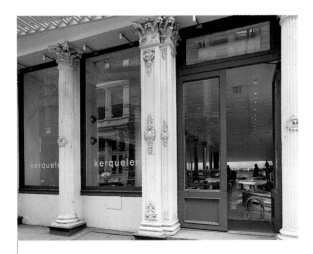

The Kerquelen storefront allows a clear view through to the rear wall, led by a linear run of spotlighting.

The plan for the West Broadway location illustrates the linearity of the site and how the undulating curves of the interior walls flow through the space.

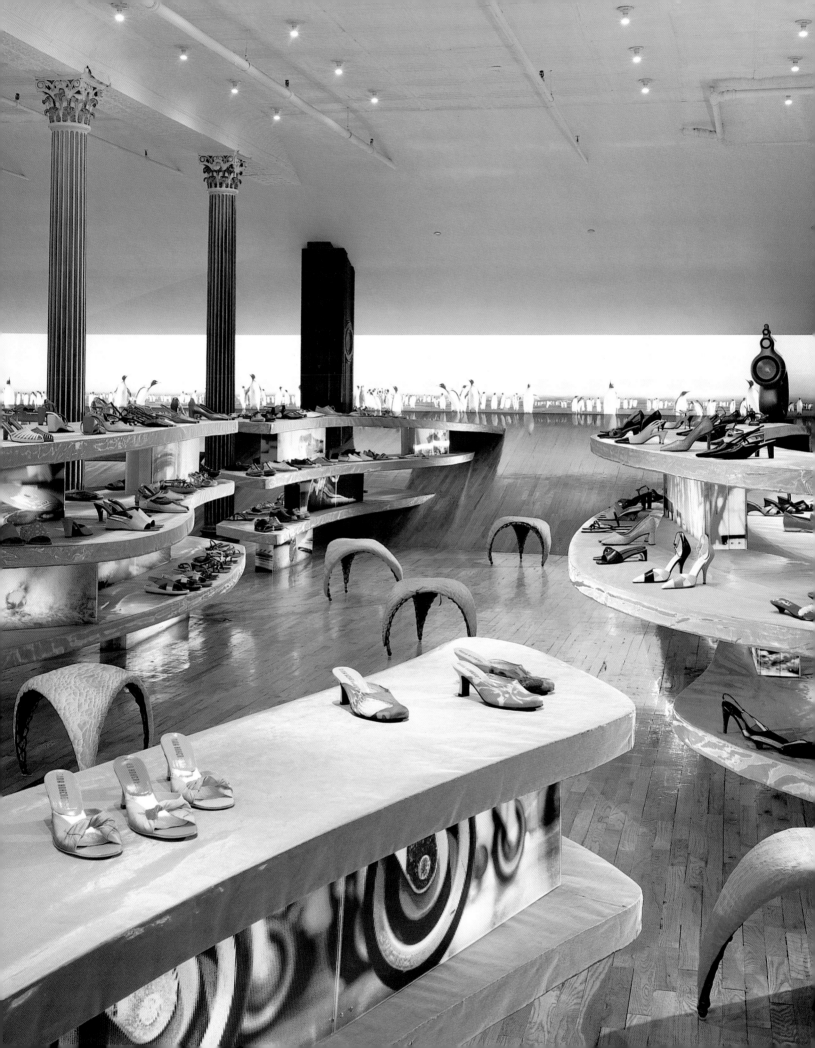

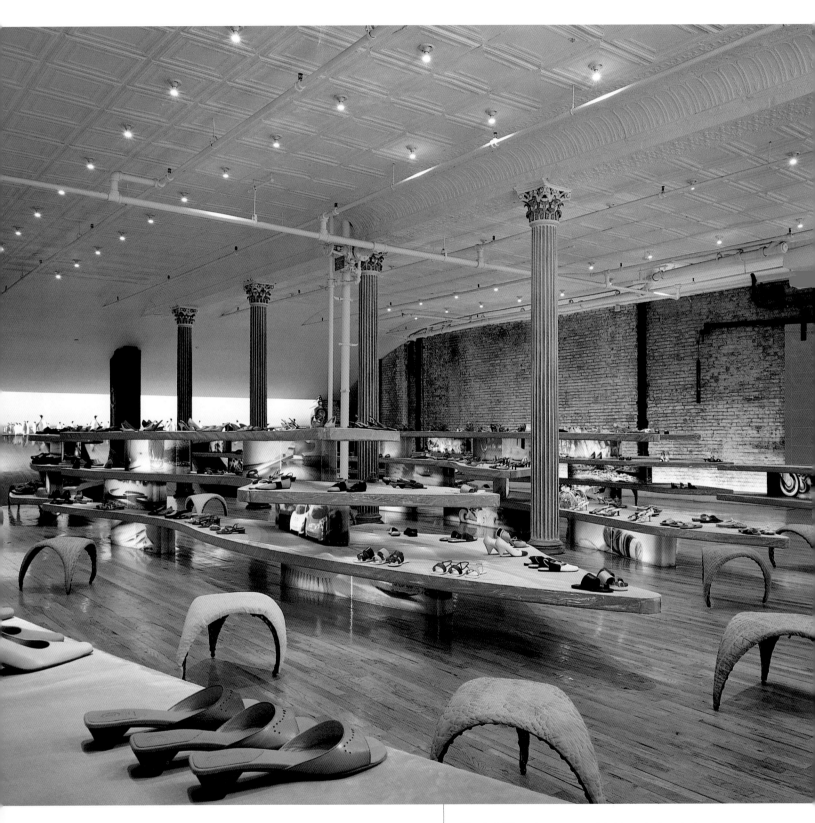

The Corinthian columns were painted in graduating shades of green by the specialist company See Painting, New York. The different creative parties involved with the store's design have resulted in a highly unique interior that reflects the products.

The second Kerquelen store is housed in a landmark cast iron building from the mid-1800s in Soho. The design highlights the existing fabric, composed of elements such as antique Corinthian cast iron columns, brick walls, and historic fire protection elements, and introduces into this setting a contemporary architectural installation.

At the back of the deep space, floor and ceiling converge to shape a long, low, beckoning, glowing violet horizon that extends the artificial landscape. The architects wanted to create an exaggerated perspective, which they call virtual distance, by painting progressively darker shades of green on the center row of columns. The contrast of the contemporary interventions the grandeur of the existing plaster decoration powerfully demonstrates the layering of history in response to the building's uses over time.

Shining metallic mesh shelves emerge from the slope of the horizon, carrying the display of over seven hundred shoes. Different zones like wavy dunes form at the edge of a waterscape. Supporting the shelves are glowing lightboxes that illuminate the shoes from a 180-degree angle.

The entire room is illuminated by simple porcelain light fixtures installed directly on the historic white metal ceiling panels. Again, the design is a site-specific response that plays with the original architectural features. Except for the presence of the animallike stools, designed by an Israeli

One experiences the space first; then the shoes begin their appeal.

company called Aquacreations, Inc., Tel Aviv, no signature elements are repeated that immediately identify the corporate identity. Instead, the client and architects chose a retail aesthetic more akin to a sculpted form on which the shoes seem to rest. One experiences the space first; then the shoes begin their appeal.

The antique Corinthian cast iron columns were an original architectural feature retained in the design of the Soho store.

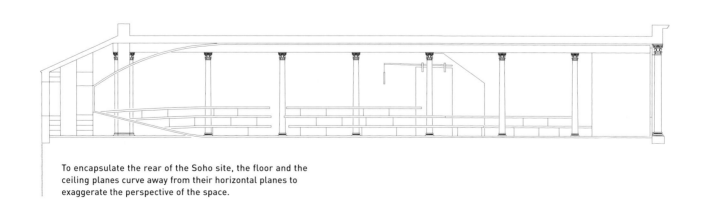

To encapsulate the rear of the Soho site, the floor and the ceiling planes curve away from their horizontal planes to exaggerate the perspective of the space.

> "In the vaporous, light-filled environment that Neil Denari has achieved, our eyeglasses read as exclamation points." Gai Gherardi, l.a. Eyeworks

L.A. EYEWORKS, LOS ANGELES,CA
NMDA, LOS ANGELES, CA

Gai Gherardi and Barbara McReynolds are no ordinary clients. The couple is credited with transforming the image of eyeglass design and has been designing innovative eyewear since 1979, when they opened their original Melrose Avenue store in Los Angeles.

l.a. Eyeworks designs has been distributed internationally since 1984. The architecturally innovative retail stores on Melrose Avenue (1979), featured in the movie *Blade Runner*, and at the South Coast Plaza (1988) in Costa Mesa, merchandise some of the most dynamic eyewear designed by a selection of international designers. l.a. Eyeworks frames are immediately recognizable; they infiltrated the popular culture landscape via Susan Sarandon's character in *Thelma and Louise* and the action figure of Joe Pantoliano in the *Matrix*. By forming alliances with artists, musicians, architects, and graphic designers, Gherardi and McReynolds continue to explore ideas and the development of a new medium. They create a cultural mix where art, design, and fashion come together.

Neil Denari, principal of Neil M. Denari Architects, Inc. (NMDA) and the architect responsible for the quintessentially Los Angeles store, describes the architectural challenge of working for the dynamic company: "For this 1,250-square-foot (116-square-meter) store located on Beverley Boulevard in Los Angeles, the client's desire was to create a unique relationship between the evolutionary needs of commercial retail practice and the stability of architecture usually associated with institutional or public work. For l.a. Eyeworks, one of the most adventurous companies in the field of contemporary design, the new store finds its idea at the moment where the fixity of architecture and the seasonal change of new collections of glasses come together."

The detail demonstrates the vaporous element that wraps around the seating bench and wall and continues on to create a ceiling plane. Details, such as the stainless steel door handle, were all designed to complement the architectural interventions.

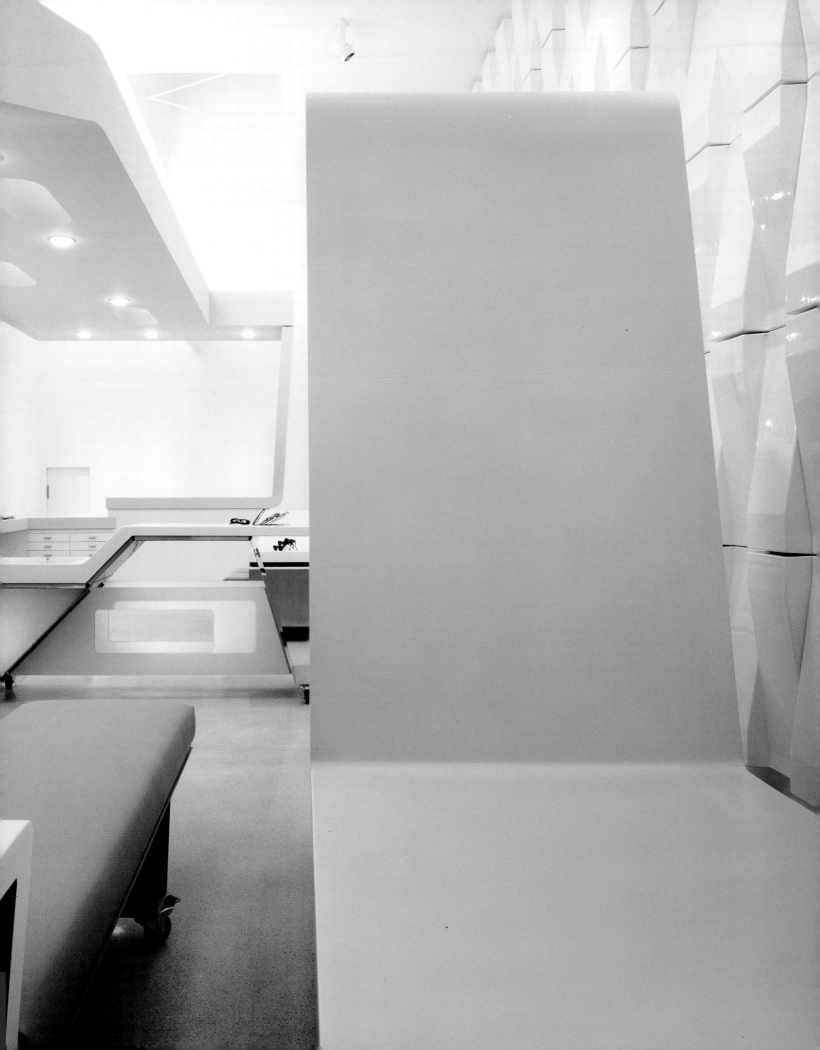

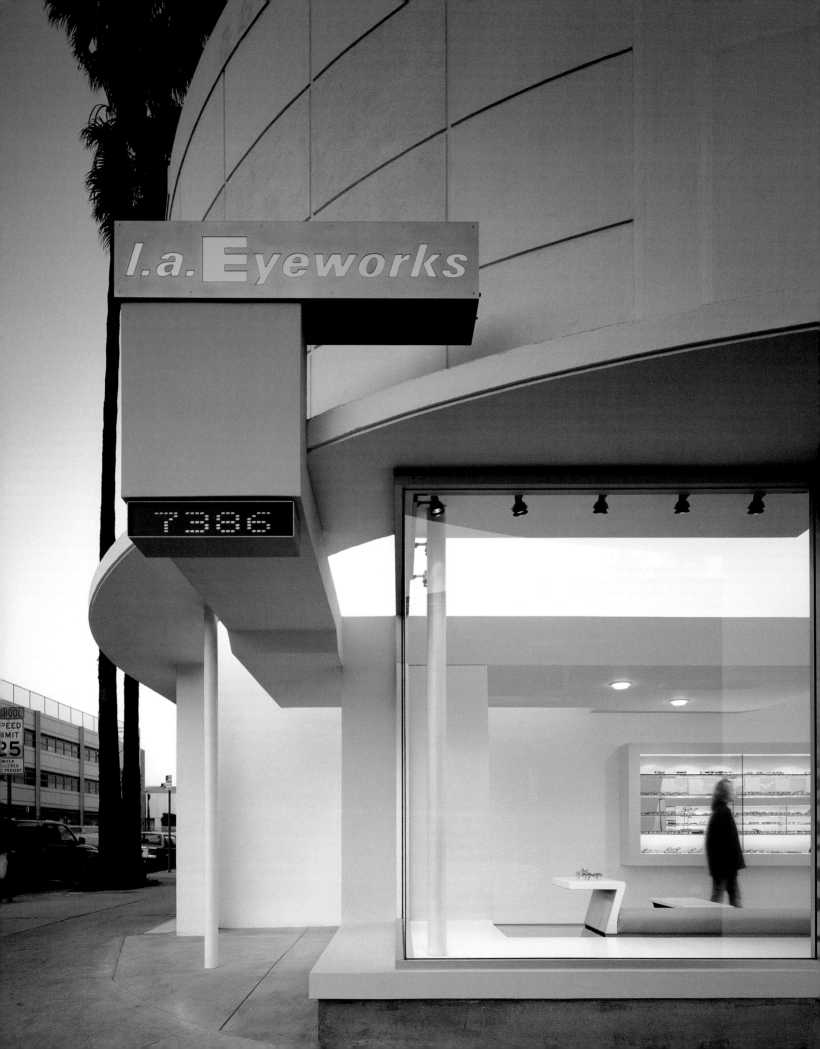

The designs of Neil Denari are characterized by "an almost mysterious, technologic expression." He is fascinated with how technology and contemporary culture are linked. As both a practicing architect and a professor, Denari explores architectural theory and its relationship to culture. The choice of NMDA to design the l.a. Eyeworks store was influenced by his design program linking digital technology to architecture; this reflected the semi scientific design quality of the eyewear, whose innovations are expressed in materials and manufacturing techniques. The site selected for this $400,000 project was a two-story corner building with an original, curved, stucco façade on the second floor.

The opening on the ground floor is a combination of planes breaking off at 90-degree angles; an LED outpost runs a continuous stream of information on news and culture. Denari describes the store as "a setting for the intricate interplay between architecture, art, and design, where each medium works reflexively with the other."

The interior of the store is shaped by a continuous, lightweight, suspended blue surface that wraps around the space and functions as a ceiling, window display, bench, shelving unit, and sales counter. The continuous plane conceals diffused fluorescent lighting and is punctured with a series of lozenge-shaped openings. The clients wanted to avoid shadows that would distract clients trying on glasses.

Gherardi and McReynolds have a history of working with artists. They had seen Jim Isermann's exterior installation at an art show, Site Santa Fe, and, on the strength of that piece, commissioned him to create a permanent wall installation at their store. The installation consists of vacuum-formed plastic panels that form a high-relief pattern set out as a grid along a 30-foot (9-meter) span.

The architecture has been described as a type of techno-luxe, and its almost futuristic, spaceship-quality creates a total experiential environment. To complement the space, Denari designed a series of display units using stainless-steel sheets 1/10 inch (3 millimeters) thick with flush fasteners. A dispensing table sits in the space where glasses are fitted; its plastic top has molded indentations for fitting devices and a portable computer.

The environment is a distinctive retail space and a bold experiment in bringing together innovative retailers, artists, and architects. The result is a space that, in Denari's words, is an achievement of what they originally set out to do—"to try and find the experience of that rare air. And how you get that is through the convergence of light, color, and form." Gheradi agrees: "By bringing these elements together, that's what we got. In the vaporous, light-filled environment that Neil Denari has achieved, our eyeglasses read as exclamation points."

Plan.

l.a. Eyeworks is Denari's first executed project. He designed an eye-catching façade where a moving LED screen displays edited news and cultural information to passersby.

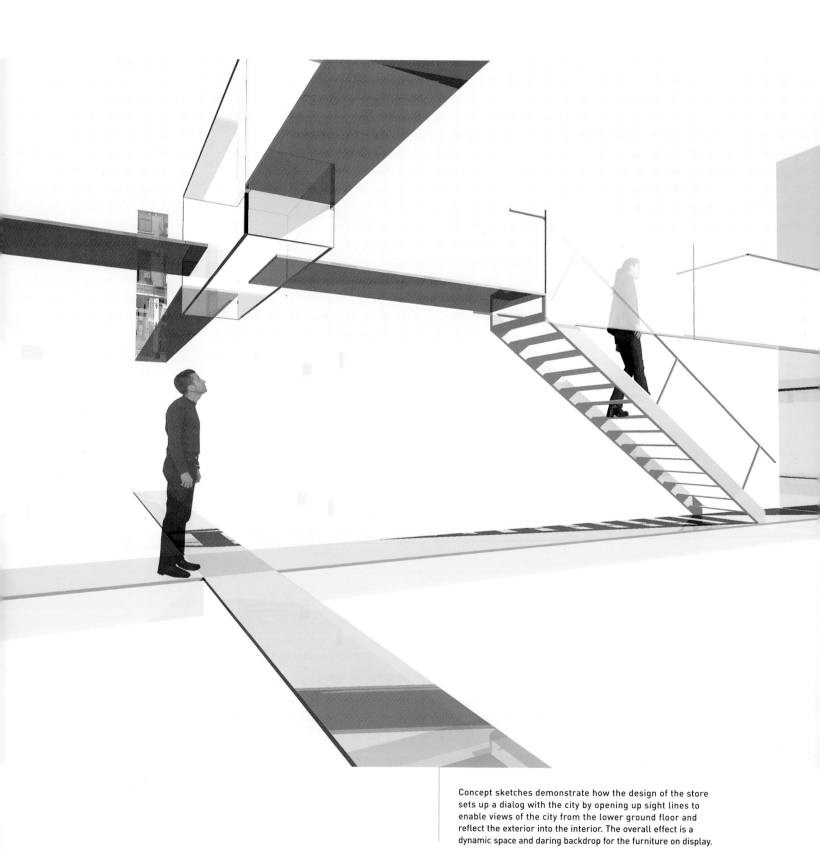

Concept sketches demonstrate how the design of the store sets up a dialog with the city by opening up sight lines to enable views of the city from the lower ground floor and reflect the exterior into the interior. The overall effect is a dynamic space and daring backdrop for the furniture on display.

In this highly orchestrated showroom experience, the visitor is an active
participant in the architecture and the exhibition of merchandise.

LES MIGRATEURS, NEW YORK, NY
LEVEN BETTS STUDIO, NEW YORK, NY

Leven Betts, the New York–based architectural practice, was invited to design the New York flagship store for the Paris-based furniture and accessories company Les Migrateurs. Henry Personnaz, president of Les Migrateurs, promotes high-quality craftsmanship and classic design in his collection of furniture, lighting, and accessories. "The furnishings we select reflect the innovative and distinctly European sensibility in contemporary design. In addition, we are constantly experimenting with new and interesting materials, mixing them with the finest construction." It was the unique combination of projects and the studio's execution of details that drew Personnaz to Leven Betts. By exploring architecture through film and photography, the partnership brings a dynamic vision to their projects in interiors, buildings, and furniture.

The furniture store, situated in Tribeca, occupies a traditional 1870s warehouse with a generous street frontage forming four bays of windows. The design direction created a sense of the unexpected by manipulating the interior of the building. The major intervention to the two-story showroom comprises three floor cutouts. The three apertures are part of a floor pattern inscribed on the street level and the sublevel of the store.

The objects for sale are displayed on and around the three floor cutouts. The first cutout, located at the front of the store, is a laminated structural glass zone. The glass floor panels allow the furniture pieces displayed on them to be viewed and inspected from below as well as from above, and they permit light to penetrate from the street level to the lower-level showroom and workspace. At night, a warm glow issues from the bottom of the store up onto the street.

The second cutout is a stairwell with a floating acrylic display platform that allows a select few pieces to be viewed from all perspectives by people on the staircase. The third cutout is a transparent sales desk that is an integral piece of the store's architecture. The desk holds all the necessary wiring for sales equipment—computer, credit card reader, and telephone. Customers can observe the transaction occurring at the point of sale from the lower level as they move about the objects in the showroom.

The architects refer to the floor cutouts as visual apertures that permit a dialog between the passerby and the interior by allowing visual penetration of the various levels and depth of the space. Through a series of framed vistas of the surrounding city and the admission of light through various apertures, a tension between the horizontal plane and the vertical city comes into play, providing a dynamic backdrop for the display of the furniture. Mirrored panels are placed at strategic positions within the store to enable the images of the city to be viewed within the store.

The dynamics of viewing the objects sets up a visual kaleidoscope and allows the customer to thoroughly contemplate the furniture or objects—a refreshing alternative to the set arrangements often found in furniture stores. In this highly orchestrated showroom experience, the visitor is an active participant in the architecture and the exhibition of merchandise. The architects' design concept successfully links the space, merchandise, and experience of the city to form a visually arresting experience.

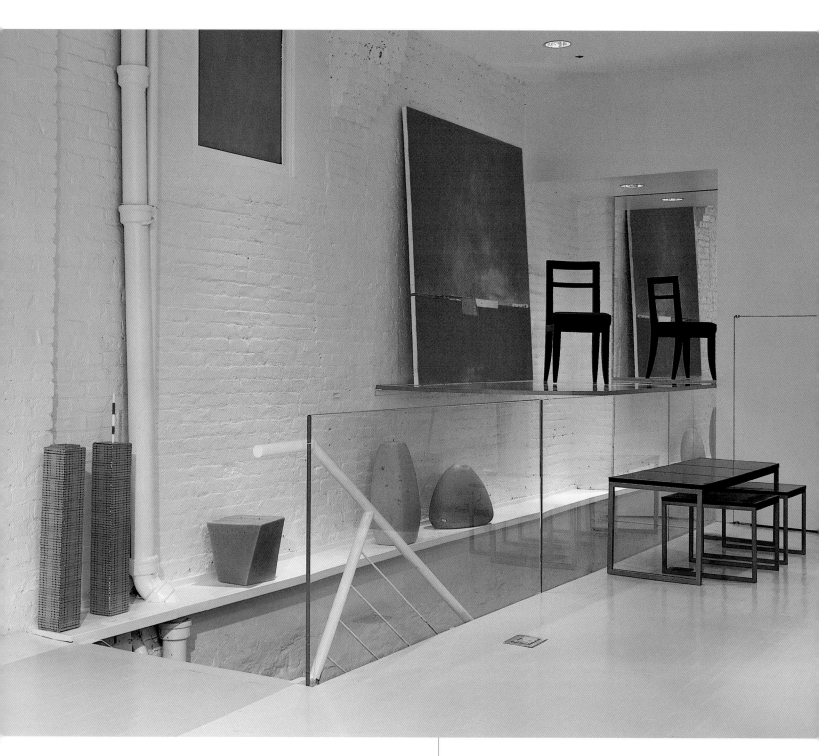

The use of mirrors and glass balustrading helps reflect and multiply the different perspectives that the interventions in the site open up to the viewer.

A close-up of the cash desk resembles an abstract image
of objects overwritten with the movements of customers.

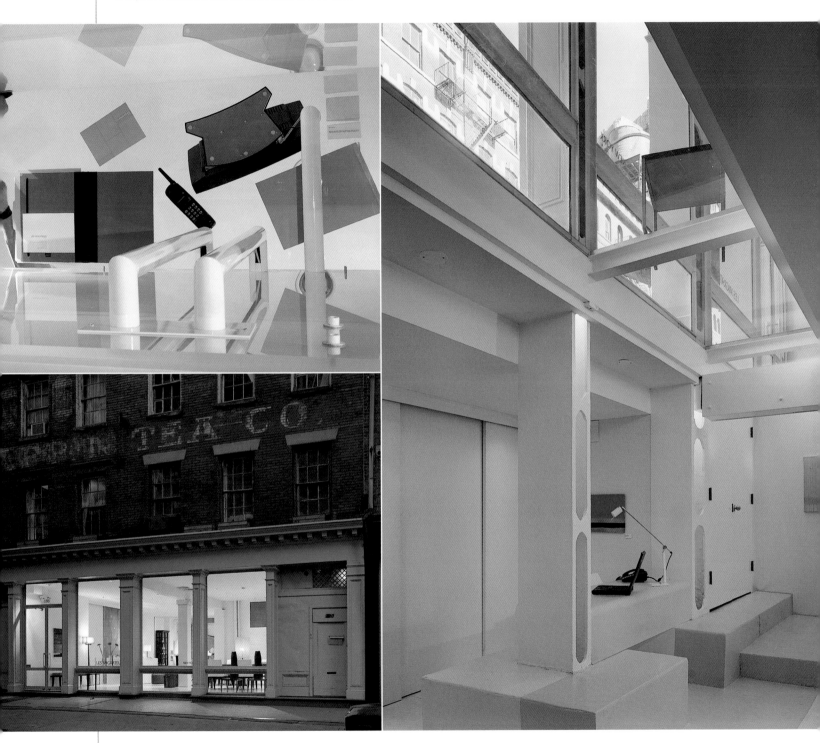

Slicing through a section of the ground floor close to the street opened a visual
connection between the two floors that allows daylight into the lower level.

The storefront's sumptuous hardwood frame and dark slate emphasize the natural element of the products on sale and reinforce the brand imagery.

SERVICE STORES

Stores that offer services—such as jewelers, watch-makers, and electrical stores—are largely something of the past as most consumer goods are designed with built-in obsolescence. However, a new kind of service store is beginning to appear on the market that offers personalized service in contrast to the anonymity of the mall or supermarket.

One area of service is in the promotion of well-being—fast becoming a growth industry. Witness the rise of health spas, fitness clubs, and the new breed of nail salons with their stylish interiors. Realizing that this potential market is just beginning to be tapped, clubs, spas, and salons are capitalizing on their reputations and selling their own brands of beauty and health products to already loyal customers, who are enticed first by the service aspect and then by the ability to bring the spa into their own home. With the added benefit of being able to try out the product through professional treatment, the customer is already convinced of the product's qualities.

With the rise of the popularity of the spa, it made marketing sense for the company Canyon Ranch, which runs a successful range of spas and complementary treatments, to expand into health and beauty products. The store became an extension of the spa treatment, the design remaining consistent in its natural materials and the pale, fresh color scheme that suggests the natural and the great outdoors.

Selling service-related products can help sell the service itself. This approach can be extremely profitable, as in the case of John Frieda and Vidal Sassoon hairdressing salons, where a large percentage of overall income is the result of product sales.

A different type of service is the attention to customer care. This has been the mainstay of L.L. Bean, established in 1911 as a mail-order company. L.L. Bean now has four stores in the U. S. and outlets in Japan. Customer satisfaction is paramount to the company, which has a liberal returns policy unrivaled by most of the market.

"Vidal put the head on fashion. It was just right.
It was like architecture—just fantastic." Mary Quant

VIDAL SASSOON, MANCHESTER, UK
ASSOCIATION OF IDEAS, LONDON, UK

This quote from the doyenne of Beatnik fashion and makeup summarizes Vidal Sassoon's revolutionary effect on hairdressing and the hair salon. Sassoon transformed the hairdressing salon from the out-moded lilac boudoir of the 1970s to a showroom for the creative art of cutting hair. The salon would never be the same.

"Straight lines, maximize the space, minimize fussiness, and complement the curve." This maxim, used by Vidal Sassoon in the 1970s to describe his approach to hairstyling, is a fitting description of the latest design, by Association of Ideas (AOI), for the Vidal Sassoon salon in Manchester, England. One of only twenty-six Vidal Sassoon salons worldwide, it is one of the largest in the United Kingdom. All the salons are fully managed by the British-born hairdresser.

Phillip Rogers, the managing director of Vidal Sassoon, describes how the design meets the requirements of both clients and staff: "To create a definitive style and timeless modernity was very important to us, and the salon really does have a soft, adaptable feel to it."

The brief was for a hairdressing salon with an integrated school to accommodate forty seats for clients and approximately sixty staff. Located in an exclusive retail street in Manchester City Centre, the salon is divided into two distinct zones, the public and the private. The public space comprises a reception area, a product retail display section, a client waiting area, and forty styling positions distributed over two floors. To achieve the best conditions for cutting hair, the design demanded complex technical and

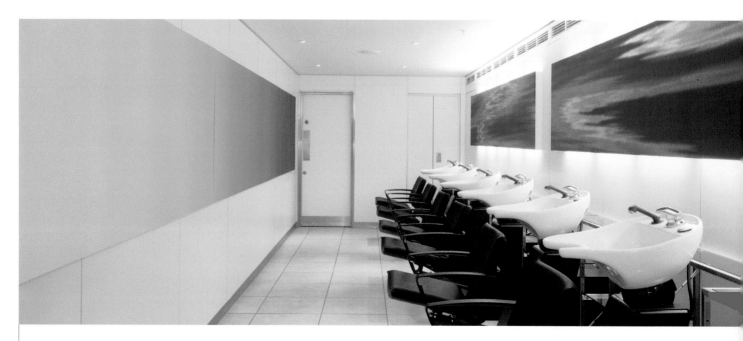

The overall look of the salon is clinical but inviting.

The Colorflow lighting system, installed in the central stairwell, is controlled by an easily programmable remote system. The extensive range of lighting generates spectacular effects, from rainbows to dramatic blocks of shifting hues, adding a subtle lighting effect that contributes to the relaxed environment.

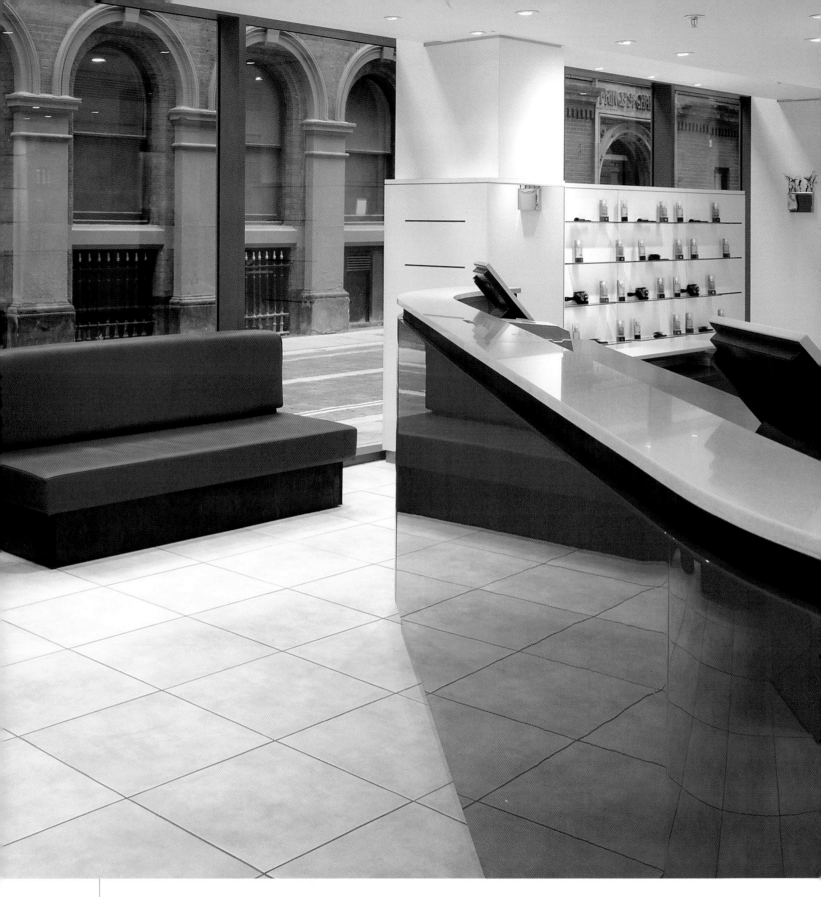

The focus of the design is the high-gloss polyester lacquer reception desk constructed on a mixed wooden fiber substrate, which is illuminated at night and provides a focus point for customers viewing from the street. The salon is situated on a prestigious retail street; its neighbors include the fashion stores Armani, Joseph, and the exclusive hi-fi store Bang & Olufson.

servicing requirements, particularly air conditioning and lighting. The private areas comprise a laundry, toilets, a staff room, a storage area, a service room, and a dispensary for color treatment preparation.

AOI focused on a series of design subheadings affecting the overall design: color and texture, flexibility, simplicity, low maintenance, meeting the client's needs, and the introduction of the curve. The reception area, at the entrance of the salon, is clearly defined by a curved desk finished in a strong red high-gloss polyester lacquer. The vibrant color of the desk is set against a palette of natural tones expressed in the Spanish porcelain floor tile and the natural subject matter—water and cherry blossom—of the digital prints hung throughout the salon. The curve assures an easy flow of traffic through the reception area. The central stairwell is illuminated by a large custom light panel that projects programmed lighting sequences of changing colors.

The principal requirement of the salon was a highly efficient and functional space. On a busy day, the salon can serve up to two hundred clients, yet, within twenty minutes, the space can be cleared to accommodate seminars or trainee fashion shows. With this amount of traffic, other important design considerations were durability of materials and low maintenance. Stone-finished countertops were specified because of their resistance to chemicals and white Thassos marble tiles in the bathrooms because of their durability. Vidal Sassoon has built its reputation by offering a cutting-edge hairdressing service and promotes the sales of its products in conjunction with its service.

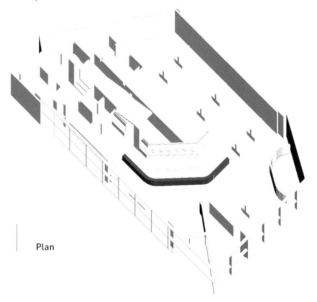

Plan

SELFRIDGES SPORTS HALL, LONDON, UK
GERARD TAYLOR DESIGN CONSULTANCY, LONDON, UK

It would not be an exaggeration to credit the renaissance of Selfridges, the department store on London's principal shopping street, to the vision of Vittorio Radice. In six years as chief executive of Selfridges, Radice has transformed the down-at-heel, tired-looking store to the most fashionable and financially successful department store in England and probably the rest of Europe. Selfridges London is a large store; at 540,000 square feet (50,000 square meters), it is almost three times the size of Harvey Nicols, the upmarket rival in Knightsbridge, London. Selfridges now has the largest cosmetic hall in Europe and twenty million customers.

Radice's makeover was instant. Even before the first new in-store designs were fully installed, Calvin Klein was checking them out, in anticipation of Radice's overhaul. International designers who previously would have considered doing business only with London's select department stores, Harvey Nichols and Harrods, did not want to miss out on Selfridges' resurgence. Radice's vision to completely overhaul the department store, from in-store design to a radical program of cultural events, was the key. During renovations, the building's façade was wrapped by a 98-foot (30-meter)-long photographic print commissioned by London's hip photographic artist, Sam Taylor Wood.

The Sports Hall, which sells everything from squash rackets to snowboards, sets itself apart as a service store within a large department store by offering a special repair department for its sports products.

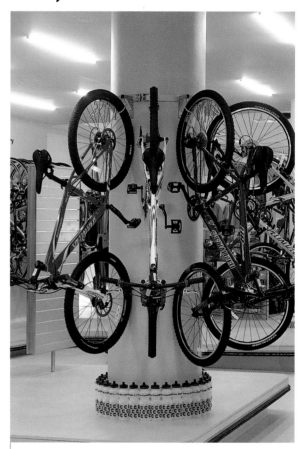

The acid yellow that defines the Cycle Surgery is a powerful, visually arresting color, and the bicycles are skillfully displayed in a space-saving manner. The whole space expresses a strong visual identity for the Cycle Surgery, where customers can purchase bicycles or take advantage of the repair service offered.

The Ocean Leisure section is identified by a deep ocean blue, featured on the walls in a high-lacquer paint and on the floors in a resin-coated finish.

When Gerard Taylor Design Consultancy was asked to redesign the Sports Hall floor for Selfridges, the challenge was to reinvent the retail typology already saturated with formulaic solutions at one end of the market and powerhouse retail theater at the other. The Sports Hall, which sells everything from squash rackets to snowboards, sets itself apart as a service store within a large department store by offering a special repair department for its sports products.

The Cycle Surgery offers a full bicycle-repair service that accompanies sales. Its signature environment is defined by an intense, acid-yellow décor. The bicycles hang elegantly from the two structural columns within the space. In the Racquet Shop, the design centers on a fluid, translucent plastic-molded form on which the rackets are displayed, suggesting the actions of tennis and other racket sports.

Such is the rapid turnaround of sports products that a lifespan of just four years was anticipated for the design. The brief was "to design a substantial environment within a limited budget," says Gerard Taylor, who met the budget with inexpensive materials that would last no longer than the intended four years. Products zones were delineated by means of strong color and forms that suggest the movement and energy of sports.

The demanding brief to mix independent specialists such as the Cycle Surgery and Wigmore Tennis with dominant international brands such as Nike and Adidas was executed by means of gentle zoning of the space and by allowing the products to express the design language. The display of the tennis rackets creates a sweeping form, adding to the dynamic displays.

Other challenges were how to combine sports with different flash levels, such as fishing and swimming, and small, cutting-edge brands with established sportswear. Creating a design language that allowed the product to take center stage produced a dynamic environment in which no one brand swamps the others. In fact, the rich mix of types and brands forms a diverse and quirky whole as well as offering service to the customers.

A close-up axonometric demonstrates display techniques and changing room units.

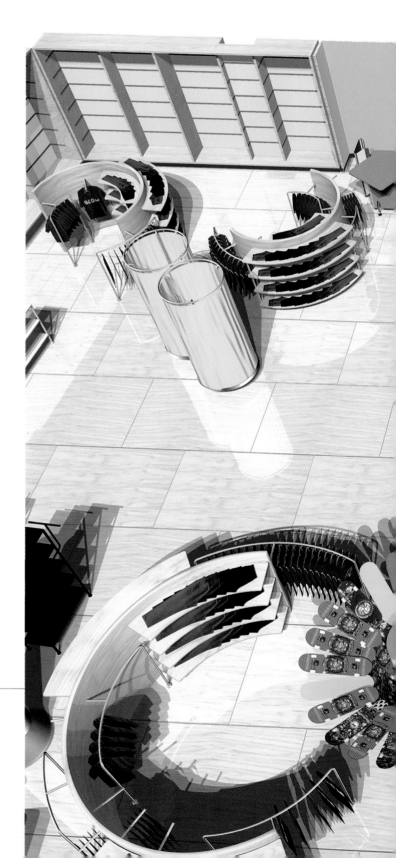

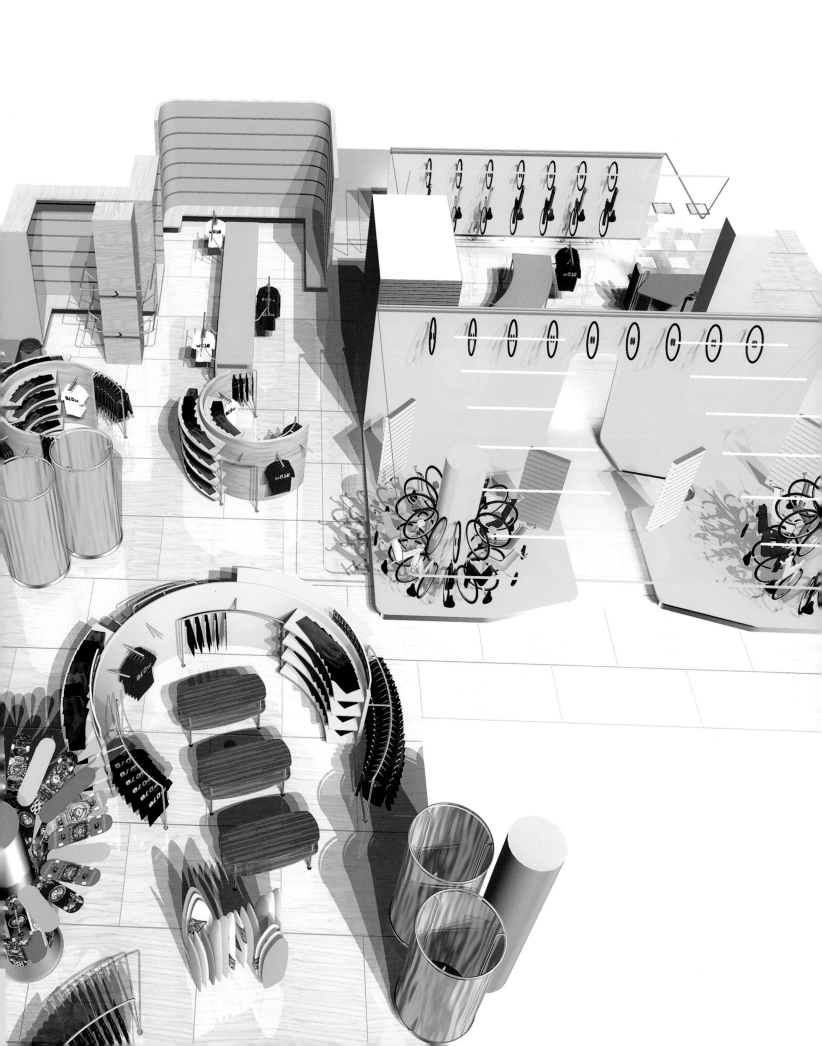

L.L. BEAN, FREEPORT, ME

Founded in 1912, L.L. Bean, which sells outdoor clothing and equipment, was one of the first mail-order catalog businesses established in America, and its reputation for high-quality products and service is international. Leon Leonwood Bean set out the premise by which he ran his business: "I do not consider a sale complete until goods are worn out and customer still satisfied."

An avid outdoorsman, Bean decided he could improve on the typical hunting shoe by stitching a pair of waterproof shoe rubbers to leather tops crafted by a local cobbler. After field-testing them in the fall of 1911, Bean sold 100 pairs the following spring. To each pair sold he attached a tag guaranteeing 100 percent satisfaction. Within weeks, the shoes began coming back. Ninety pairs were returned with the rubber bottoms separated from the tops. With a small loan, Bean quickly refined the shoe design, making it stronger and making good on his promise. He replaced the 90 pairs and in the process established a business and a guarantee that are still going strong.

Universally known as the industry leader in personalized service, L.L. Bean's customer-satisfaction representatives are available 24 hours a day, 365 days a year. Phone orders account for approximately 76 percent of all catalog orders. The products offered are listed in 80 separate catalogs representing the 16,000 items on offer. To give an idea of the amount of customer response, 227 million catalogs were distributed in 2001. When competition is tough, high-quality service can be a real edge.

To aid in the distribution of products, in 1996 L.L. Bean opened a 650,000-square-foot (60,387-square-meter) order-fulfillment center in Freeport, Maine. The state-of-the-art distribution facility, 1/4 mile (0.4 kilometer) long, has the capacity to process 27 million items per year. It houses 3 1/2 miles (5.6 kilometers) of conveyor belts and twenty-five shipping docks.

L.L. Bean introduced business-to-business operations in the 1970s. The corporate sales department was created to meet the demands of corporate customers seeking high-quality products to use as premiums, incentives, uniforms, and other high-volume purposes.

The L.L. Bean flagship store occupies the site of the original Freeport, Maine, store, which opened in 1917. A staggering three million visitors experience this store each year. The store has grown over the last ninety years with a variety of architects responsible

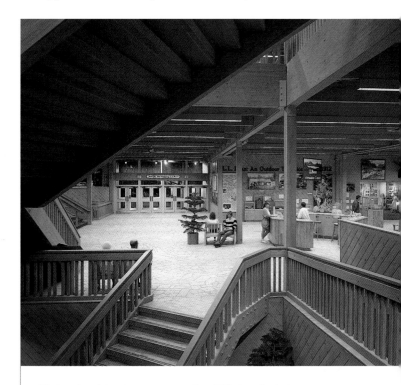

The interior of the store represents the middle America look, with sections of solid pine timber and park benches. A small exhibit charts the history of the company.

for the extensions. Nearby is L.L. Kids, a separate store that incorporates children's products with outdoor activities specially designed to make children happy. By creating an adventure park theme combined with the retailing aspect, the store appeals to children as a venue for a fun day out. A two-story waterfall, complete with trout pool, a Trail of Discovery that includes a rock-climbing wall, an interactive mountain bike test, and a hiking trail for testing hiking shoes mean that kids won't get bored.

On July 28, 2000, the company opened its first store outside of Maine in McLean, Virginia. The 75,000-square-foot (7,000-square-meter) store features a 16-foot (5 meter) indoor waterfall that drops two stories into a trout pond. On May 4, 2001, L.L. Bean opened a 30,000-square-foot (2,800-square-meter) store in Columbia, Maryland, completing its out-of-Maine expansion. All stores repeat similar design principles, which is to let in as much natural light as possible, normally through the introduction of a clearstory into the entrance area, wood cladding used throughout to emulate the outdoors, and the introduction of a natural feature such as fish pond or waterfall.

Approximately three hundred products are made by L.L. Bean's own manufacturing division in Brunswick, Maine. The classic L.L. Bean boot and tote bag are still manufactured on the premises, as are fleece blankets, sleepwear, dog beds, fleece outerwear, and soft luggage. The manufacturing division is responsible for the repair and reconditioning of the classic L.L. Bean boot; more than 9,000 boots were repaired for customers in 2001.

In 1996, L.L. Bean added electronic home shopping to its Web site, where customers can view the full product selection online. As part of the company's ongoing commitment to conservation of the countryside, a section titled Explore the Outdoors offers tips and information on fitness, biking, responsible hiking, and L.L. Bean's Outdoor Discovery Schools. L.L. Bean also continues to expand into the international market. Products can be ordered in over 140 countries worldwide via the catalog, and, in 2002, the company expanded into the Japanese market with nine stores, its first expansion outside of the U.S.

The Freeport store is set in a landscaped plot. Its artificial waterfalls and footbridges reflect the outdoor orientation of the merchandise. The quality of the merchandise, its competitive prices, and relaxed atmosphere of the stores mean that the product is made as accessible as possible.

Embracing Leon Leonwood Bean's desire to please his customers, all of L.L. Bean's stores feature as much natural light as possible and products are displayed to allow for close inspection.

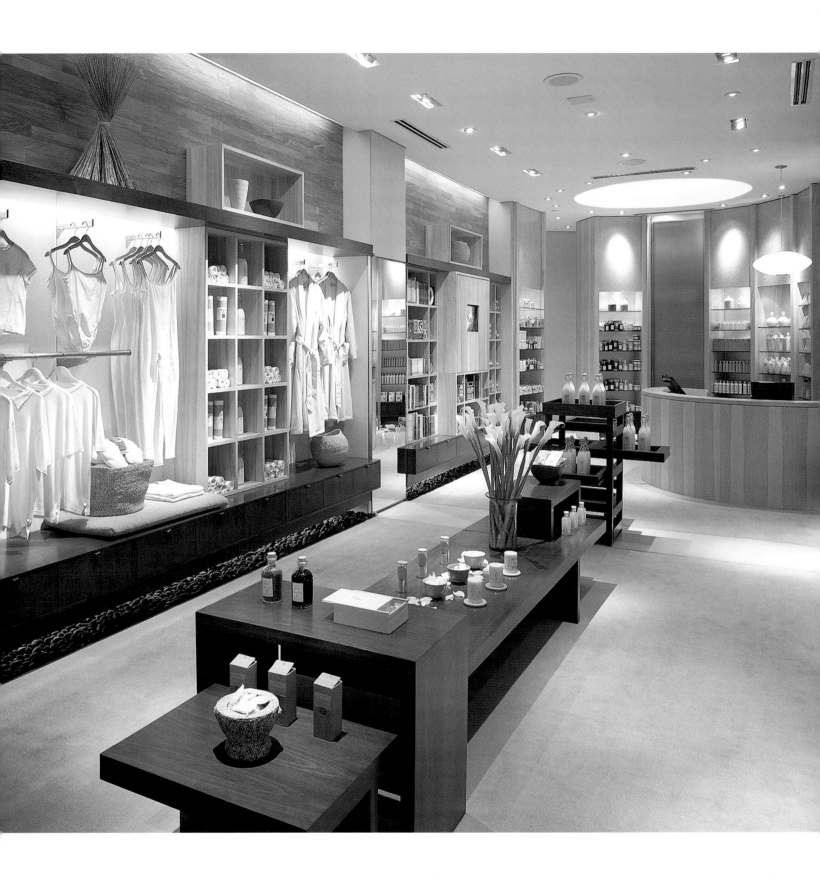

CANYON RANCH'S LIVING ESSENTIALS, LAS VEGAS, NV

MOVK, NEW YORK, NY

Canyon Ranch Spa Club's decision to expand into the retail sector from being purely a service provider was fueled by the strength of the brand in the company's established spa section. The flagship health-and-beauty boutique store, Living Essentials, opened at the Grand Canal Shops at the Venetian Resort in Las Vegas as a companion to the spa and fitness center.

"We saw an opportunity to expose our brand through retail," says Gary Milner, Canyon Ranch project director for Living Essentials. "Las Vegas brings in a lot of foot traffic and exposure to potential clients. We just reacted to a prime retail opportunity." The 1,200-square-foot (111.5-square-meter) boutique offers Canyon Ranch beauty and health products and educational tools that reflect the philosophy of the Spa Club while simultaneously creating a brand of its own. "We laid out a very brief vision of the project, and the design team came in and created an entire brand. We bought the entire concept and are now in the process of applying the brand to the entire corporation," says Milner. The creation of the holistic brand covered retail display units and packaging branding.

MOVK, the New York–based architecture and design firm chosen for the project, knew that the retail outlet needed a strong brand identity to succeed in the highly competitive market for well-being and beauty products. Mark Oller, AIA, principal of MOVK, describes the consultancy's approach to the design: "We wanted to act on the spa's holistic approach to wellness. A botanical motif emerged as an etched abstraction of an aloe plant, known for its restorative and healing properties. We developed it as a simple icon that was reinforced in the packaging and brand products." This simple design approach—identifying a recognizable natural primary source and repeating it in the styling of the boutique—became a winning feature.

"We wanted to speak through simplicity with a juxtaposition of sensuality and tactile feeling and respect the horizon line of the desert. We wanted the simplicity of the store to be antithetical to the glitzy glamour of Las Vegas."
Mark Oller, AIA, principle of MOVK

The desert reference appears in the design's use of natural colors and the linearity of the interior. The cabinets appear to hover above dry river pebbles that imply a continuation of space beyond the store's boundaries. All the design features add to the orientation of well-being promoted by the products.

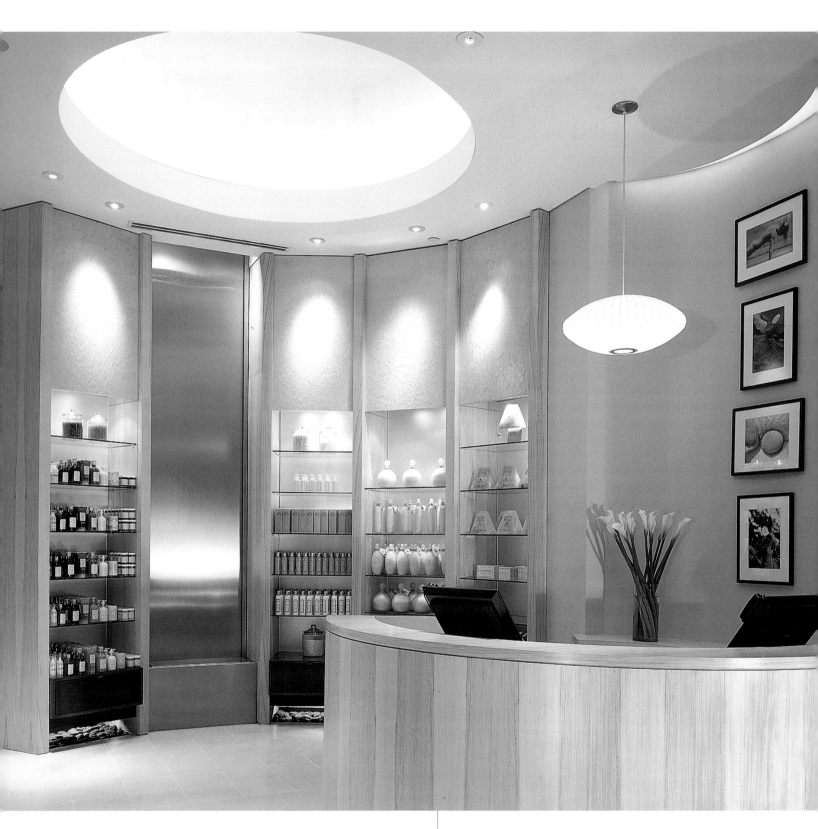

The water feature enhances the calming atmosphere and accentuates the natural elements of the design. The circular dome adds an unusual quality to the lighting of the store.

From the highly themed environment of Las Vegas, known for its visual extravaganza of styles and entertainment, emerged the restrained simulation of the desert manifested in the design of the store—the antithesis of the city's assault on the senses. "We wanted to speak through simplicity with a juxtaposition of sensuality and tactile feeling and respect the horizon line of the desert at the same time," Oller says. "We used the desert as a metaphor for balance and life. We wanted the simplicity of the store to be antithetical to the glitzy glamour of Las Vegas." The desert references are reflected in the emphasis on horizontal planes; the display areas run the length of the store above a bed of softly lit river stones that outline the floor. A combination of light and dark woods make up the high-quality cabinetry and interior paneling.

The lighting of the store creates a tranquil and relaxed setting. Japanese lanterns decorate the fitting rooms. Oller describes the lighting concept for the store: "The lighting had to be subtle because it essentially evokes the brand's calming, spiritual aspects, which we wanted the store to also emit."

To add to the calmness and Zen-like atmosphere, a paneled wall containing a 13-foot (4-meter) waterfall was placed at the rear of the store to entice the customer through the environment. The area is centered below a lit dome in the ceiling that points to this focal feature.

A team of specialists created the custom store cabinetry. Oak paneling contrasts boldly with the cedar of the cabinets.

SHOPPING AND THE MASS MARKET

In response to standardization and globalization, mass-market consumer forecasters have to work hard to predict the taste of a large section of consumers and to appeal to the common denominator—at the same time attracting new customers and providing inspiring retail spaces. The design challenge is often to resolve competing needs to display both mass-market products and unique items in the more exclusive lines.

Habitat, the British home furnishings store established in the 1960s, is a good example of this effort to predict as well as influence popular taste. With its history of introducing the basics of good contemporary design from the salad bowl to Noguchi pendant lights, Habitat can be partly credited for introducing the British public to modern design. Habitat's method of display, which involves stacking small products on shelves to encourage customers to handle the products combined with styled room settings, provides an "at home" look to inspire the customer.

Architects and designers are increasingly aware of marketing trends and introduce these strategies into store designs. In-store advertising and product placement are integral to the psychology of shopping and, therefore, to the design and floor plan. In the case of the American shoe store Keds, a set of design guidelines was produced and applied to each retail outlet to maintain retail consistency. Chute Gerdeman, the designer of Keds and winner of many retail awards, worked closely with the marketing department to ensure that advertising, graphics, and packaging were part of the overall design scheme.

IKEA global success in the mass market is founded on providing products and furniture at competitive market prices. Due to the company philosophy of producing flat-packed products, storage, transport and assembly costs are hugely reduced. Although customers may complain of shopping fatigue after walking the labyrinths of an IKEA warehouse, then battling with the instructions for the do-it-yourself home assembly, there are few competitors to rival IKEA's prices. IKEA's strong identity is communicated through the use of the yellow and blue of the Swedish flag, represented in the company's logo. Design features within the store are minimal; instead, a series of room settings re-create the domestic environment.

A consistent design plan in each of the Keds retail outlets, including contemporary graphics and advertising, helps to build brand identity.

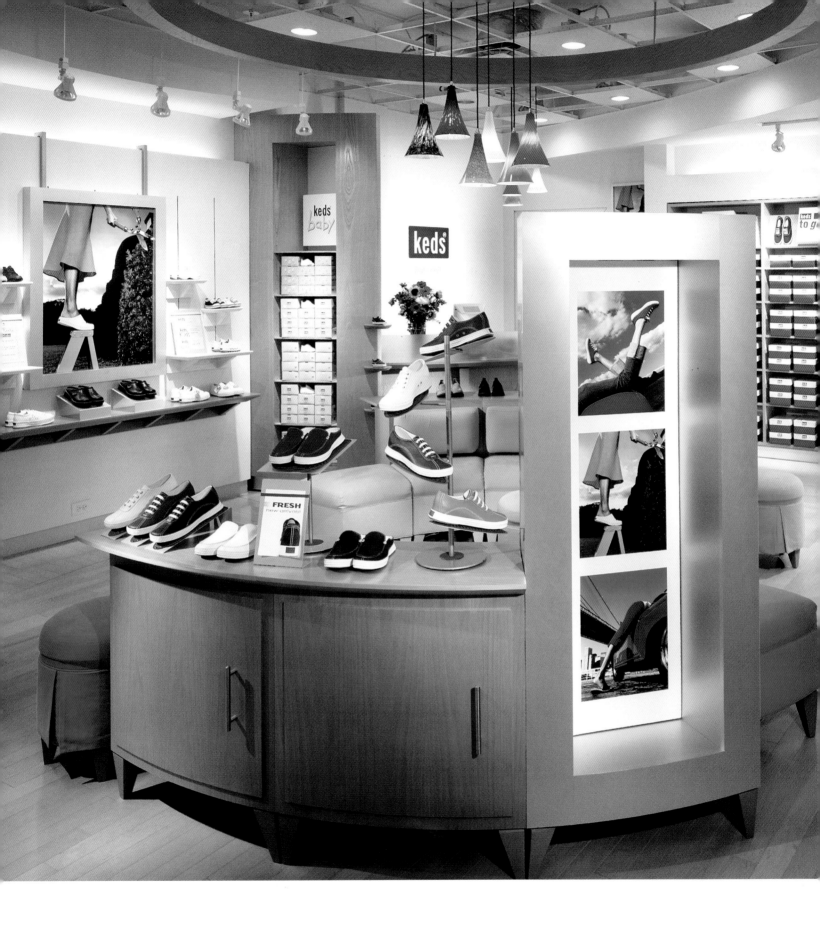

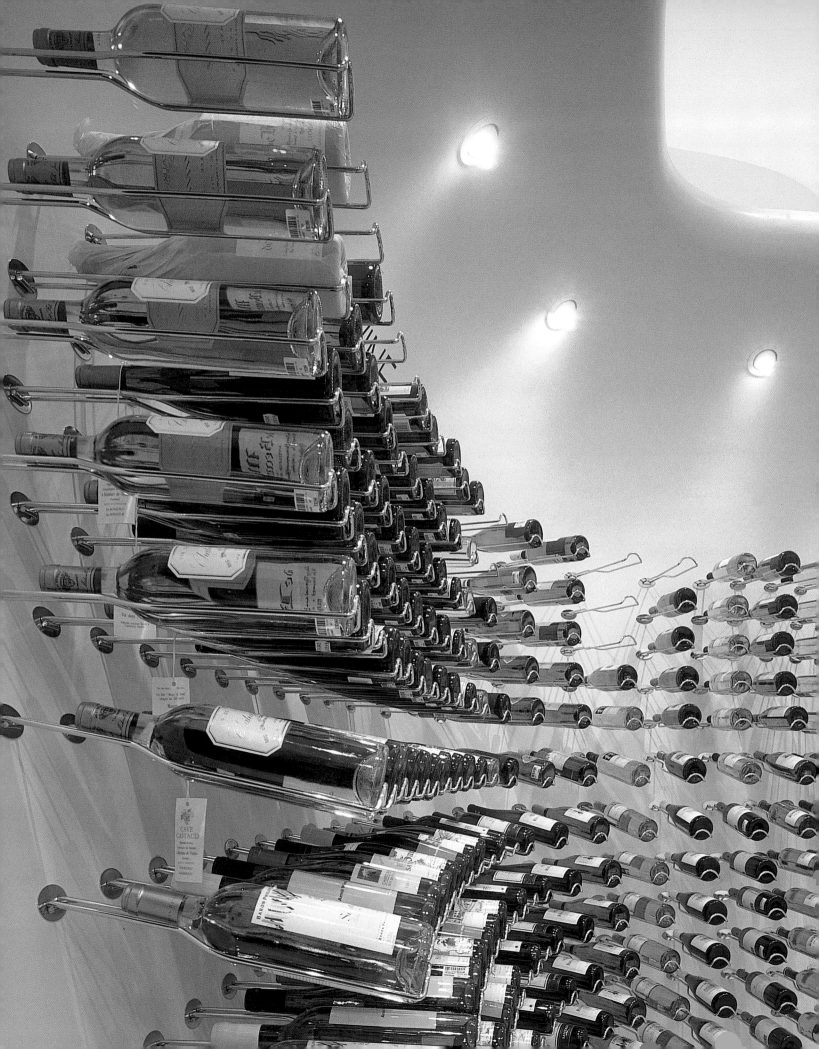

SELFRIDGES FOOD HALL, MANCHESTER, UK
FUTURE SYSTEMS, LONDON, UK

As chief executive of Selfridges, the London-based department store, Vittorio Radice invited Future Systems to design the Food Hall at the Manchester Selfridges. The designers began by looking at the traditional market, an intrinsic part of urban living and a social place where shopping is intermingled with social eating and drinking. This is in contrast to the supermarket, which offers a rapid route through monotonous aisles. The design successfully combines the familiarity of the market stall with a futuristic design language.

Jan Kaplicky founded Future Systems in 1979 and was joined ten years later by his partner and wife, Amanda Levete. The practice won the prestigious Stirling Prize and international recognition for its design of the NatWest Media Centre, an organic, semimonocoque structure that forms a cantilevered viewing platform over Lord's, the famous English cricket ground.

Future Systems' design ethos combines organic architecture with soft lines and poetry. "We attempt to marry the organism of nature with modern technology," states Jan Kaplicky. In this way, the structural form of the fruit and vegetable counter was inspired by a droplet of water. The free-form structures are arranged around the escalators and form the high point in the space from which a series of ripples emanates in the form of smaller counters.

Eateries, refrigerated counters, and display units are all given soft sculptural forms; circulation patterns are diverse. The display counters are finished in a high-gloss surface in neutral colors to emphasize the colors of the products. Around the perimeter, a sinuous, sculpted wall dramatically displays a myriad of products. A radial array of lights in the ceiling reinforces the curvilinear form.

The Food Hall uses a bold and abstract language that breaks from the conventional food counters. This contemporary design has broad appeal and creates an experimental landscape from which customers can enjoy both familiar and unfamiliar foods and wine.

"We attempt to marry the organism of nature with modern technology."
Jan Kaplicky, principal, Future Systems

The bottle display walls are made from Corian sheets with recessed spotlights. The advantage of Corian, which is made from aluminum waste, is its hard-wearing appeal that can be filled if damaged.

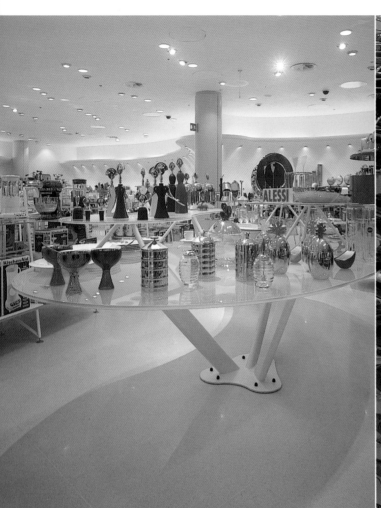

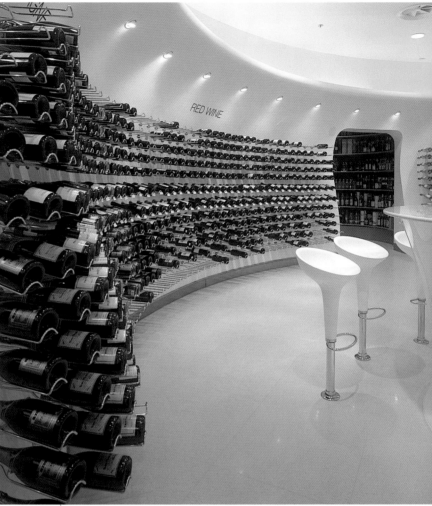

The display table for Alessi picks up on the humor and color inherent in the design of Alessi products.

Customers can sample wines at the bar area before buying, helping to re-create the market atmosphere where customers can sample products before buying.

The counters form sinuous curves that mirror the shelf display to the rear.

"Design as democracy." Sir Terence Conran, Habitat founder

HABITAT, HAMBURG, GERMANY
GERARD TAYLOR DESIGN CONSULTANCY, LONDON,UK

The history of Habitat, the home furnishings store, goes back to 1964 and founder Sir Terence Conran, who aimed simply "to ensure that every household in Britain owned a decent salad bowl." Although society was in the midst of the swinging sixties, the consumer market was very different, with choices largely limited to the offerings of department stores. Conran fought against this with his philosophy of "design as democracy." The range of products offered in his growing chain of stores reflected its goal of bringing affordable and high-quality products to the average consumer. From vernacular to designer products, Habitat sold everything from Provençal chicken casserole dishes to Lucienne Day textiles.

Over time, however, Habitat began to lose direction, and Vittorio Radice was brought in to develop a much-needed, revamped design strategy, which involved introducing brand consistency from the furniture to the accessory range. A master of design promotion, Radice has gone on to head one of Britain's success stories, Selfridges, a deteriorating department store he turned around with a progressive architectural program.

Habitat, with a chain of stores from Glasgow to Lisbon, hired Gerard Taylor Design Consultancy to carry out the design of a new store in Hamburg, Germany. The design firm was already familiar with the Habitat agenda after designing one of Habitat's British stores. The consultancy has completed a range of inspiring retail spaces that display an imaginative attention to detail in the execution of the concept.

In approaching the design of the Habitat store, Gerard Taylor, the principal of the design firm, took the view that "the product was the hero." Incorporating this dictum with the history of the Habitat store became the challenge. When Habitat was created, the design

formula was "stack them high, sell them cheap." Taylor added to such storage areas within the store to allow "a new visibility for the individual design object." The architecture introduces a processional division between object display areas—where individual products occupy plinths—and open shelving, where stacks of competitively priced objects are displayed.

To allow the interior to be read easily, which provides the customer with information as to where each department is located, Taylor decided to create a strong visual language for the functional zones within the store. This was achieved by denoting the cash desk and circulation zones with a strong primary red. The same principle was applied to separate the ground and basement floors, which are divided by the circulation staircase. The basement and principal floor furniture items are colored sand to match the concrete flooring. The staircases are designed as

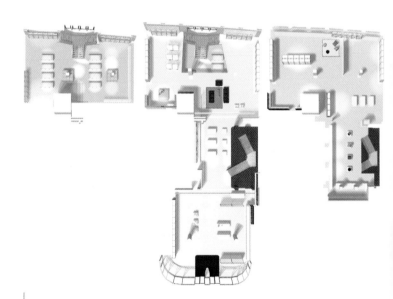

Above: The floor plan clearly expresses the elements of the scheme: a neutral palette to showcase the products, with zoned areas for transactions and circulation, articulated in primary red. Zones are labeled eat, cook, sleep, party, store/work so that customers can clearly identify each zone. **Opposite:** The staircases have galvanized treads that stand up to heavy use.

An abstract perspective shows the effect of the glowing linear fluorescent against the red hues of the staircase and cash register.

pronounced, solid space dividers. Both stairs are steel and clad in MDF, which is painted in the color of the adjacent floor. The stair treads are individualized, industrial galvanized and textured box sections. The balustrades, which line the openings from the ground level to the basement, are made of structural glass fixed within the plaster bulkhead to create a visual transparency.

The signage veers away from the conventional graphics of department stores and, instead, uses verbs to indicate product categories. For example, home furnishings are labeled laben, which means "live," with subtitles meaning "sit, relax." The London-based

design studio Graphic Thought Facility, which works closely with Habitat on printed communication and the annual catalog, collaborated with the architects to integrate the site-specific signage with the architecture.

Taylor's store design works to unite the crucial elements of the Habitat brand—the intensive cycle of seasonal collections, basic design classics, and pressworthy concept products. The design of the midmarket store, along with careful placement of products, has begun to blur the aesthetic boundary with the high-end furnishing stores and to distinguish itself apart from its direct competitors.

The main interior offers two display strategies: one draws out the principal pieces from the Habitat collection and displays them gallery style on plinths, and the other relates to the original display strategy where smaller products, such as kitchenware, are stacked on open shelves in multiples.

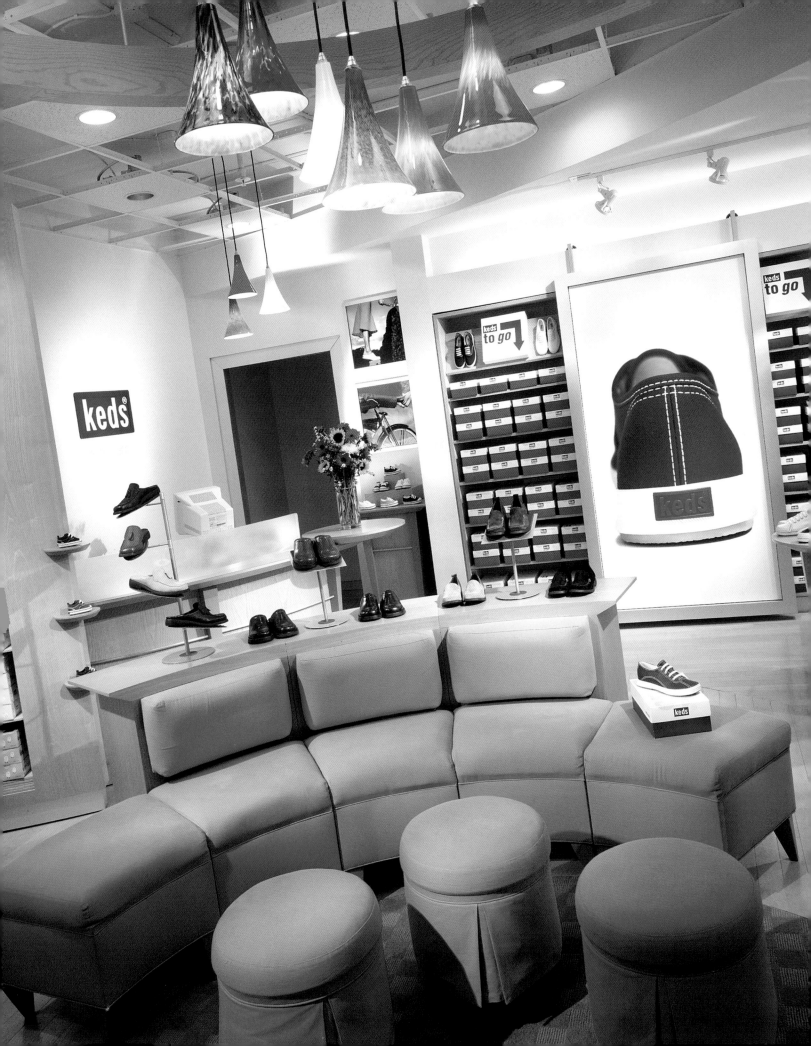

> "The Keds stores are a great opportunity to provide customers with a complete representation of the brand." Dan Friedman, Keds' president

KEDS, U.S.
CHUTE GERDEMAN, INC., COLUMBUS, OH

As part of a new direction in corporate strategy, Keds, the sneaker company, decided to expand its appeal to the younger customer. Chute Gerdeman, the retail consultant, was commissioned to design Keds' first retail store and, subsequently, a chain of stores in shopping malls in Georgia and Florida. The goal was to design a store that focused on comfort. "Keds has always been a strong lifestyle brand," says Lee Peteron, who led the design project. "Chute Gerdeman took the essence and emotion of Keds' updated brand and translated it into a truly classic

retail environment. It's crisp, clean, and contemporary without losing what the brand has meant over the years." Bright colors and a relaxed atmosphere with informal seating appeal to the younger customer.

Chute Gerdeman, founded in 1989, has a strong track record in retail design; among its many clients are Macy's, Wal-Mart, Red Lobster, and Eddie Bauer. Chute Gerdeman also designs for alternative retailing sites such as hotels, airports, and sports stadiums.

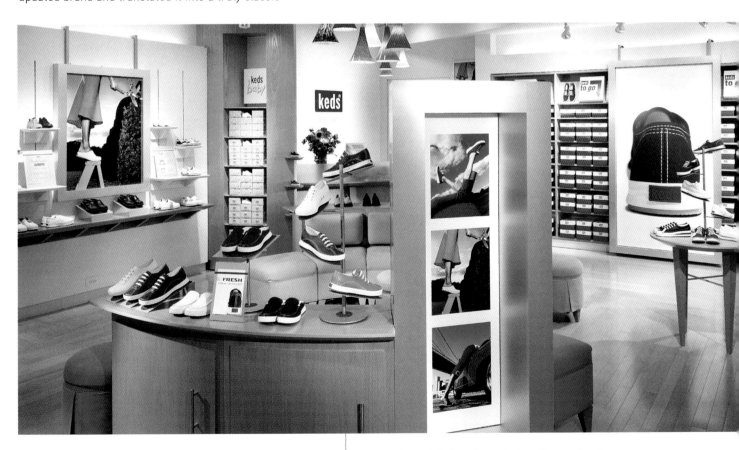

Poster-sized images of the product, which tie in with the advertising campaign, are used in the store's interior to reinforce the brand image. All stock is kept on the shop floor in shelving units behind the sliding poster wall.

The seating and display units are designed in curved sections to allow flexibility of use and configuration at the varying sites.

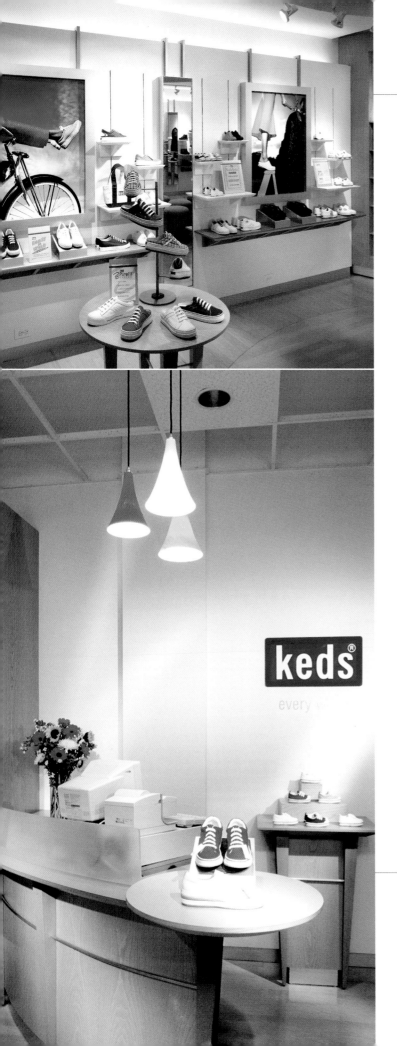

The secondary screen acts as a structural wall from which the shelving and vertical sliding display levels are cantilevered.

"The Keds stores are a great opportunity to provide customers with a complete representation of the brand," said Dan Friedman, Keds' president. The initiative was backed by a new direction in a defining media and print campaign by Toth Brand Imaging of Concord, Massachusetts. Large-scale prints of the products were featured in the print campaign, and photographs from the campaign were used to reinforce the brand in the stores and to connect the product to the print advertisements.

Strong, identifiable design features are part of every Keds store. The shop front is fitted with white canvas awnings that reinforce the fresh, sporty image of the product. The Keds' vulcanized rubber logo, featured on the shoes, is mounted at the right side of the store entrance, on the cash register shield, and on the interior of the seating areas. Flexibility is key to the overall design concept. Mobile and modular display and seating units allow many configurations of freestanding seating areas with interlocking display units.

Merchandise is displayed in clearly defined areas for distinct types of products. Deep, metal-veneered etagères at the store window display the new merchandise. These low-level displays allow passersby to look into the store. New footwear lines are displayed on the left-hand wall. The standardized use of nickel framing for the mirrors, graphic panels, and etagère shelving unifies the store's look. To demarcate the central seating area, a light-colored, wood-veneered ring and colorful glass pendant lights hang from the ceiling.

The soft wood and stainless steel support details are reproduced throughout the store.

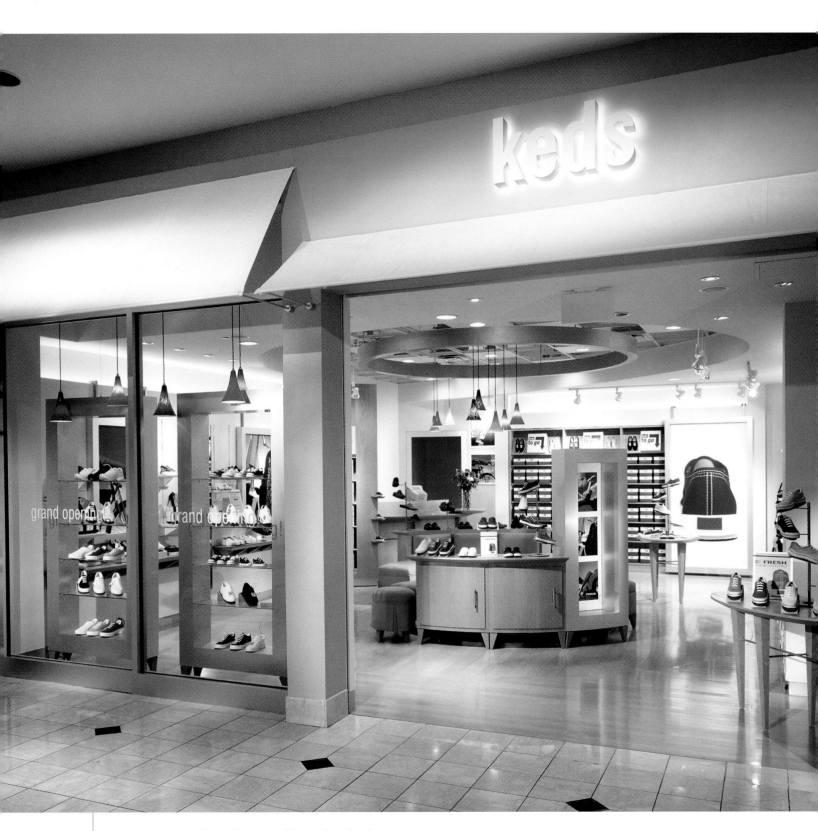

The store design for Keds is designed to fit in a variety of mall retail outlets. The recognizable design features are the white canvas awning, fresh blue palette, and generous open format with visibility through the glass façade into the store's interior.

IKEA, SWEDEN

IKEA's ability to combine low-cost furniture with designs that reflect current trends in the contemporary furniture market has contributed to making it one of the most successful furniture retail stores in the world. It is no coincidence that the IKEA logo carries the colors of the Swedish flag. IKEA, founded in Stockholm, offers products that reflect the design qualities often associated with Sweden, including an emphasis on natural materials and the use of bright colors to counteract the long Nordic winters. IKEA stores, found from Shanghai to Berlin, offer a complete range of home and office furnishings as well as free home-furnishing advice. Usually built on the outskirts of cities, IKEA stores consist of a basic architectural shed structure clad in the corporate colors.

IKEA's strong identity is communicated through the use of the yellow and blue of the Swedish flag, represented in the company's logo. Design features within the store are minimal; instead, a series of room settings re-create the domestic environment. Principally, IKEA's success is founded on providing products and furniture at below-market prices.

To help customers think of shopping at IKEA as a fun day out for the family, the stores emphasize entertainment for children. Playrooms full of multicolored, interactive toys are situated near the entrance to the store. Each store also has its own restaurant that offers traditional Swedish foods such as meatballs, lingonberries, salmon, and pastries. To keep prices down, most of the stores have few sales-people; instead, customers are encouraged to come prepared with their required furniture dimensions and to pick up a set of "shopping tools," comprising a pencil, notepaper, measuring tape, and a yellow shopping bag for carrying smaller purchases. Customers are urged to clamber over the products to fully test them before purchasing. Everything in the store has a price tag listing comprehensive information about size, color, craftsmanship, measurements features, and care of the product.

Each store features a clearly marked trail that leads customers through a progression of departments. The first stop is the showroom, where room sets, from kitchens to children's bedrooms, are displayed. Second on the trail is the Market Hall, which features a plethora of household items including home office equipment, dishware, and bed linens. The last section is the self-serve area, where bulky items are stored flat on warehouse shelving units. Here, customers select items to be assembled at home, carrying on the time-honored tradition of doing it yourself. The trail is engineered so that customers will view all products from the full-scale room sets to the kitchenware and general accessories.

IKEA was founded in 1943 by Ingvar Kamprad in Stockholm, who showed early signs of the entrepreneurial gift when he started selling matches to neighbors from his bicycle. From matches, his merchandise expanded to include fish, Christmas decorations, seeds, and, later, ballpoint pens and pencils. At the age of seventeen, with a gift from his father, Ingvar launched IKEA (the initials of his name followed by EA, the first letters of Elmtaryd and Agunnaryd, the farm and village where he grew up). In 1945, the first IKEA ads appeared in local news papers, and Kamprad designed a makeshift catalog, distributing products locally from the county milk van.

In 1951, the first IKEA catalog carried furniture produced by a local Swedish manufacturer. The contemporary IKEA emerged with the discontinuation of the small product lines and the decision to establish

a low-priced furniture business. The first showroom opened in the early 1950s in Almhult, Sweden. For the first time, customers could see and touch the furniture before ordering. IKEA's main rivals did not appreciate the competition and pressured manufacturers to boycott the production of IKEA's goods. IKEA responded by designing and manufacturing its own low-cost furniture; by chance, an employee removed the legs of a table to fit it into the back of his car, which led to the realization that the flat-pack approach would revolutionize the transport of furniture.

In 1965, thousands of people thronged to the opening of the 493,000-square-foot (45,800 square meter) IKEA store in Stockholm. The store was designed with a circular concrete façade inspired by Frank Lloyd Wright's design for New York's Guggenheim Museum. When demand outstripped supply, it was decided to open the warehouse, in addition to the store to the public—a move that precipitated the concept of self-service.

IKEA opened its first shop outside Scandinavia in 1974 in Munich; since then, Germany has become its largest market. IKEA's expansion brought innovations in both design and manufacturing solutions. The result was continuing low prices that challenged the market. For example, the SKOPA plastic injection-molded chair was, after months of unprofitable searching, finally manufactured by a company that produced plastic buckets and bowls. Another example of unorthodox manufacturing is the matchup of a sofa design and a manufacturer of supermarket carts; the MOMENT sofa was designed by Niels Gammelgaard with a stainless steel base. A side table made with the same design principles won the Excellent Swedish Design Prize in 1985.

IKEA has grown from its humble beginnings to the largest furniture store in the world. Its strategy has been to bring low-cost contemporary furniture to the largest buying audience possible. One way of keeping prices low is the production of flat-pack furniture,

IKEA stores are always built on the outskirts of cities to keep costs down.

IKEA succeeds as a mass-market retailer because of its ability to manufacture at mass-market prices—due to large-production runs—in addition to the company's innovation in design.

which yields huge savings in storage and distribution. Another IKEA approach to minimizing costs and keeping prices low is to capitalize on, or appropriate, existing manufacturing techniques. For example, the KUBIST storage units were built with board-on-frame construction, a technique adapted from door manufacturing. Adapting the technique to create inexpensive and sturdy but lightweight storage units meant no outlay for product development. In this case, factories in Poland were retooled to make parts for the KUBIST products. The IKEA shopping experience has changed dramatically from its first architecturally designed showroom in Stockholm. To maintain low costs, IKEA sales outlets are built in out-of-town locations in standard industrial sheds branded with IKEA's blue and yellow.

IKEA succeeds as a mass-market retailer because of its ability to manufacture at mass-market prices—due to large-production runs—in addition to the company's innovation in design, thus enabling customers to buy current furniture trends at competitive prices. When shopping at IKEA, one is almost compelled to follow the pathway through the full range of room sets, each a variation on the theme of domesticity; the effect is much like following the path of super-market aisles. IKEA's shopping strategy is to attract the consumer—whether a single city dweller or a newly formed suburban family—who is setting up a new home. A trip to IKEA is pitched as a day-out experience where you can sample the delights of Swedish national cooking—just in case you forget IKEA's humble Swedish roots.

The corporate colors of IKEA, yellow and blue, are articulated in the façade design.

Consumers visiting the Tweeter Design Center are often amazed by how today's newest electronics are so unassuming. The components are nowhere to be seen. Conversely, components and speakers are visible in Tweeter's more traditional showroom space, which is also set in a living-room environment.

TWEETER DESIGN CENTER
TWEETER HOME ENTERTAINMENT GROUP, BRAINTREE, MA

Home electronics have become very popular. Yet many are so complex they can overwhelm the consumer, who would hands-down prefer in-home demonstrations of high-tech gadgetry so that they can see how it works in their home and have their questions fielded by someone with actually knows the answers.

Tweeter Home Entertainment Group understands this group and has come as close as they can to in-home demonstrations. Since home electronics aren't exactly as mobile as carpet swatches, Tweeter is doing the next best thing. They have created a store within a store-or better yet, a home within a store-where buyers can see how the product can be integrated into a home setting.

A Tweeter Design Center is a home within the store, complete with kitchen, bathroom, bedroom, living room, and billiard room that allows consumers to take a virtual tour of a home using Tweeter's Pronto system-a one button control system that operates the entire house. Sound complicated? It isn't. Tweeter provides all the macros so that this remote control easily operates everything in the home. Push "Play Movie" and the lights dim, the shades are drawn, and the DVD player begins playing the movie. Visitors tour the "home" and work one-on-one with an experienced salesperson. The initial meeting is followed by a visit to the buyer's home for a free consultation. From there, the salesperson is the liaiason between the buyer and the installation team, making the entire process hassle free.

The Tweeter Design Center debuted in Tweeter's flagship store in Braintree, Massachusetts, in 2001 and it occupies about 4,000 to 5,000 square feet (371.6 to 464.5 square meters). Most of the design was handled internally, but the group did consult with Dacon Construction of Massachusetts, who was retained as the builder.

"The biggest challenge was agreeing on a format and a style because there were a lot of different entities involved," remembers Anne-Marie Boucher, director of brand communications. Installers wanted to highlight how seamlessly they were able to integrate speakers into the wall, salespeople wanted to emphasize the product's sex appeal and sizzle, while corporate types wanted to focus on all these aspects.

"There was a lot of trial and error," says Boucher. "You compromise and work back and forth incorporating different opinions, concepts, and theories. Working with Dacon, we also developed a lot of 'what can we do' scenarios. In the end, they did a very good job. It went back on a drawing table a few times. But it came out beautiful."

The appeal of the Tweeter Design Center is that it invites consumers into a home to experience the equipment in a more intimate setting akin to what they have in their home. This store actually seats you on a comfortable couch to see how you like watching a 50-inch (127 cm) diagonal plasma TV above the fireplace. "The center creates environments that you couldn't necessarily describe as well as you can show them," says Boucher.

The big advantage is that prospective buyers can actually see how products will fit into their home relative to other furnishings. More importantly, they can see how easy these items are to hide. "Consumers, particularly men, used to buy the

Visitors to Tweeter's Design Center can often forget they are
in a retail store. The check-out register, however, is more
in keeping with the style of traditional retail outlets.

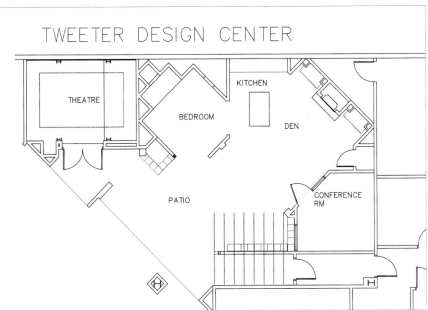

TWEETER DESIGN CENTER

THEATRE

KITCHEN

BEDROOM

DEN

PATIO

CONFERENCE
RM

An LCD screen is built into the bathroom mirror.
When the TV is off, there is no indication that a TV even
exists, which best exemplifies the trend toward hiding
electronic components.

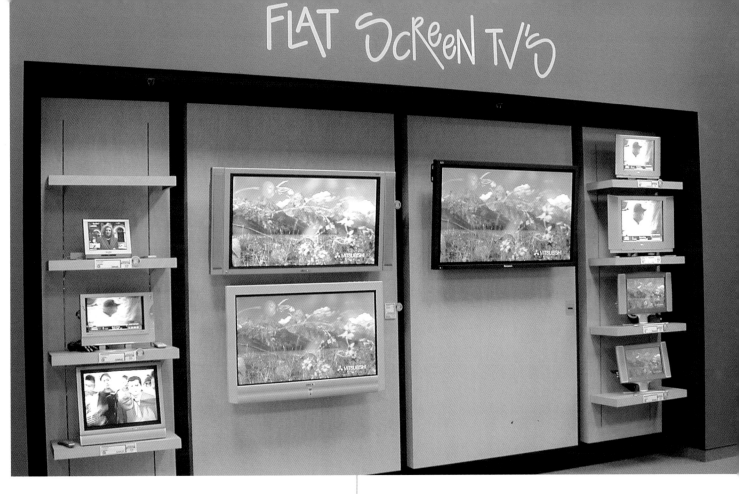

The Tweeter store also features more traditional merchandising systems, such as this display that features its flat screen TV offerings on one, uncluttered wall.

biggest speakers to show off how much money they spent, but now they are building them into the wall and hiding them with paint so that one gets only the visual or audio experience without seeing all the components," explains Boucher. "The trend is to hide everything for more appeal. Consumers don't want to see wires everywhere. We needed to show how easily these components are integrated into an existing environment."

The environment needed to be approachable for anybody, regardless of income or lifestyle choice. The solution was to make it contemporarily comfortable. "It is definitely contemporary, but not industrial modern," Boucher is quick to add. The decor had to appeal to a mainstream market, but that description can translate to boring. That's not the case with these interiors, which feature a brick fireplace, warm earth tones, a rich, sumptuous billiard room, and a bathroom adorned in warm yellows.

"It is purposely designed to be warm and comfortable without making a fashion statement. The equipment makes the fashion statement." That's why the focal point of the interior space is not an architectural element or furnishing, but the plasma TV hanging over the fireplace.

Tweeter Design Centers are presently in three Tweeter stores including one in Dallas, Texas, and another near San Diego, California. The other centers follow the same blueprint established with the Massachusetts location, but they are customized regionally to appeal to the popular decor and interiors of the local homeowners.

"The thing that differentiates Tweeter is our experienced sales staff. They have the knowledge to ascertain the customers' needs and to create a desire or translate a desire that exists into a solution. We use this space to articulate what can actually go into a customer's home."

APPLE STORE
APPLE COMPUTER, INC., PASADENA, CA

For years, Apple computers have been on the leading edge of design, taking risks that other high-tech companies shy away from. Remember the big splash Apple made when it ignored the then rule of only manufacturing computers in neutral beiges and grays, and instead, launched a line of personal computers in mouthwatering juicy purples, oranges, and greens-colors reminiscent of Lifesavers candies-to delight of thousands?

Well, Apple has done it again. Like Nike and other trend-setting manufacturers before it, Apple has introduced its own retail store that is, in itself, a mecca of entertainment sure to lure the younger demographic. Unlike other large electronic component retailers, Apple doesn't line up its merchandise on staid store shelves.

Walk into an Apple store and you walk into a world of all things Apple. Naturally, visitors are exposed to the entire line of Macintosh computers as well as an array of digital cameras, camcorders, and the entire iPod family. It's the place to learn and get your questions

answered, but while retailing is serious business, in this store, the accent is on fun.

The interior is open, airy, and spacious. Light wood tones and white walls reinforce this feeling of openness. Nothing appears to be cramped or crowded. Remember seeing people crowd around a computer screen while a particularly knowledgeable salesperson explained a software feature? Well, forget about the horde of people. At the Apple store, anyone wanting to see the latest software releases can visit the store's theater.

The theater offers free presentations on the latest products and solutions. Most evenings, buyers can see demonstrations on the latest Macintosh software presented by representatives from some of the biggest software titles, including Adobe, DiamondSoft, Final Draft, and MYOB. It is all part of the company's "Works on a Mac" series, one of several educational presentations, demonstrations, and workshops presented throughout the year-free of charge. Others series include "Made on a Mac," which features filmmakers, photographers, designers, and musicians discussing how they create their art using a Mac, along with a Business Solution series and more. The Apple Theater alone makes the Apple store a destination for families and teens.

While the theater is the place for special events and ongoing classes, other sections of the store are devoted to educating the entire family on what can be accomplished on a Mac.

The home section shows how easy it is to share the Internet among multiple computers at home. In the music department, consumers can burn their own CDs or load their Mac or MP3 player with their favorite songs. Kids can explore the latest educational software

The color palette throughout the store is kept to warm neutrals: warm white with warm, light wood tones. Punctuating this palette are unexpected bursts of color, such as this image in the music department.

and games in their own department while their parents are asking questions at the Genius Bar.

Anyone visiting the "pro" section of the store can learn how to make movies with Final Cut Pro or get the most from their DVD Studio Pro. They can also record, mix, and master their own CD. Want to improve your home movies? Then the movie department is where you want to be. Amateur and expert digital photographers will enjoy the photo department.

There's something for everyone at this destination store that shuns stainless steel, black and gray color palettes and ultra modern accessories-typically associated with high-tech electronics-in favor of something that feels more like home. Something everyone in the family can enjoy.

The photo department features all there is to know about digital photography in an intimate, almost officelike setting.

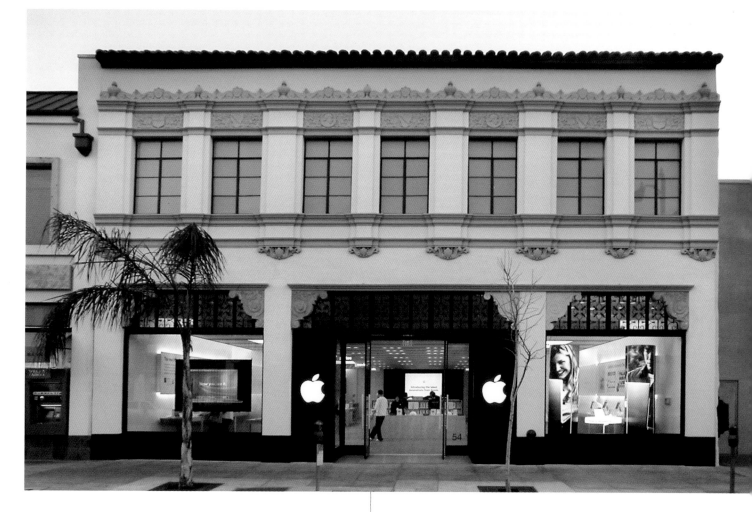

Large, expansive windows and an illuminated apple icon are trademarks of the Apple retail outlet. The Apple signage is visible from a distance and the large windows contribute to the open, airy feeling inside the store.

OUTSIDE CONVENTIONAL SHOPPING BOUNDARIES

Shopping as a leisurely pursuit is not a new phenomenon. In nineteenth-century Paris, the renowned poet Charles Baudelaire invented the name *le flâneur* to describe the gentleman indulging in a slow perusal of the city's newly designed glass-covered shopping arcades. Strolling and absorbing the city and the pleasure of shopping was a cultural event.

As lifestyles change and convenience becomes an important factor in people's lives, retailers strive to introduce new buying methods. Home computers have made e-retail a popular way to purchase goods —a useful addition to mail order and an alternative to weekly supermarket trips. New typologies of retail stores are beginning to appear that break from the standard codes found in conventional stores. Oki-Ni, for example, the joint British and Japanese retailer based on London's Bond Street with outlets in Japan and Leeds, offers limited-edition products such as snakeskin sneakers and has built a reputation for selling products that gain cult status. Oki-Ni has done away with the traditional in-store purchase. Instead, customers can view and try on the fashion apparel in the store, which has more in common with an art gallery than a clothes store, and then order the merchandise from the Oki-Ni Web site.

The peripatetic clothes designers Vexed Generation pitches its designs on an environmental and political agenda. This is reflected in the company's approach to retail. Vexed takes on short leases and completely revamps the venue to react to the principles of each design collection. This means finding a space that can be stripped down and refitted economically and quickly. The Vexed customer buys into the underground shopping culture where Vexed's credibility is spread via word of mouth rather than by any advertising campaigns.

Anatomical's unconventional approach has put a facelift on the old vending machines found in public toilets and clubs. The company introduced a zany collection of must-have beauty and health-rescue products dispensed from revamped vending machines. The vending machines have become stylish objects that enable an alternative form of retail where products can be bought at all hours, matching the customer's lifestyle.

On the other side of the scale to vending machines is the Fashion Show in Las Vegas, housing the highest concentration of leading fashion department stores in the United States. The store is a mecca to the fashion-orientated customer where, in addition to eight department stores, there is a plethora of small retail outlets. A professional facility also houses catwalk shows in the Grand Hall that are broadcast onto screens on the 600- by 120-foot (183- by 37-meter) plaza, which gives out onto the pedestrian walkway. The combination of entertainment and scale and the number of retail outlets in this neo-high-tech mall is unprecedented.

ANATOMICALS, LONDON, U.K.

MOSLEY MEETS WILCOX, LONDON, U.K.

The vending machine has now moved upmarket. The tired-looking machines that hung in school toilets or clubs with rusting façades choking on your change have been given a makeover. With backgrounds in advertising, Paul and Gary Marshall of London left their jobs to set up the company Anatomicals with the help of George Hammer, the man behind the Aveda cosmetic company. The company sells essential beauty products predominantly through vending machines—about which it is set to change consumer perception.

Anatomicals approached the design firm Mosley Meets Wilcox and asked designers Steve Mosley and Dominic Wilcox to design the machines and all branding merchandise to match. Mosley Meets Wilcox has worked on a diverse range of briefs including innovative custom packaging, furniture, interiors, and Internet sites. Their projects derive from a mixture of experimentation with materials and manufacturing processes, and their often unconventional approach to mass production leads to unique and distinctive products.

Anatomicals was Mosley Meets Wilcox's first collaborative, client-based brief. This included designing the packaging, the vending machine, the point-of-sale unit for nonvending machine products, and the Web site. From the outset, the goal was a loose identity inspired by the clean and often understated look of most pharmaceutical products mixed with a blend of tactile and sensual materials.

The packaging of Anatomicals products, for example, is made of high-pressure-formed paper pulp, similar to environmental packing material. The white rubber wall-mounted vending machines dispense "essentials for hedonists." The sleek boxes, with metallic casements and embossed text, are desirable tactile objects in themselves.

The company's pervasive advertising slogans shout volumes. These products—strictly for the frenetic, outgoing party goers of society—have names such as Bender Mender ("for when you've had one over the eight, two over the sixteen, three over the twenty-four, or even four over the thirty-two"), Snog Me Senseless (a breath spray for when your mouth's about as fresh as your pet Labrador's), and A Long Time Coming ("for when you want to last all night, not all of thirty seconds"). These are designed to address all contingencies—or at least the most physical—in the course of a successful night on the town.

Anatomicals is also available at countertop point-of-purchase units, hotel mini-bars, and via mail order and online purchasing. The vending machines, first installed in London's upmarket department store Harvey Nichols, now adorn the walls of clubs, bars, and stores all over London. The marketing strategy, combined with the stylish vending machines that allow purchases to be made at all hours, reflects the up-beat nature of the products.

The sleek boxes, with metallic casements and embossed text, are desirable tactile objects in themselves.

The distinctive vending machines are constructed using cast-PVC front panels with embossed copy, a vacuum-formed ABS shell, and incorporate a clear pod component. The operating chassis is powder-coated with overmolded pull knobs.

Anatomicals set out to revolutionize the vending machine. Frank product descriptions adorn the product packaging.

FASHION SHOW, LAS VEGAS, NV
ORNE + ASSOCIATES, LOS ANGELES, CA AND THE ROUSE COMPANY, COLUMBIA, MD

The Fashion Show sets a precedent in retail typologies by offering a complete array of fashion outlets from department stores to small, specialized boutiques selling sunglasses to lingerie. The design of the mall has been driven by the theming concept prevalent in many of Las Vegas's buildings, such as New York, New York—the entertainment center in Las Vegas that themes the skyline of New York and provides simulations of New York's landmark buildings. For the Fashion Show, the theme is fashion and its accompanying notion of the spectacle.

Las Vegas is not only one of America's favorite gambling venues but is also fast becoming a prime shopping location. A twenty-first century interpretation of Alison and Peter Smithson's theories, explored in their seminal publication *Learning from Las Vegas*, the Las Vegas Fashion Show puts a new dimension on strip architecture. It achieves this by addressing the public walkway: The main visual stimulus consists of a 480-foot (146 meter) cloud canopy hanging above a 72,000-square-foot (6,700-square-meter) piazza where shoppers can gather and watch the large-scale video wall that simultaneously projects images of fashion shows occurring within the building.

"The Cloud is Fashion Show's architectural "icon" on the Strip and is an integral part of the overall audio/visual experience. Its scale and design distinguish it from the plethora of neon, and create a landmark for Fashion Show on a street where competition for the customer's eye is fierce. Together with the LED video screens, it provides unparalleled audio/visual capability to project images."
Rita Brandin, vice president and group director for The Rouse Company

The 600- by 120-foot (183-by 37-meter) plaza is a meeting and social place where visitors to the Fashion Show can absorb the street life of the boulevard or take in the giant projections screened on the bottom of the Cloud or the four moving LED televisions of the Media Curve wall.

The Rouse Company, behind the development of the Fashion Show, is known for intelligent inner-city development, retail innovation, and property management. Rouse is committed to urban renewal that connects the new intervention with the existing city fabric.

Rouse employed architect Richard Orne, AIA, principal of Orne + Associates, to design the scheme for expanding and renovating the twenty-year-old mall. The combined costs of the project, including the department stores, is in excess of one billion dollars and adds 1 million square feet (93,000 square meters) and renovates another million square feet (93,000 square meters) of existing shopping center.

Building in Las Vegas was a challenge for the architects. With no previous experience in urban development or in themed entertainment per se, Orne + Associates wanted to design a building that would compete with the surrounding architecture but not emulate the historical simulation so common in the city.

Richard Orne describes the main design directive: "At the concept stage, we were invited to reimage the existing architecture. And true to Rouse's track record of sensitive inner-city development, we wanted to provide a civic response to the famous strip architecture. We did this by creating a plaza at street level where pedestrians could meet and gather."

"We wanted to provide a civic response to the famous strip architecture. We did this by creating a plaza at street level where pedestrians could meet and gather."
Richard Orne, principal of Orne + Associates

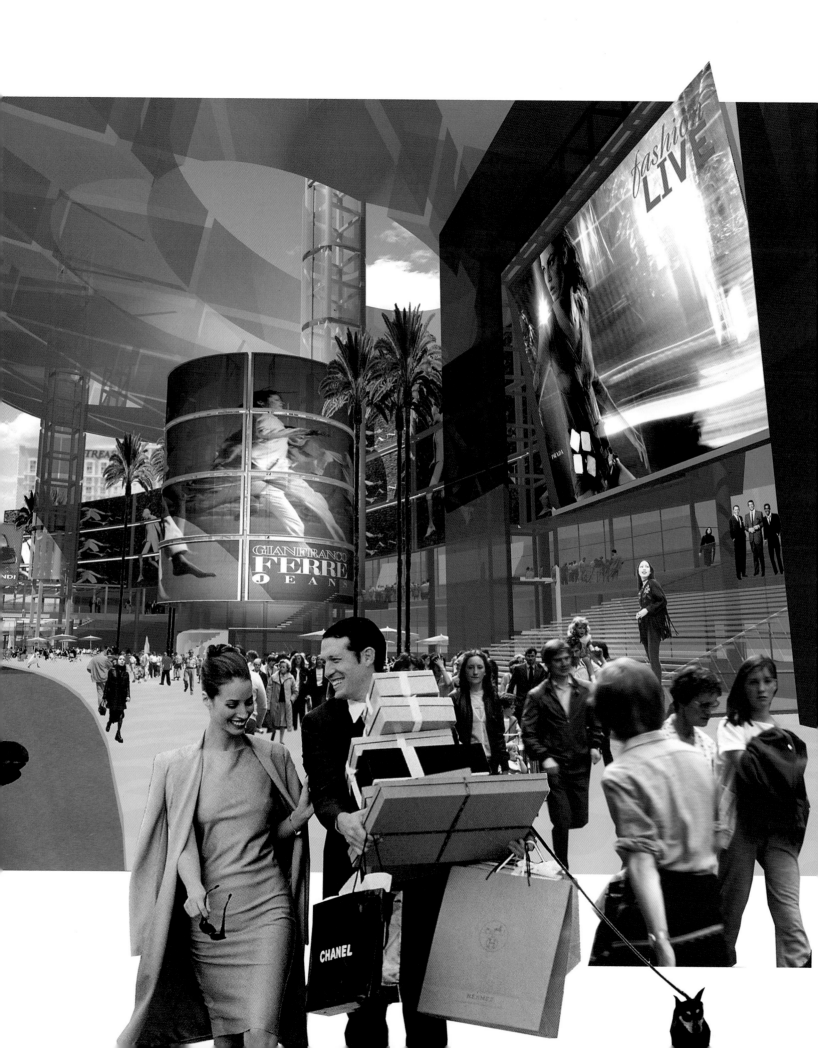

The footfall on the main Las Vegas Boulevard is enormous. With more than 30,000 people walking by this feature weekly, potential sales revenue is high. To attract customers, Orne designed a streetscape-style of architecture with the façade dissected into various elements and levels of circulation. For example, a principal outdoor staircase takes visitors from the plaza level to the second-floor shops, and a pedestrian bridge brings visitors over the nine-lane boulevard to the mall—pulling the circulation zones away from the main structure and adding to the dynamism of the scheme. The Cloud canopy shelters a retail and restaurant area, a video wall, the pedestrian bridge, and the plaza, all of which are formally placed to provide the varied and dissected façade.

The Fashion Show offers an array of activities, including street cafés and merchandising stalls, and incorporates eight of the leading fashion department stores—one of the largest concentrations in the world of high-quality fashion department stores under a single roof. The scheme's pivotal feature is the display of cutting-edge technological displays that transport the viewer to the center of the global fashion scene. The Cloud canopy, with a metal paneled skin, is the architectural element that unites the project. It is suspended 100 feet (31 meters) above the street from three steel truss towers and performs a dual function: It is a signifier so that the building can be identified from a distance, and it is a projection screen that allowing images to be projected on the underside, visible to the people in the plaza and strip at night. In case that doesn't dazzle the spectator enough, a 330-foot (101-meter)-long Media Curve wall of special video screens continuously displays fashion images.

The marketing platform, a runway and stage house in the Great Hall, part of the development's expansion of the Fashion Show, is made up of three large LED screens that descend from the ceiling for fashion-related events. On the Plaza, facing out toward the Las Vegas Boulevard is the Media Curve—a 350-foot (107-meter)-long steel track that incorporates four moving giant LED television screens. The LED screens can either be viewed as four separate images or tracked to display one 170-foot (52-meter)-long continuous image. This arrangement allows simultaneous telecasting of live events onto the boulevard screen and events on the plaza on the media curve. The media spectacle incorporated into the architecture of the building creates a sense of future technology and progress, of which customers want to be part.

Against the backdrop of Las Vegas's famous themed hotels, visitors live out their high-fashion dream in this high-tech temple to fashion and entertainment.

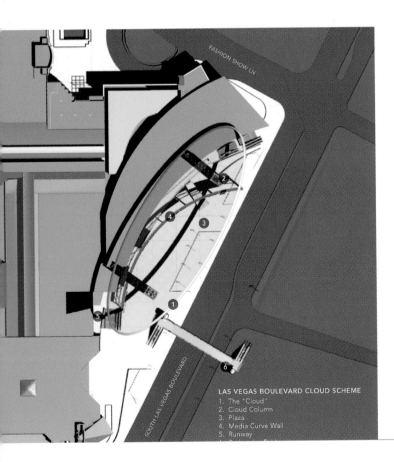

FASHION SHOW LN

SOUTH LAS VEGAS BOULEVARD

LAS VEGAS BOULEVARD CLOUD SCHEME
1. The "Cloud"
2. Cloud Column
3. Plaza
4. Media Curve Wall
5. Runway

The plan shows the dynamism of the scheme, with its high-tech street façade addressing the main Las Vegas boulevard. The dark line denotes the perimeter of the 450-foot (137-meter) cloud canopy.

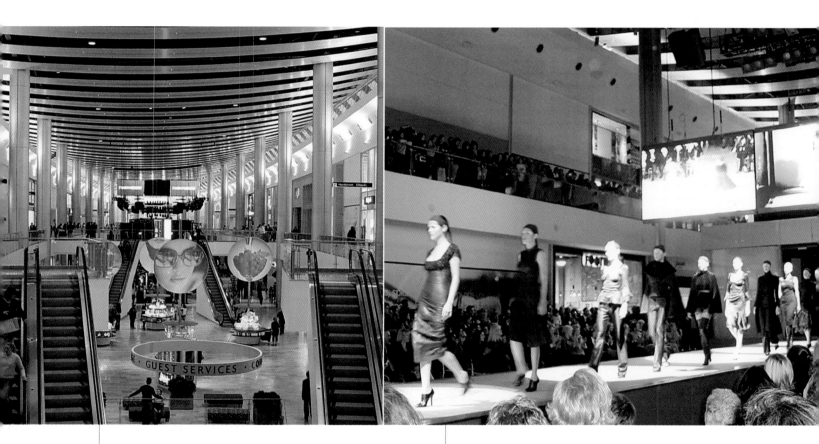

Internally, the Fashion Show houses eight of the leading fashion department stores, among them on Saks Fifth Avenue, Bloomingdale's, and Neiman Marcus .

Centered in the Great Hall, an 80-foot (25-meter)-long " runway" rises mechanically from the floor, as does a 28-foot (9-meter)-square "stage house." In support of these live fashion shows, three large LED television screens and theatrical lights descend from the ceiling.

The architects' aim was to design a space more like an art installation than a boutique.

OKI-NI, LONDON, UK
6A ARCHITECTS, LONDON, UK

When one first passes Oki-Ni on London's Saville Row, its identity is unclear: Is it a shop, an art gallery, a youthful creative agency? Oki-Ni, which means "thank you" in Osaka dialect, displays none of the normal syntax of a retail space. There is no window display, no cash desk; instead, shop assistants sit casually on stacked layers of felt. This is because Oki-Ni is a Web-based company; the boutique acts only as its showcase for limited-edition fashion apparel and accessories. By removing the point of sale, the assistant-customer relationship is displaced, creating a relaxed atmosphere. The pressure to buy is not a factor in this retail experience.

6a Architects, a three-partner practice that includes a fine artist, won the commission to design the showroom through a limited competition. The showroom was Oki-Ni's first test of the market; the untested concept summed up in the tag line "Uniqueness Is Rarity" meant that the architects were working, in their own words, "on virgin territory."

The architects' aim was to design a space more like an art installation than a boutique. Oki-Ni's merchandise is predominantly limited-edition pieces, some produced by branding giants such as Levi's and Adidas; therefore, the reading of the product as a semioriginal item, with its connotation of uniqueness and authencity, is not dissimilar to the rarefied art object.

Perhaps it is no coincidence that the principal design features of stacked felt and simple domestic light fittings nod in the direction of the Italian art movement Arte Povera. The term, coined by Germano Celant to describe the emerging group of Italian artists who used "poor" gestures and simple materials, was a reaction to minimalism and high art. Retail has turned decisively away from minimalism, the almost hegemonic style. Oki-Ni's adoption of this artistic influence makes a suitable connection between retail and art.

The site on Saville Row previously consisted of two shops; these were knocked together to provide 1,700 square feet (160 square meters) of space. The existing

The architects approached the system of hanging
clothes in an entirely fresh way, employing the paneling
as a hanging system similar to the way one might hang
one's clothes at home.

As the shop discarded the conventional premise of shopping to purchase on the spot and replaced it with Internet shopping, the only visible display of technology is the wireless laptop computers.

shell was in poor condition, but instead of making good the existing fabric, a tray of oak paneling was slotted in, leaving a perimeter area that houses changing rooms and office space. The stacked can be rearranged in a variety of configurations.

The design concept is meant to portray the flexibility of the space and to focus on the social side of shopping. Customers can, if they like, check merchandise on convenient laptops, but this is the evident technology. Clothes are casually propped over the top of the wooden shell. Hangers are refreshingly absent; in fact, there is no sign of any generic shop fitting details. The box, as it is termed by the architects, is slightly off kilter. The floor at the back of the shop is raised slightly, which brings the rear of the space into the foreground. The box is exactly the same height as a domestic door, creating an ambiguity between the art references at play in the space and the domestic sphere.

To re-create the Oki-Ni brand in a series of concession outlets, the felt is used as the definitive feature. For this company, the brand is always shifting, so this malleable composite of many woolen fibers is a good representation. Flannels in Leeds, United Kingdom, was the first concession to open. The architects created a temporary feel to the space analogous with a market trading stall. In the meantime, Oki-Ni sits in the heart of London's custom tailoring district, a fitting analogy between the manufacturing quality of the goods and subtle influence of technology now pervading the fashion industry. Five concessions are due to open in Japan, where the proprietor, Paddy Meehan, first launched his fashion collection and collaborative work with such revered names in fashion as Evisu—but Meehan will tread cautiously. The architects suggest a fitting motto for both their approach to design and Oki-Ni's penetration into the market: "We do things by stealth."

The concept collage illustrates the pared-down elements of the Oki-Ni brand: stacked layers of felt from a Munich-based supplier, the original supplier to Joseph Beuys, and the stripped-down light fittings designed specifically for the boutique.

An initial concept sketch demonstrates the casual display system
for the clothes that provides an informal retail atmosphere.

A blue-striped plastic flooring, normally used as a nonslip surface around swimming pools, covers the floor as water runs down the walls. The use of materials appropriated from their original usage is a recurring element introduced into the installations.

VEXED GENERATION, LONDON, UK
VEXED, LONDON, UK

Itinerant in its nature, Vexed Generation, established in 1995, chose to set up its own retail outlet and organize all aspects of the business from the manufacturing of clothing and accessories to sales and promotion. The first location in London's entertainment neighborhood, Soho, was sited neighboring London's underground activities, such as semi-illicit businesses, when the upwardly mobile moved in. When rents rose, Vexed moved on. Because Vexed locations are often highly masked by urban detritus or under the guise of a club, it is not perceived as a retail outlet.

Vexed relies on a different type of brand loyalty: The Vexed customer stays loyal to the Vexed social and political agenda. Clothes designers Adam Thorpe and Joe Hunter as they define themselves, as opposed to fashion designers, have established a political and social agenda that forms the conceptual basis for the clothing. This design agenda encompasses the promotion of two-wheeled transport, examining surveillance techniques in the city and information surveillance, and a push for civil liberties. With the effort to promote two-wheeled transport over the car came the much-copied, over-shoulder courier bag. In response to the heavily armed policemen who disbanded Britain's underground warehouse parties in the 1980s, Vexed designed a line of clothes that parodies the police riot gear.

Over six years in retail, Vexed has had two venues and a number of shop installations. The changes of location and rapid turnaround of interior installations aptly reflect the design collections titled "Itinerant Retail."

Vexed's first store display. The clothes were displayed in glass
boxes with holes in the sides. Customers had to reach through
the holes to feel the material, then travel to another area to
purchase the merchandise.

Vexed does not produce seasonal collections; instead, the clothes are designed to react to the political or environmental agenda.

The first shop, in London's Covent Garden on 12 Newbury Street, included record decks and a video library. Situated in the city's film and advertising area, creatives were invited to drop by and use the space as a makeshift cinema.

Vexed does not produce seasonal collections; instead, the clothes are designed to react to the political or environmental agenda. The first Vexed store display featured a glass box, much like an incubator unit, in the middle of the floor. Holes were cut into its sides so that prospective customers could feel the items but not remove them from the incubator—hence the store had no need for security. Customers would then progress to the ground floor, where DJs played music, movies were screened, and the actual merchandise sold. The storefront, after years of neglect, was camouflaged under city grime. A discreet slit on the glass was cleaned to allow a glimpse of the interior; otherwise, a closed-circuit television monitor, visible from outside the store, monitored the goings-on internally. The installation was a reaction to the debate in the 1980s about surveillance versus civil rights, air quality, and a greener transport system.

The second installation, titled "The Green Shop," was located on the first floor of 3 Berwick Street in London's Soho. Breathing garments linked to an air compressor were inflated and deflated on a timer, giving the impression of breathing clothing and walls. Fast-growing plants such as ivy and clematis were weaned through the clothes to create a living installation. Sensor lights illuminated the clothes when viewers were present, adding a sense of the unexpected.

The third installation, named "The Grow Room 98/99," featured £750, or $1,200 worth of one-penny coins lightly set into a thin resin layer. The floor was a statement on safety in numbers because it seemed unlikely that someone would go to the trouble to remove 75,000 coins from the floor.

In the shop installation "A Stitch in Time," customers were encouraged to leave their personal details on a label attached to the wall; these were then randomly reproduced on a garment, which could result in a chance meeting of wearer and identity donor.

Vexed is now being lauded by the big clothing players. They are working with the anticrime squad division of the police and independent bodies that promote safety to design a range of protective clothing for women.

THE MUSEUM OF USEFUL THINGS
SUSAN AND TIM CORCORAN, CAMBRIDGE, MA

Talking to Tim Corcoran, co-owner with his wife, Susan, of the Museum of Useful Things in Cambridge, Massachusetts, you'd think that this retail venture is a casual affair. "We're not very scientific about this," Corcoran is quick to admit.

The unique store was the brainchild of Susan Corcoran and although the pair already had two other retail stores in the area, this shop was to be entirely different. They forged ahead without any consultants and they did the interior design themselves. In theory and in fact, simplicity rules, which plays perfectly to the products the store proffers.

The store is unlike any other and doesn't neatly fit into any niche. While it sells kitchen gadgets, it isn't Williams-Sonoma. Although it sells products as a reasonable price, it isn't a discount store either. It may be more akin to an old-fashioned mercantile than anything else, but no matter how it is described, it cannot be pigeonholed.

The store offers a diverse range of products from kitchen gadgets to office supplies, whose primary purpose is function not beauty. "Any beauty is contingent on the function. So we don't want anything that is over embellished," says Corcoran. Products offer good values and are not embellished for the sake of embellishment. For instance, the store proudly sells a courier/messenger bag but would not consider selling a Pokéman backpack.

Displayed alongside these functional items is its historical predecessor from the Corcorans' personal collection of vintage items. "We wanted to show that these products did not just grow on trees, people worked at them and modified them over the years. One way to show that is to place vintage items interspersed with the new items."

Because the store is chocked full of antiques, its name is a perfect fit, for it is like a museum with many of the older, not-for-sale pieces, kept behind glass. "We strive to show the vintage aspect and historical linkage," adds Cocoran. "Not only do we show how things have changed over time, but we show that they don't always get better." Surprisingly, something as seemingly inconsequential as a spatula has changed over the years. Some have changed for the best; others have not. "We'll show examples of a good new one and a great old one."

In designing the 1,000-square-feet (92.9 square meter) store, the Corcorans avoided forced nostalgia. The rule of thumb was simplicity. They did all the design work and construction themselves, improvising as they went along and learning by trial and error.

The exterior is a typical urban storefront, says Corcoran. It blends in with its neighbors and its window displays are changed weekly to reflect its diverse offerings, everything from a mixture of furniture to gadgetry. Even the window displays

The decor of the shop mirrors its product offering—its beauty is secondary to its function. Above all, the store, like many of its best-selling products, is simple in design but nevertheless works well.

"We're not very scientific about this."
Tim Corcoran, co-owner

The Museum of Useful Things breaks many of the rules of traditional retailing. Best-selling items can often be found stacked high on shelves near the ceiling or placed close to the floor. The rule of placing things at eye level doesn't necessarily apply to this successful retail outlet.

Gray shelving units are the focal point of the store, which the owners describe as "plain functional."

are kept simple. There are no rules for themes, either by color or function. "We're no where near that formal."

The store works off a grid pattern that provides flexibility and allows the Corcorans to highlight any one item without overwhelming the others. Gray shelving units are the focal point. "We wanted them that way. That's a glib answer, I know but it isn't meant to be a wisecrack," he says. "When someone comes in, we hope they latch onto a shelf or one of the grids with their eyes and get pulled throughout the store."

The modular shelves can be outfitted with glass to protect vintage items. The color palette is dark blue and raw steel, which work off of a black floor.

Corcoran is careful not to characterize the store's decor as industrial modern, but prefers describing it as "plain functional-very simple, very inornate."

"The way we display an item is unconventional," says Corcoran, who readily admits that they've broken many traditional rules of retailing. "We generally stack things on the shelves, often to the ceiling. We place things that are for sale up way too high and down too low."

Despite the unconventional approach or perhaps because of it, consumer response has been enthusiastic. "People tend to spend a lot of time in the store. They enjoy themselves. They find what they need and they rekindle memories," says Corcoran.

"Retail ought to be fun for the retailer and the customer. It doesn't have to be so serious and we try to remember that."

THE POP SHOP
MICHAEL ANDALORO ASSOCIATES, INC, NEW YORK, NY

Imagine graffiti so attractive, distinctive, and eye-catching that it makes it way into the annals of pop culture. That's the story of Keith Haring in a nutshell. In the late 1970s and early 1980s, Haring used New York City's subway walls as his canvas. He'd glue a piece of black paper atop an advertisement and create an image-on walls, sidewalks, anywhere. In no time Haring's cartoon-y outlined figures had generated a lot of talk about the unknown artist, who wasn't regulated to obscurity for long.

By 1985, Haring was famous; he then opened the Pop Shop on New York City's Lafayette Street. The 100-square foot (9.29 square meter) store was tiny by retail standards, but for Haring, 100 square feet (9.29 square meters) provided plenty of canvas space and he used every inch of it, painting a black-and-white mural on the walls, ceiling, and floors. The look was as much a part of his identity as the products that were to adorn the store-T-shirts and the like featuring his artwork.

Items were pinned on the walls of the shop; buyers would write down the number of the product they wanted and give it to a cashier at a pass-through teller's window. "The feeling wasn't retail at all," remembers Michael Andaloro, who was hired to renovate the space. "It felt like an off-track betting joint."

After Haring died in the early 1990s, the Keith Haring Estate commissioned Andaloro, an interior designer and principal of Andaloro Associates, Inc., to redesign the store in a larger 550 square foot (51.1 square meter) location that would keep up with demand and commemorate the tenth anniversary of the store opening.

Andaloro's primary objective was to retain the eclectic atmosphere of the original store, while creating a more workable retail environment that didn't detract from Haring's artwork. Andaloro preserved Haring's murals whenever possible. What wasn't used was painted black before being discarded so that scavengers wouldn't be able to resurrect the art from the garbage.

The focal point of the new space remains the mural, accented by the artwork. Haring's black-and-white identity, interspersed with bold, primary-colored art, can be seen clearly from the street through large, unadorned windows. The store's name appears as a stenciled logo on the awning outside the store. Haring's artwork hangs on panels centered in the spacious windows and can be easily changed in and out as needed.

The interior is remarkable for what isn't seen—fixtures that fades into the background. Andaloro's intent was to create a grid structure of fixtures that "frames" the art on the wall without drawing attention to itself.

A structural steel grid framework performs multiple functions throughout the store. It not only works hard as the merchandising system and foundation for track lighting, but the grid pattern frames Haring's artwork and doesn't obscure his black-and-white mural, which covers nearly every inch of the store's surface.

The structure runs up the walls and across the ceiling and performs multiple functions. The grid frames artwork, holds curtains around the changing room, and supports track-mounted lights. Fluorescent lights are used to further illuminate the merchandise, but they are kept hidden behind support poles. The grid framework extends to the floor displays, which are designed as multipurpose modular steel cubes, reminiscent of the crates used by college students in dormitories around the world. They are stackable, movable, easily adaptable to changing retail needs, and most importantly, they don't detract from or obscure the art.

The only fixture that stands out—and is a work of art unto itself—is a display that holds postcards featuring Haring's work. Andaloro says that theater marquees inspired the display, which consists of a four-tiered rack that lines a hallway and holds hundreds of Haring's eye-popping designs on red acrylic shelves. Running along the top and bottom of the display is a back-lit metal band with the stenciled words, Pop Shop, cut out. Where the display crosses the hallway, it is mounted on a clear acrylic panel so as not to obscure the black-and-white mural behind it.

"The biggest challenge was walking that fine line between keeping the original feel of the first store and blending it with the new, thereby creating a cohesive whole," says Andaloro. "I think the redesign achieves just that."

DIRECTORY

PROJECT: Agent Provocateur
PAGE 58
Jenny Armit Design
3425 La Sombra Drive
Los Angeles, CA 90068 ,USA
www.agentprovocateur.com

PROJECT: Alessi
PAGE 42
Shaygan Interiors
5 Sebastian Street
London EC1V OHD, UK
TEL: +44 20 7253 6403
FAX: +44 20 253 6396
e-mail shideh.shaygan@telia.com

PROJECT: Anatomicals
PAGE 134
Mosley Meets Wilcox
1C Darnley Road
London E9 6Q4, UK
TEL: +44 208 525 2665
www.mosleymeetswilcox.com

PROJECT: Apple Store
PAGE 130
Apple Computer, Inc.
Cupertino, CA, USA
www.apple.com

PROJECT: Bally
PAGE 24
Craig Bassam Architects
480 Canal Street
New York, NY 10013, USA
TEL: (212) 941-9700

PROJECT: Bloom
PAGE 54
Janson Goldstein Architects
180 Varick Street
New York, NY 10014, USA
TEL: (212) 691-1611
FAX: (212) 691-2244

PROJECT: Camper
PAGE 20
Estudio 22
Bonavista 22, bajos int.
0812 Barcelona, Spain
TEL: 0034 93 217 5986
FAX: 0034 93 237 78 04
estudio22@terra.es

PROJECT: Canyon Ranch
PAGE 104
MOVK
325 West 38th Street, Suite 805
New York, NY 10018, USA
TEL: (203) 631-0891
FAX: (212) 631-0895 (fax)
www.movk.com

PROJECT: Chanel
PAGE 10
Peter Marino + Associates
150 East 58th Street
New York, NY 10022, USA
TEL: (212) 752-5444
FAX: (212) 759-3727 (fax)

PROJECT: Fashion Show
PAGE 136
Orne + Associates
3517 S. Centinela Avenue
Los Angeles, CA 90066, USA
TEL: (310) 397-9995
FAX: (310) 397-8862
oa@orneassociates.com
Developer: The Rouse Company
Columbia, MD
Design Architect: (in collaboration
with Orne + Associates, Inc.)
MONK, LLC
Laurin B. Askew, Jr., FAIA
Baltimore, MD and
Altoon + Porter Architects
Los Angeles, CA, USA

PROJECT: Gibo
PAGE 62
Cherie Yeo Architecture + Design
24 Sunbury Workshops
Swanfield Street
London E2 7LF, UK
TEL: +44 207 729 3907
FAX: +44 207 729 1013
cherie.yeo@virgin.net

PROJECT: Habitat
PAGE 114
Gerard Taylor Design Consultancy
26 Rosebery Avenue
London EC1R 4SX, UK
TEL: +44 20 7713 0675
FAX: +44 20 7713 0676
mail@gerardtaylor.com

PROJECT: IKEA
PAGE 122
Ikea
496 West Germantown Pike
Plymouth Meeting, PA 19462, USA
TEL: (800) 434-4532
www.ikea.com

PROJECT: Keds
PAGE 118
Chute Gerdeman, Inc.
455 South Ludlow Alley
Columbus, OH 43215, USA
TEL: (614) 469-1001
FAX: (614) 469-1002
www.chutegerdeman.com

PROJECT: Kerquelen
PAGE 78
Stürm and Wolf
Quellenstrasse 27
CH-8005 Zürich, Switzerland
TEL: +41 1 272 57 57
FAX: +41 1 272 57 83
stuermwolf.net
info@stuermwolf.net

PROJECT: Les Migrateurs
PAGE 88
Leven Betts Studio
511 West 25th Street, #809
New York, NY 10001, USA
TEL: (212) 620-9792

PROJECT: l.a. eyeworks
PAGE 84
NMDA
12615 Washington Boulevard
Los Angeles, CA 90066, USA
TEL: (310) 390-3033
FAX: (310) 390-9810 (fax)
info@nmda-inc.com
www.nmda-inc.com

PROJECT: L.L. Bean
PAGE 102
Casco Street
Freeport, ME 04033, USA
TEL: (207) 865-4761
www.llbean.com

PROJECT: L'Huillier Bridal Store
PAGE 66
Studio Ethos, Inc.
451 San Vicente Boulevard, #16
Santa Monica, CA 90402, USA
TEL: (310) 260-1021
FAX: (310) 260-1024
info@studioethos.com
www.studioethos.com

PROJECT: McQueen
PAGE 14
WRAD Ltd.
William Russell Architecture
24 Sunbury Workshops
London E2 7LF, UK
TEL: +44 20 7729 3133
FAX: +44 20 7729 1013
will@wrad.freeserve.co.uk

PROJECT: Museum of Useful Things
PAGE 152
Museum of Useful Things
370 Broadway
Cambridge MA 02139, USA
www.themut.com

PROJECT: Oki-Ni
PAGE 142
6a Architects
6a Orde Hall Street
London WC1N 3JW, UK
TEL: +44 207 242 5422
FAX: +44 207 242 3646

PROJECT: Paul Smith Shops
PAGE 28
Sophie Hicks Ltd. Architects
16 Powis Mews
London, W11 1JN, UK
TEL: +44 207 792 2631
FAX: +44 207 727 3328
mail@sophiehicks.com
www.sophiehicks.com

PROJECT: The Pop Shop
PAGE 156
Andaloro Associates, Inc.
11 East Third Street
New York NY 10009, USA
mandaloro@aol.com
www.michaelandaloro.com

PROJECT: Puma
PAGE 38
Kanner Architects
10924 Le Conte Avenue
Los Angeles, CA 90024, USA
(301) 208-0028
mbur@kannerarch.com

PROJECT: Paul Smith Horn Store
PAGE 32
Sophie Hicks Ltd. Architects
16 Powis Mews
London, W11 1JN, UK
TEL: +44 207 792 2631
FAX: +44 207 727 3328
mail@sophiehicks.com
www.sophiehicks.com

PROJECT: Selfridges Food Hall
PAGE 110
Future Systems
20 Victoria Gardens
London W11 3PE, UK
TEL: +44 207 243 7670
FAX: +44 207 670 7690

PROJECT: Selfridges Sports Hall
PAGE 98
Gerald Taylor Design Consultancy
26 Rosebery Avenue
London EC1R 4SX, UK
TEL: +44 207 713 0675
FAX: +44 207 713 0676
mail@gerardtaylor.com

PROJECT: Tag Heuer
PAGE 34
Curiosity, Inc.
2-45-7 Honmachi
Shibuga-ku, Tokyo
151-0071, Japan
TEL: +81(0) 3 5333 8525
FAX: +81 (0) 3 5371 1219
www.curiosity.co.jp

PROJECT: Trina Turk
PAGE 70
Kelly Weastler Interior Design (KWID)
317 North Kings Road
Los Angeles, CA 90048, USA
TEL: (323) 951-7454
FAX: (323) 951-7455

interior@kwid.com
PROJECT: Tweeter Design Center
PAGE 126
Tweeter Home Entertainment Group
Canton, MA 02021, USA
kmonaghan@twtr.com
www.tweeter.com

PROJECT: Volkswagen Marketplaces
PAGE 46
Gensler Architects
One Woodward Avenue, Suite 601
Detroit, MI 48226, USA
TEL: (313) 965-1600
FAX: (313) 965-8060
www.gensler.com

PROJECT: Vexed Generation
PAGE 148
10 Andrew's Road
London E8, UK
TEL: +44 207 254 3344
FAX: +44 207 254 4411
office@vexed.co.uk

PROJECT: Vidal Sassoon
PAGE 94
Association of Ideas
189 Munster Road
London SW6 6AW, UK
TEL: +44 207 381 6001
FAX: +44 207 386 0149
aoi@aoi.uk.com

PROJECT: Zao
PAGE 74
Calvert Wright Architecture
645 Broadway, 5th Floor
New York, NY 10012, USA
TEL: (212) 475-3531
FAX: (212) 253-6841
calvert@spatialdiscipline.com
www.spatialdiscipline.com

PHOTOGRAPHER CREDITS

Courtesy of Apple Computer, Inc., 130; 131

Courtesy of The Association of Ideas, 94; 95; 96; 97

Björg, 21; 22; 23 (left); 75; 76; 77

Benny Chan, 85; 86

David Churchill, 6; 98; 99; 115; 116; 117; 163

Grey Crawford, 58; 59; 60; 61; 71; 72; 73 (bottom)

Courtesy of Curiosity, Inc., 34; 35; 36; 37

Richard Davies, 110; 112; 113

Andy Day/Lostrobot, 63 (top); 64 (top); 65

© Patrik Engquist.se, 43; 44; 45

Courtesy of Estudio, 23 (right)

© Elizabeth Felicella Photography, 90; 91

Courtesy of Gensler Architects, 47

David Grandorge/Courtesy of 6A Architects, 143; 144

Courtesy of Sophie Hicks Ltd. Architects, 28; 30; 31; 32; 33

Courtesy of Ikea, 123; 124; 125

Courtesy of Janson Goldstein Architects, 54; 57 (bottom)

Courtesy of Kanner Architects, 40 (left)

Eric Laignel/Courtesy of Gensler Architects, 46; 48; 49; 50; 51

Courtesy of Leven Betts Studio, 88

John Edward Linden, 9; 66; 67; 68; 69 (bottom)

Courtesy of Peter Marino Architects, 13 (bottom)

Steven Mays, 157; 158

Courtesy of Mosley Meets Wilcox, 135

Courtesy of NMDA, 87

J. D. Peterson/Kanner Architects, 38; 39; 40 (right); 41

Mark Plyler/Courtesy of MOVK, 92; 104; 106; 107

Greg Premru, 133; 153; 154; 155

Courtesy of William Russell Architects, 14; 16; 17; 18; 19

Philip Sayer, Domus, 29

Simmons Productions and Opulence Studios/Courtesy of Orne + Associates, 136; 139; 140; 141; 167

Courtesy of 6A Architects, 146; 147

Jonathan Skow, 73 (top)

Mark Steele/Courtesy of Chute Gerdeman, 109; 118; 119; 120; 121

Courtesy of Studio Ethos, 69 (top)

Courtesy of Gerard Taylor Design Consultancy, 101; 114

Courtesy of Tweeter Home Entertainment Group, 126; 128; 129

Brian Vanden Brink, 102; 103

Courtesy of Vexed Generation Retail Installations, 148; 150

Paul Warchol, 11; 12; 13 (top); 25; 26; 27; 53; 55; 56; 57 (top); 78; 80 (left); 81; 82

Courtesy of Isa Stürm Urs Wolf SA, 52; 79; 80 (right); 83

Courtesy of Cherie Yeo Architecture & Design, 62; 63 (bottom); 64 (bottom)

ABOUT THE AUTHOR

Corinna Dean completed her postgraduate studies in architecture at the Bartlett School of Architecture, University College, London. Since then she has carried out a variety of study programs into war-torn areas such as the Gaza strip, Beirut, and Cyprus. In addition, she contributes to the following journals: *The Architectural Review*, *The Architects' Journal*, *Bauwelt*, *Blueprint*, *Deutsche Bauzeitung*, *Idea*, and *Wallpaper*. Corinna continues to curate and design exhibitions for a range of commercial and noncommercial clients.

ACKNOWLEDGMENTS

Thanks to Betsy Gammons for her guidance.